READING RAILROAD
RAILROAD
HERITAGE

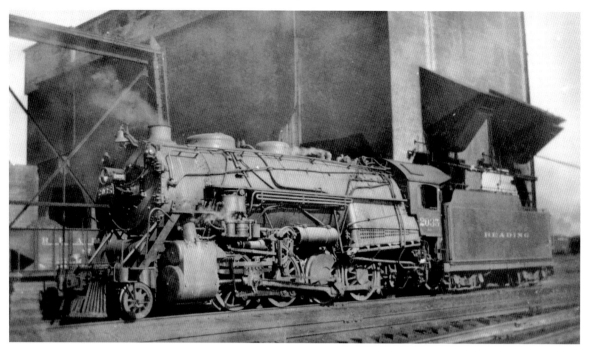

Consolidation type Reading Company class I10-sa steam locomotive No. 2035 with a 2-8-0 wheel arrangement is at Rutherford, Pennsylvania, on November 11, 1935. This was one of 50 locomotives, Nos. 2000-2049, built by Baldwin Locomotive Works during 1923-1926. With 61.5-inch diameter drive wheels, the locomotive had a tractive effort of 71,000 pounds, which is the force that a locomotive can apply to its coupler to pull a train. Number 2035 was built in March 1925, rebuilt by the Reading shops as class T1 No. 2116 in September 1946, and was retired in October 1958. (Jerry Hoare collection)

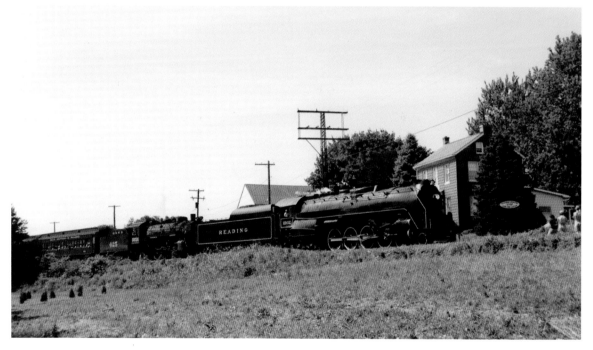

In June 1986, Blue Mountain & Reading Railroad (BM&R) steam locomotive No. 425, a Pacific type with a 4-6-2 wheel arrangement, and former Reading Railroad steam locomotive No. 2102, a Northern type with a 4-8-4 wheel arrangement, are powering a rail excursion north of Reading, Pennsylvania. From 1960 to 1964, No. 2102 operated on the Reading Iron Horse Rambles. Elephant ears were applied to No. 2102 in 1973, and it served in the Delaware & Hudson Railroad sesquicentennial as number 302. Following excursions in 1985 sponsored by the Reading Company Technical & Historical Society, No. 2102 was acquired by the BM&R in 1985 and operated excursions until the early 1990s. In 2016, the locomotive is being restored. (Reading Railroad Heritage Museum collection)

READING RAILROAD
HERITAGE

KENNETH C. SPRINGIRTH

AMERICA
THROUGH TIME®
ADDING COLOR TO AMERICAN HISTORY

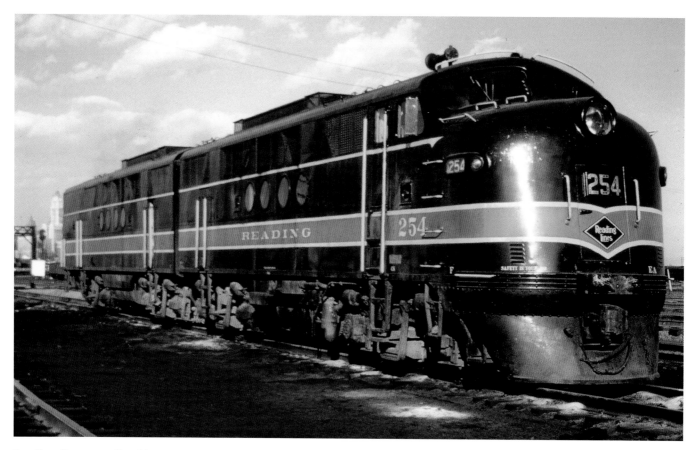

Reading Company diesel locomotive type FTA No. 254A and type FTB No. 254B, built in 1948 (each rated 1,350 horsepower) by the Electro-Motive Division of General Motors Corporation, are waiting for the next assignment. (Martin S. Zak photograph, Jerry Hoare collection)

On the top portion of cover: Wayne Junction is the scene of Reading Company steam locomotive No. 2124 powering an Iron Horse Ramble on October 25, 1959. This locomotive was originally No. 2024 class I10-sa Consolidation type with a 2-8-0 wheel arrangement built by Baldwin Locomotive Works in December 1923. It was rebuilt as No. 2124 class T1 Northern type locomotive with a 4-8-4 wheel arrangement at the Reading shops in January 1947. (Kenneth C. Springirth photograph)

On the bottom portion of cover: Klapperthal Junction is the location of Reading Company 3,000 horsepower type GP40-2 diesel locomotives Nos. 3671 and 3672 around 1974. Both locomotives were built in December 1973 by the Electro-Motive Division of General Motors Corporation. After the Reading Company became part of Conrail, locomotive No. 3671 became Conrail No. 3275 and later Norfolk Southern Railway No. 3000, while locomotive No. 3672 became Conrail No. 3276, later CSX Transportation No. 4400, and was renumbered CSX Transportation No. 6982. (Reading Railroad Heritage Museum collection)

Back cover: Type FP7A No. 904 diesel locomotive is powering the Reading Company "Wall Street" passenger train westbound through Elizabeth, New Jersey, in June 1963. This was one of eight locomotives, Nos. 900-907 (each rated 1,500 horsepower), built for the Reading Company by the Electro-Motive Division of General Motors Corporation. Locomotive No. 904 was built in May 1950 and retired in 1965. (Jerry Hoare collection

America Through Time is an imprint of Fonthill Media LLC

First published 2017

Copyright © Kenneth C. Springirth 2017

ISBN 978-1-63499-023-3

Typeset in Utopia Std

Published by Arcadia Publishing by arrangement with Fonthill Media LLC

For all general information, please contact Arcadia Publishing:

Telephone: 843-853-2070
Fax: 843-853-0044
E-mail: sales@arcadiapublishing.com
For customer service and orders:
Toll-Free 1-888-313-2665

Visit us on the internet at www.arcadiapublishing.com

Contents

Acknowledgments

Thanks to the Erie County (Pennsylvania) Public Library system for their excellent interlibrary loan system. The Reading Railroad Heritage Museum (500 S. Third Street, Hamburg, PA 19526) operated by the Reading Company Technical & Historical Society was an excellent source of information (website www.readingrailroad.org) and a number of photographs were purchased from them. Clifford R. Scholes was an excellent source for pictures. The Reading Blue Mountain & Northern Railroad excursion from Pottsville, which included a shop tour at Port Clinton, was an example of a well-run railroad which allowed passengers to photograph their shop facilities. Thanks to the Railway Restoration Project 113 of Minersville, Pennsylvania, for restoring Central Railroad of New Jersey steam locomotive No. 113 and steaming it down to the September 24, 2016, Schuylkill Haven Borough Day. Thanks to the Schuylkill Haven Borough Day Committee, the Reading Blue Mountain & Northern Railroad, and the residents of Schuylkill Haven, Pennsylvania, for that wonderful September 24, 2016, event. Jerry Hoare, owner of the Gandy Dancer at 12 Hill Road (Opera House Square) in Jim Thorpe, Pennsylvania 18229 (telephone number 610-533-3556) was an excellent source of pictures. Books that served as excellent reference sources were *The Reading Railroad: History of a Coal Age Empire Volume I: The Nineteenth Century* by James L. Holton; *The Reading, Building a Modern Railroad* by the Reading Railroad; *The Reading Railroad: History of a Coal Age Empire Volume II: The Twentieth Century* by James L. Holton; *Steam Locomotives of the Reading and P & R Railroads* by Edward H. Wiswesser, P.E.; *Anthracite Rebirth: Story of the Reading & Northern Railroad* by Mike Bednar; *Electric Trains to Reading Terminal* by Wes Coates; and *History of the Locomotives of the Reading Company Bulletin No. 67* by George M. Hart. Jim Schlegel wrote an excellent article, "The Allentown Railroad," which appeared in Railpace Newsmagazine March 2016.

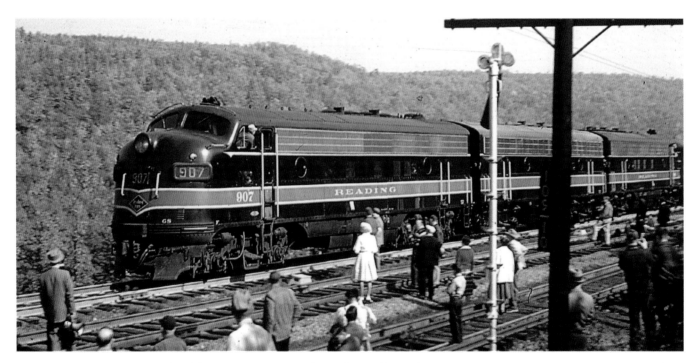

Reading Company type FP7A diesel locomotive No. 907 is the lead unit of three locomotives powering a passenger excursion making a photo stop at the borough of Catawissa in Columbia County, Pennsylvania, on October 16, 1960. Built in September 1952 by the Electro-Motive Division of General Motors Corporation, the 1,500-horsepower locomotive was a dual service passenger and freight hauling locomotive. (Bob Crockett photograph—C. R. Scholes collection)

Introduction

The Philadelphia, Germantown & Norristown Railroad began operation on November 23, 1832. Pennsylvania Governor George Wolf signed the charter for the Philadelphia & Reading Railroad (P&R) on December 5, 1833. Regular service from Philadelphia to Reading began on December 5, 1839. The first train operated from Pottsville to Philadelphia on January 1, 1842. In 1847, the Philadelphia, Reading & Pottsville Telegraph Company, a subsidiary of the P&R, was chartered to build telegraph lines to transmit messages by electricity. This telegraph company continued to operate until the Reading Company went out of business in 1976. On July 5, 1858, the Lebanon Valley branch of the P&R opened for freight and passenger service between Reading and Harrisburg. Reading to Allentown train service began on April 21, 1859. In December 1871, the P&R began identifying locomotives by number in place of names. Philadelphia's Reading Terminal opened at 12th and Market Streets with full service on January 29, 1893. The P&R became the Reading Company on November 30, 1893. Construction began in 1900 on a large classification yard at Rutherford, four miles east of Harrisburg on the Lebanon Valley branch. Another major yard was built north of Williamsport at Newberry Junction where the Reading Company connected with the New York Central Railroad.

The Reading Company created the Reading Belt Railway, which began construction in 1900 of a 7.4 mile double track line that bypassed the city of Reading on the west shore of the Schuylkill River. After completion, it was formally dedicated on May 15, 1902. The Reading Company and the Jersey Central Railroad jointly initiated *Queen of the Valley* on May 12, 1901, a high-speed train between New York and Harrisburg with speeds that reached 75 miles per hour. The train that had linked the two cities for two years was given a speed upgrade and renamed *The Harrisburg Express*. During 1903, a large 388,464-square-foot shop building (one of the largest locomotive shop buildings in the world at that time) was completed in Reading at a cost of over $1.7 million. In 1903, the Reading Company established a company pension plan under which any man reaching the age of 70 would be eligible for retirement pay. On June 12, 1905, six new dining cars were placed in service on the New York Division. In 1917, the Reading Company announced that salaried workers would receive one week of paid vacation annually. By the end of 1917, 1,497 Reading Company employees had been called for World War I military service, and the company assured those employees their jobs and seniority would be held for them during the duration of the conflict. Effective January 1, 1918, the United States Government took over the entire railroad industry. Although World War I ended on November 11, 1918, government control of the railroads did not end until February 29, 1920.

The car shops at Reading were replaced between 1925 and 1929 to handle the repair of freight and passenger cars. According to *The Reading Railroad: History of a Coal Age Empire Volume II: The Twentieth Century* by James L. Holton, page 214, "The company was spending $14,000,000 a year to maintain its 1,130 locomotives, 43,000 freight cars, and 1,650 passenger cars in 1928. And much of that money was being spent at the Reading Shops."

On November 12, 1928, Reading Company President Agnew T. Dice announced that the suburban lines operating from Reading Terminal in Philadelphia would be electrified. The Reading Company chose 11,000 volts, 25 cycles, and an alternating current system. A new fleet of 100 multiple unit electric motor cars, based on Reading Company specifications, was built during 1931-1932 by the Harlan & Hollingsworth plant of Bethlehem Steel at Wilmington, Delaware, for these commuter lines. There were 28 passenger cars, built in 1925, that were converted to trailer cars. An additional eight cars were built in 1949 by American Car & Foundry Company. These cars proved to be economical to operate, easy to maintain, and provided years of reliable service. On July 26, 1931, electrified passenger service began from Reading Terminal in Philadelphia to Lansdale and Hatboro. Full revenue electrified service on the Norristown branch and Chestnut Hill branch from Reading Terminal began on February 5, 1933.

On June 25, 1933, the Reading Company and Pennsylvania Railroad operations in South Jersey were merged into the Pennsylvania-Reading Seashore Lines. This merger was necessary by the decline in passenger riding that occurred after the Delaware River Bridge opened on July 1, 1926, between Philadelphia and Camden, New Jersey, providing easy highway access to the New Jersey seashore resorts. The merged rail line used 45 miles of the Reading Company track at the north end and 33 miles of the Pennsylvania Railroad track at the seashore end.

During 1929, 12 railroads were formally absorbed into the Reading Company as follows: Catasauqua & Fogelsville Railroad Company; Gettysburg & Harrisburg Railway Company; North East Pennsylvania Railroad Company; Perkiomen Railroad

Company; Philadelphia & Chester Valley Railroad Company; Philadelphia, Newtown & New York Railroad Company; Pickering Valley Railroad Company; Port Reading Railroad Company; Reading & Columbia Railroad Company; Reading, Marietta & Hanover Railroad Company; Stony Creek Railroad Company; and Williams Valley Railroad Company. In spite of the October 29, 1929, stock market crash that marked the start of the Great Depression, the Reading Company continued the electrification project. In 1930, a new electric car shop, with a capacity of 160 cars, was completed at Wayne Junction, costing $300,000. As a result of the Depression, Reading Company freight and passenger business declined as follows: from 1929 to 1932, freight tons declined from 65,124,330 to 37,945,632; the number of passengers carried declined from 16,340,726 to 9,367,541; and net income declined from $15,508,740 to $4,228,789.

In May 1937, the Reading Company announced a new stainless steel streamlined train would be built by the Budd Company, which would be the first streamlined steam passenger train between Philadelphia and Jersey City. Stainless steel sheathing was applied to Reading Company class G-1sa Pacific locomotives Nos. 117 and 118 at the Reading shops. Budd Company built five passenger cars. The first and fifth cars had observation ends (so the train would not have to be turned), the middle car was a tavern car, and the second plus fourth cars were coaches. Following three days of display at the Reading Terminal, the train was viewed at Jersey City, Elizabeth, Plainfield, Trenton, Norristown, Pottstown, Lebanon, Harrisburg, Pottsville, and Reading. The train went into regular service on December 13, 1937. A contest was held to name the train, which resulted in over 6,000 suggestions. Railroad officials selected *The Crusader* as the winning name, submitted by Plainfield, New Jersey, businessman Parker W. Silzer.

Beginning in 1939, as Germany began its campaign to conquer Europe, the United States Government started military preparations. In March 1941, the Pennsylvania's National Guard's 28th Infantry Division of 20,000 soldiers was ordered to assemble at the Indiantown Gap military facility, and the Reading Company handled the troop movement. As a result of the December 7, 1941, Japanese attack on Pearl Harbor, United States railroads, including the Reading Company, played a vital role in the national war effort. With many of its employees in military service, women were hired and some retirees went back to work. In February 1945, the Reading Company received its first road diesel locomotives, which marked the beginning of the end of Reading Company steam locomotives. The Reading Company introduced a new steam powered train, *The Wall Street*, which was placed on display at the Reading Terminal in Philadelphia on February 25 and 26, 1948, and in Jersey City on February 27, 1948. It was placed in regular service on March 1, 1948, between Philadelphia and Jersey City with three reclining chair cars, a dining car, and a club car. On November 14, 1948, a nine-car, two-tone green, steam-powered passenger train known as *The Schuylkill* was placed in service between Philadelphia and Pottsville. During

1949, another new train, *The King Coal*, was placed in service from Philadelphia to Shamokin. The expensive improvement in passenger service did not increase ridership, which declined seven percent in 1949. Freight tonnage declined 23 percent as an unusually mild winter reduced the demand for coal. In 1952, the passenger train *Crusader* was refurbished and its steam locomotives were replaced by type FP-7A diesel locomotives. The final regularly scheduled passenger train steam locomotive was Pacific type locomotive No. 134 on a Newtown branch commuter local on May 6, 1952. By the beginning of 1953, 99 percent of the Reading Company's freight service was dieselized, and by the end of 1954 the railroad was completely dieselized. On June 1, 1956, the Pennsylvania Railroad leased Reading Company class T1 steam locomotives Nos. 2107, 2111, 2112, 2113, 2114, 2115, 2119, and 2128. The lease ended in December 1956. According to *The Reading Building a Modern Railroad*, published by the Reading Company on April 4, 1958, "One of the ten largest tonnage carriers among American railroads, the Reading's 1,300 mile system stretches through Eastern Pennsylvania and parts of New Jersey and Delaware—a strategic location which encompasses some 23,000,000 persons and about 16 percent of the nation's purchasing power within a 100 mile radius."

During the 1957 National Boy Scout Jamboree at Valley Forge, Pennsylvania, the Reading Company transported 119,000 passengers, which included Scouts and visitors. United States President Dwight David Eisenhower signed into law the bill that authorized the construction of the Interstate Highway System on June 26, 1956. The new Interstate Highway System resulted in a decline of freight business for the railroads as freight shifted to trailer trucks. Passenger traffic declined as the new superhighways made it easier to travel by automobile. By June 1957, seven remaining Pacific type Reading Company steam locomotives that had been assigned to Pennsylvania Reading Seashore Lines were replaced by diesel locomotives, making the railroad 100 percent dieselized.

Beginning three fall weekends in 1959, the Reading Company operated Iron Horse Rambles using type T1 steam locomotive No. 2124 that attracted thousands of riders. During 1960, 13 steam trips were scheduled, including one double header with Nos. 2124 and 2100. In the final trip of the 1961 season, No. 2124 had run out of service time and went to Steamtown, U.S.A. Steam locomotives Nos. 2100 and 2102 handled eight more trips during 1962. The backup locomotive for the Iron Horse Rambles was No. 2101. This locomotive was later pulled from retirement, overhauled, and was the first of three locomotives used for the *American Freedom* train which operated from April 1, 1975, to December 31, 1976, hauling historic artifacts. The other locomotives were Southern Pacific No. 4449 with a 4-8-4 wheel arrangement and Texas & Pacific No. 610 with a 2-10-4 wheel arrangement.

In 1960, the City of Philadelphia began subsidizing Reading Company commuter service. In 1962, the U.S. Postal Service and Railway Express announced they would discontinue the use of passenger trains to carry intercity mail and express by October

1962. In response, the Reading Company announced that train service would be reduced, and an order had been placed with the Budd Company for twelve new stainless rail diesel cars (RDCs) to replace most of its locomotive hauled trains on the service that would be retained. Four daily round trips on the Philadelphia to Pottsville, and four on the Bethlehem branch to Bethlehem, would be handled by the Budd RDCs. Three Pottsville trips would continue to use passenger cars drawn by diesel locomotives. The one remaining Harrisburg-Allentown passenger train, two daily passenger train trips to Pottsville, and all service beyond Pottsville to Shamokin would be discontinued. Two round trips would be discontinued on weekdays on the Philadelphia to Jersey City line, leaving five round trips. During 1963, the City of Philadelphia leased to the Reading Company seventeen new stainless electric multiple unit Silverliners, with the first cars going into service in August 1963. The Southeastern Pennsylvania Transportation Authority (SEPTA) financed the refurbishment in 1964 of 38 of the original electric multiple unit commuter cars that had been purchased by the Reading Company in 1933. They were repainted in a royal blue and cream paint scheme and became known as *Blueliners*. In September 1966, the electrification of the five-mile Fox Chase Line between Newtown Junction and Fox Chase was completed. State and local subsidies for commuter service, plus an increase in freight carloadings resulted in a $1.5 million profit for the Reading Company in 1966, its last profit earned as a common carrier. In 1967, the Reading Company began "Bee-Line Service" to serve on-line customers with short point-to-point dedicated trains operated by minimum crews. At a special meeting on November 23, 1971, the Reading Company directors were informed that the company was filing for bankruptcy, because it was not able to pay debts that exceeded eleven million dollars. On December 21, 1971, Judge J. William Ditter Jr. of the U.S. District Court in Philadelphia, appointed Richardson Dilworth, former Philadelphia mayor, and Andrew L. Lewis Jr., business executive, as trustees for the company. In a letter dated March 29, 1976, to Reading Company employees, Chief Executive Officer A. W. Hesse Jr. stated, "After almost five years in bankruptcy—years in which we were unable to reorganize independently because of economic and political forces beyond our control—Reading Company will cease to exist as a railroad operator after March 31."

On Thursday April 1, 1976, at 2 a.m., the Reading Company became the Reading Division of Conrail. In 1979, the Reading Division was merged into the Philadelphia and Harrisburg Divisions. After the Reading Company became part of Conrail in 1976, the commuter service was operated by Conrail under contract to SEPTA, and the Reading shops were used for the repair and updating of cabooses. During 1981, diesel operated passenger service from Philadelphia to Bethlehem; Philadelphia to Newark, New Jersey; and Philadelphia to Pottsville was discontinued. On January 1, 1983, the Southeastern Pennsylvania Transportation Authority took over the commuter operation which included the six former Reading Company Lines: Chestnut Hill East, Fox Chase, Lansdale/Doylestown, Manayunk/Norristown, Warminster, and West Trenton. In Philadelphia, groundbreaking for the new Center City Connector was on June 22, 1978, to link the former Pennsylvania Railroad and Reading Company commuter lines. The tunnel was extended 1.7 miles eastward from Suburban Station under Filbert Street to the new Market East Station, and then north under 9th Street to join the former Reading Company embankment near Spring Garden Street. The Reading Terminal train station, which opened January 29, 1893, was closed by SEPTA on November 6, 1984, and replaced by the new Market East station. In 1990, the Pennsylvania Convention Center Authority purchased the Reading Terminal Market, which has continued to thrive as a food market and tourist attraction. The train shed was rehabilitated into the Convention Center's Grand Hall and Ballroom, while the main building on Market Street has been renovated. On May 1, 1991, the Reading shops closed as a railroad repair facility, and the work was transferred to Altoona.

Andy Muller Jr. formed the Blue Mountain & Reading Railroad (BMRR) to acquire the former Schuylkill Division of the Pennsylvania Railroad between Hamburg and Temple, which began operation on September 10, 1983. The success of this line resulted in Conrail picking Muller to acquire additional Reading lines effective December 15, 1990, and the name was changed to Reading Blue Mountain & Northern Railroad (RBMN). Conrail would make money in the long haul business and pay a fee to RBMN to deliver plus service customers. One of the commodities handled is anthracite coal, which is shipped to the Quebec Iron & Titanium Company (QITC) that takes the place of lead in paint. While Conrail had maintained the main line from Reading to Schuylkill Haven, maintenance on the branch lines had been deferred, but the RBMN track crews gradually made track improvements. In 1992, the eight-mile Minersville branch was rebuilt with 5,000 ties replaced, and by the beginning of 1993, most of the railroad was in good condition. Freight increased from 5,022 carloads of anthracite and 2,105 carloads of other commodities, or a total of 7,127 carloads in 1992, to 5,768 carloads of anthracite and 2,288 carloads of other commodities, or a total of 8,056 carloads in 1993. Port Clinton became the headquarters of the railroad, as it was the point where the wye was formed with the northwest line to Pottsville and the northeast line via Tamaqua and Hazleton to Mount Carmel. After Conrail informed the railroad in March 1995 they would no longer provide empty hopper cars for the coal that was shipped to QITC, 270 hopper cars were purchased, quickly repainted, and placed in dedicated service for QITC coal. The railroad handled 6,726 carloads of anthracite and 4,098 carloads of other commodities in 1995. On August 20, 1996, the RBMN purchased from Conrail the former Lehigh Valley Railroad line between Penn Haven Junction and Mehoopany, which almost doubled the size of the RBMN to a 314-mile regional railroad.

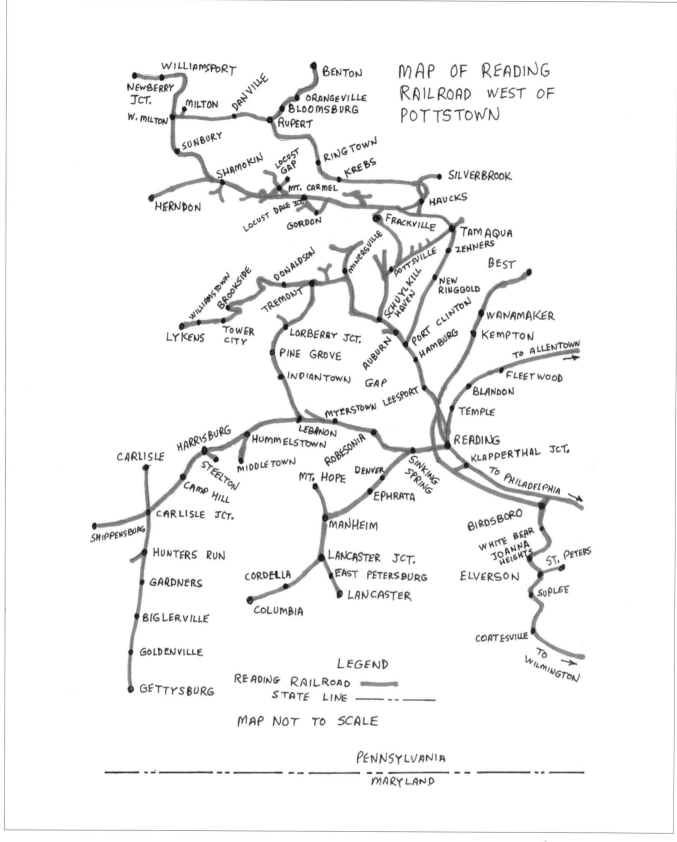

Reading Company routes west of Pottstown are shown on this map. In 2016, the former Reading Company line from Shippensburg via Harrisburg and Reading to Philadelphia is operated by Norfolk Southern Railway. Many of the former coal region lines are now operated by the Reading & Northern Railroad. Operations of former Reading branches include the Middletown & Hummelstown Railroad between Middletown and Hummelstown and the Wanamaker Kempton & Southern Railroad between Kempton and Wanamaker.

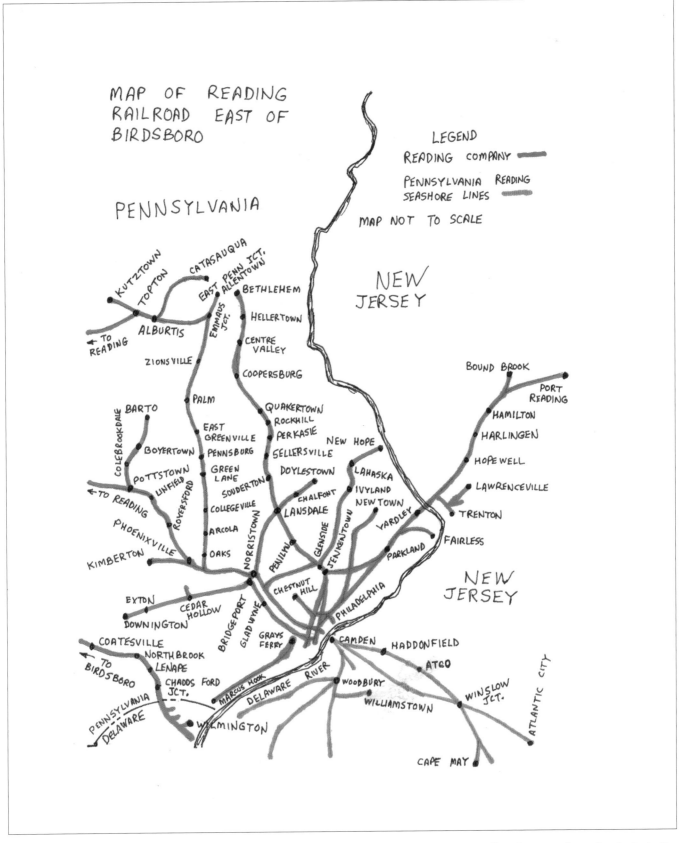

Reading Company routes east of Birdsboro are shown on this map. Operations of former Reading Company branches include the Colebrookdale Railroad between Boyertown and Pottstown; the Allentown & Auburn connecting Kutztown and Topton; and the New Hope & Ivyland Railroad connecting New Hope and Ivyland. In the Philadelphia area, SEPTA operates the former Reading Company commuter lines: Chestnut Hill East, Fox Chase, Lansdale/Doylestown, Manayunk/Norristown, Warminster, and West Trenton.

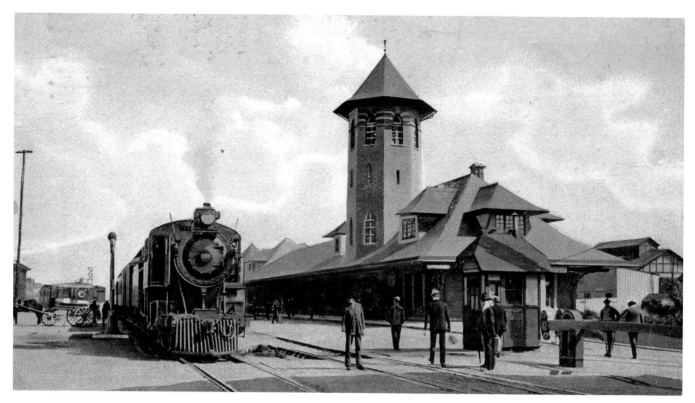

In this postcard postmarked November 9, 1907, a Philadelphia & Reading Railroad passenger train headed by No. 266, a class D5-f camelback steam locomotive with a 4-4-0 wheel arrangement, is at the Lebanon, Pennsylvania, passenger station. The locomotive, built by Baldwin Locomotive Works in April 1901, was scrapped in June 1928. Construction of the $32,772 station began in May 1900 and was completed in January 1901. In 2016, the station houses the Lebanon County Child Care Services.

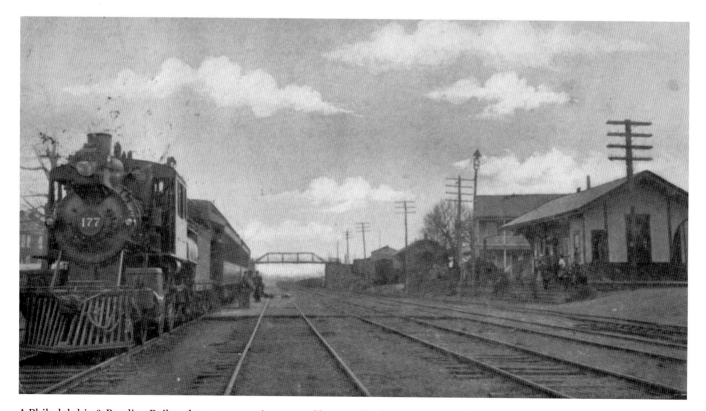

A Philadelphia & Reading Railroad passenger train powered by camelback steam locomotive No. 177 is at the Frackville, Pennsylvania, passenger station waiting for departure time in this postcard scene around 1910. The May 28, 1916, schedule showed five Monday through Saturday trains and two Sunday passenger trains in each direction between Frackville and Pottsville.

Right: The Reading Terminal is shown with streetcars on Market at 12th Streets in downtown Philadelphia in this postcard postmarked June 6, 1922. Designed by F. H. Kimball and constructed by Wilson Brothers, architects and engineers, this station was opened by the Philadelphia and Reading Railroad on January 29, 1893, and contained the railroad's general offices plus passenger ticketing and waiting area. The last train used this station on November 6, 1984, and it was replaced by a new Market East Station as part of Center City Connector. In 2016, the building is used for commercial purposes.

Below: Renovated Reading Company multiple unit commuter car No. 9110 (originally No. 839 and one of 15 cars, Nos. 826-840, built by Bethlehem Shipbuilding in 1931) is shown at the Reading, Pennsylvania, shops in August 1964. This was the first of 38 cars that had been refurbished at the Reading shops at a cost of $35,000 each. The cars had been sold by the Reading to the City of Philadelphia for one dollar each and were leased back to the Reading Company by the Philadelphia Department of Public Property. (Reading Railroad Heritage Museum collection)

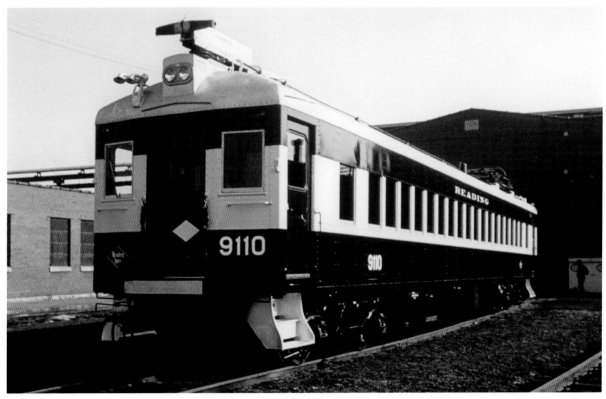

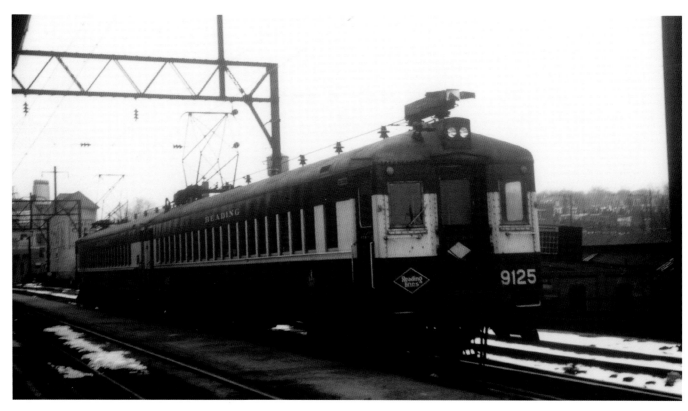

Car No. 9125 is part of a two-car train at Wayne Junction station in the Nicetown neighborhood of North Philadelphia on February 22, 1969. This was originally car No. 870 one of 28 cars, Nos. 861-888, built by Bethlehem Shipbuilding in 1932. The car was refurbished at the Reading shops in March 1965. (Kenneth C. Springirth photograph)

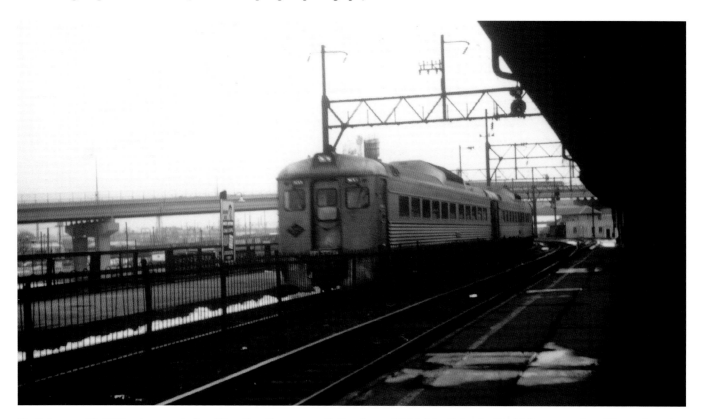

On February 22, 1969, a two-car train of Reading Company rail diesel cars (RDCs), built by the Budd Company, is at Wayne Junction station in Philadelphia. These cars were cheaper to operate than having a diesel locomotive pull passenger cars. The Chestnut Hill East commuter line splits off at this junction. (Kenneth C. Springirth photograph)

Chapter 1

Reading Steam Locomotive Era

Old Ironsides was the first locomotive built by Matthias W. Baldwin for the Philadelphia, Germantown & Norristown Railroad in 1832. Baldwin also built the *Neversink*, the first locomotive purchased by the Philadelphia & Reading Railroad (P&R), which was delivered in 1837. Eastwick & Harrison of Philadelphia built the *Gowan & Marx*, which was delivered in 1840 and was one of the first locomotives designed to burn anthracite coal. By 1843, the P&R had 37 locomotives. The Norris Locomotive Works of Philadelphia built the *Chesapeake* for the P&R in 1847, which was the railroad's first Ten Wheeler with a 4-6-0 wheel arrangement. After the P&R expanded north of Reading into the coal regions of Pottsville, Shamokin, and Tamaqua, the railroad made a decision to establish its locomotive shops at Reading which was a midpoint of the main line between Philadelphia and the coal regions. In 1879, the P&R had 495 locomotives and began standardization of parts and components. Under master mechanic John Wootten, a new boiler was designed along with a very wide firebox and grate that efficiently burned waste anthracite.

Early P&R passenger locomotives were the American type with a 4-4-0 wheel arrangement. As fireboxes became larger for better steaming capabilities, trailer trucks were added, creating an Atlantic type locomotive with a 4-4-2 wheel arrangement. In 1897, P&R locomotive No. 1027 set a speed record for being the fastest regularly scheduled passenger train in the world by averaging 69.3 miles per hour, and reached 71.6 miles per hour on the run between Philadelphia and Atlantic City. In the P&R classification of locomotives of 1900, each class was assigned a letter such as A, and for chronological purposes, a number such as 1. In each class, there were subdivisions such as "a" to denote design changes. In later engines, there was also an "s" which indicated the boiler had a superheater. The 0-4-0 switcher was classified as A class and as a change was made it would become A1 and the next locomotive at a later date would be A2. Changes in steam pressure and weight would result in a subdivision; for example, the class might be A2-a to reflect a design change.

In 1903, new locomotive shops were opened in Reading on North Sixth Street and north of Robeson Street. At the same time, Baldwin Locomotive Works in Philadelphia had become the largest locomotive builder in the United States. The P&R served their plant by bringing in the raw material needed to build locomotives and in moving out the finished locomotives. Baldwin was one of the best customers of the P&R and even handled locomotive rebuilding projects for the P&R.

To handle larger passenger trains, the P&R shops designed a G class Pacific type with a 4-6-2 wheel arrangement in 1916. By 1924, these locomotives were equipped with superheaters and classified as G1-sa. In 1937, locomotives 117 and 118 were encased in fluted stainless sheathing and became class 1-sas for the *Crusader*, pulling five stainless steel passenger cars for the fast schedule between Philadelphia and Jersey City. From 1923 to 1926, 50 class I10-sa Consolidation type locomotives with a 2-8-0 wheel arrangement, Nos. 2000-2049, designed by the Reading Company and built by Baldwin, were placed in service. With a tractive effort of 71,000 pounds, these locomotives were noted for their heavy freight handling ability. Beginning in 1924, the Philadelphia & Reading lettering on their tenders became simply Reading.

In 1927, the first Santa Fe type locomotive with a 2-10-2 wheel arrangement entered service on the Reading with a tractive effort of 90,500 pounds. The largest locomotive ever built for the Reading was a compound Mallet with a 2-8-8-2 wheel arrangement. With a tractive effort reaching 116,600 pounds, they served as pushers or helpers and modifications were made on these locomotives up to 1945.

The final class of Reading steam freight locomotives was the T class Northern type locomotive with a 4-8-4 wheel arrangement, built by the Reading shops in 1945-1946. These locomotives had a tractive effort of 68,000 pounds and had a maximum speed of 70 miles per hour. They served up to the end of the 1950s and gained fame in powering the Iron Horse Rambles of the 1960s.

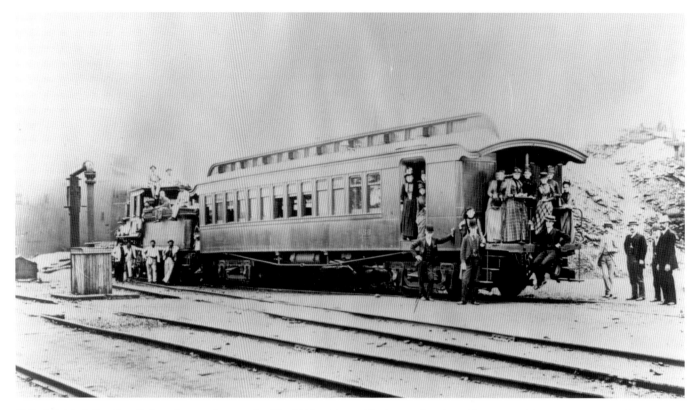

Philadelphia & Reading Railroad steam locomotive No. 658 is at Pottsville, Pennsylvania, pulling a combination passenger-baggage car in 1892. (Reading Railroad Heritage Museum collection)

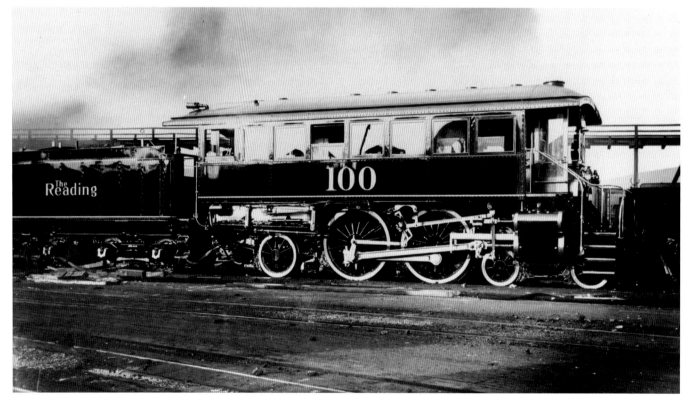

Reading inspection stream locomotive No. 100 is ready for duty. According to *History of the Locomotives of the Reading Company Bulletin No. 67* by George M. Hart, this Atlantic type locomotive with a 4-4-2 wheel arrangement was built at the Reading, Pennsylvania, Philadelphia & Reading Railroad (P&R) shops in 1913 and "With a tractive force of 19,300 pounds, it was capable of handling considerably greater tonnage than was customary for an inspection engine." It was removed from service in April 1929. (Reading Railroad Heritage Museum collection)

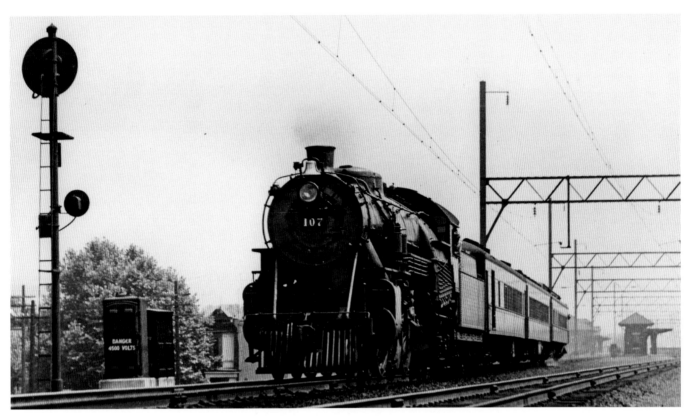

Class G1-sa Pacific type locomotive No. 107 (built in August 1916 and scrapped in July 1951) is heading a three-car passenger train on the Philadelphia & Reading Railroad. With 80-inch diameter drive wheels, this locomotive had a tractive effort of 40,900 pounds and was one of 25 class G1-sa locomotives, Nos. 105-129, built at the Reading shops of the P&R during 1916-1923. (Reading Railroad Heritage Museum collection)

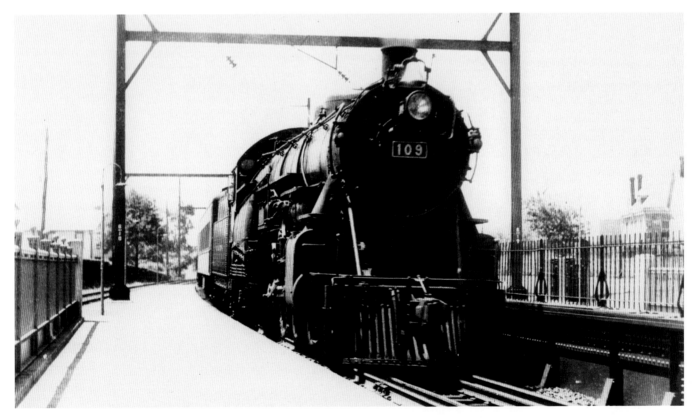

Reading Company class G1-sa Pacific type steam locomotive No. 109 (built in August 1916 and scrapped in November 1950) is heading a passenger train, providing accessibility to communities all along its route. (Reading Railroad Heritage Museum collection)

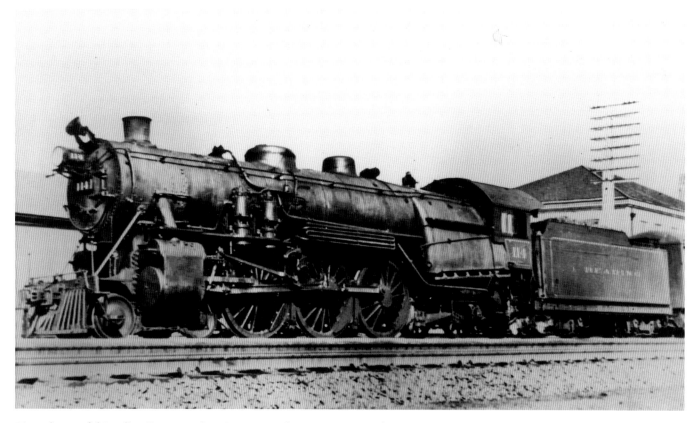

Big and powerful Reading Company class G1-sa steam locomotive No. 114 (built in July 1917 and scrapped in October 1951) is waiting for departure time. (Reading Railroad Heritage Museum collection)

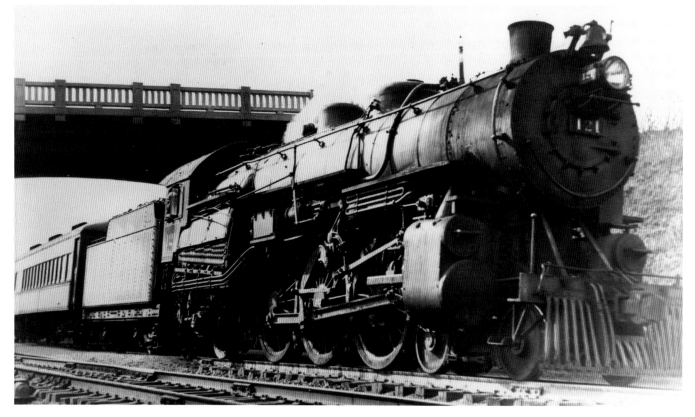

Class G1-sa Pacific type Reading Company steam locomotive No. 121 (built in June 1921 and scrapped in September 1952) is waiting for departure time. (Reading Railroad Heritage Museum collection)

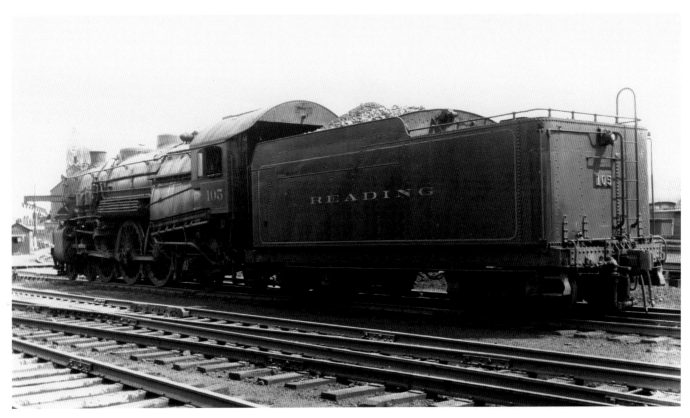

Reading Company class G1-sa Pacific type steam locomotive No. 105 (built in June 1916 and scrapped in July 1951) is awaiting the next assignment in July 1950. (Reading Railroad Heritage Museum collection)

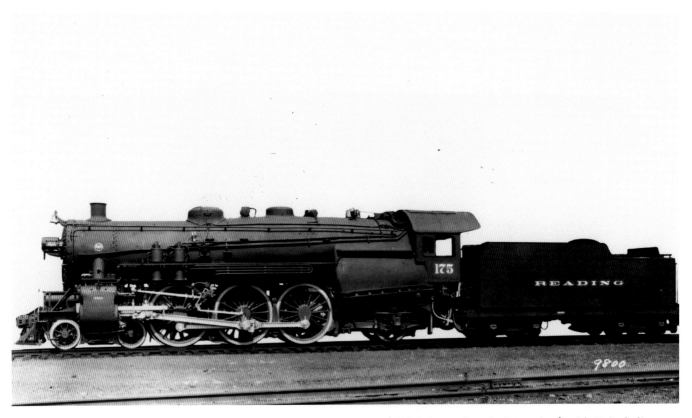

Baldwin Locomotive Works built five class G2-sa locomotives, Nos. 175-179 (slightly larger than the G1-sa class), with 80-inch diameter drive wheels and a tractive effort of 42,800 pounds during 1926. Locomotive No. 175 was built in May 1926, rebuilt at the Reading shops in 1947, and was scrapped in June 1954. (Reading Railroad Heritage Museum collection)

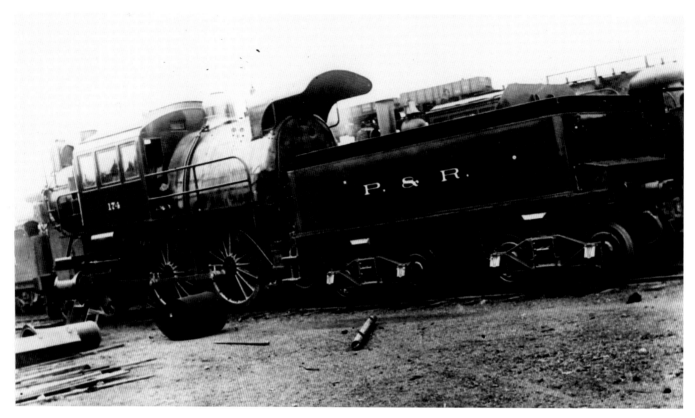

Camelback class D2-c Philadelphia & Reading Railroad steam locomotive No. 174 with a 4-4-0 wheel arrangement is waiting for the next assignment. This locomotive had a tractive effort of 12,146 pounds. (Reading Railroad Heritage Museum collection)

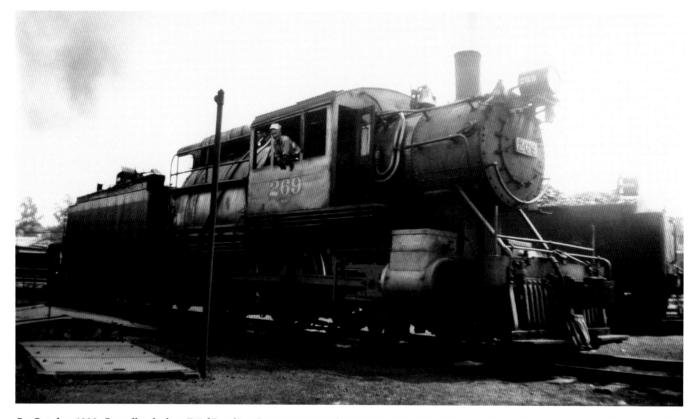

On October 1938, Camelback class D5-f Reading Company steam locomotive No. 269 with a 4-4-0 wheel arrangement and tractive effort of 21,839 pounds is at Bridgeport, Pennsylvania. This locomotive was built by Baldwin Locomotive Works in April 1901 and was scrapped in June 1946. (Reading Railroad Heritage Museum collection)

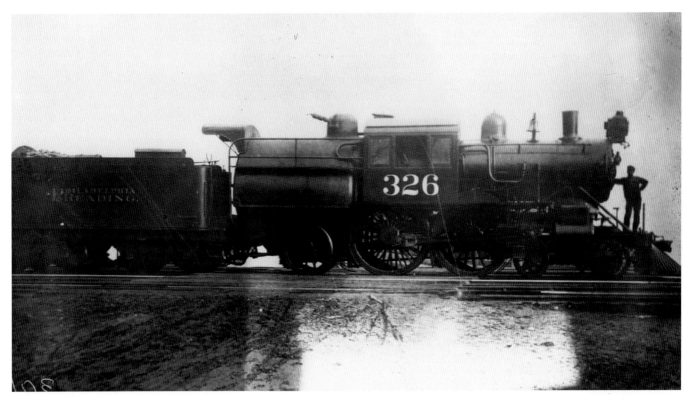

Camelback class P3-d Reading Company steam locomotive No. 326 is awaiting departure time in Philadelphia. This Atlantic type locomotive with a 4-4-2 wheel arrangement was built by Baldwin Locomotive Works as a class P3-a in May 1900. It was rebuilt as class P3-c at P&R Reading shops in December 1903, later rebuilt as class P3-d at P&R shops in March 1916, and scrapped in January 1933. (Reading Railroad Heritage Museum collection)

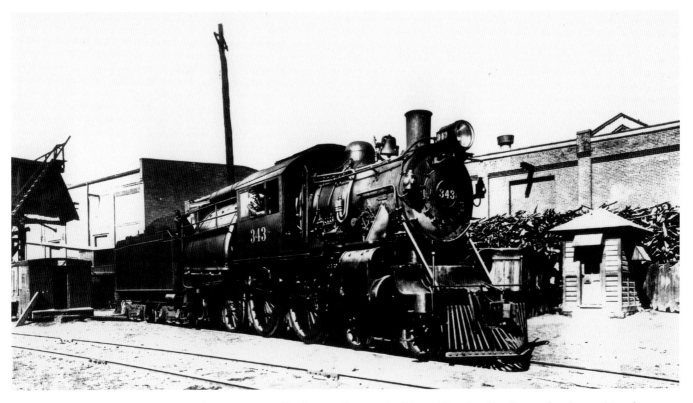

In February 1922, Reading Company class P5-se Camelback steam locomotive No. 343 is at Reading, Pennsylvania, awaiting departure time. This Atlantic type locomotive with a 4-4-2 wheel arrangement was built as a class P5-a by the P&R shops in May 1906. It was rebuilt as a class P3-se by the P&R Reading shops and scrapped in October 1948. (Reading Railroad Heritage Museum collection)

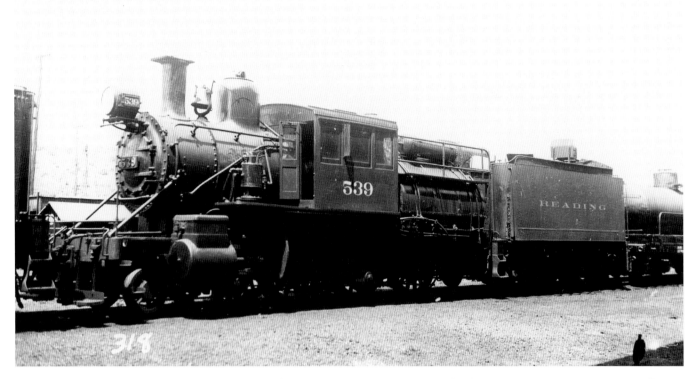

Reading Company class L1-c Camelback type steam locomotive No. 539 with a 4-6-0 wheel arrangement is at St. Clair, Pennsylvania, in September 1940. This was one of 15 locomotives originally numbered 554-568 built by the Baldwin Locomotive Works in 1890, and renumbered 531-545 in 1900. This locomotive was rebuilt by the P&R Reading shops in October 1917 as class L1-c and was scrapped in April 1944. (Reading Railroad Heritage Museum collection)

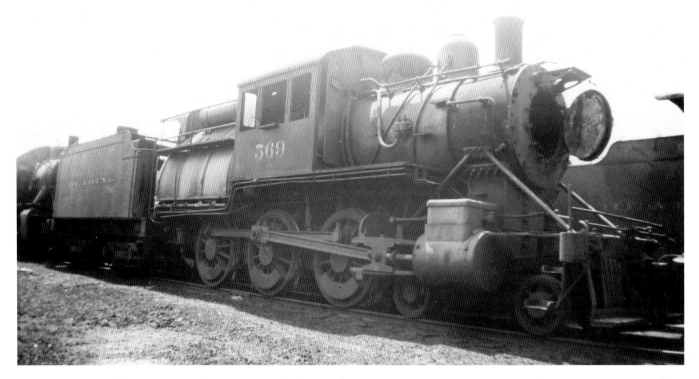

In March 1939, Reading Company class L4-e Camelback steam locomotive No. 569 with a 4-6-0 wheel arrangement is at Reading, Pennsylvania. This was originally class L4-a No. 455 built by Baldwin Locomotive Works in April 1899. It was rebuilt as class L4-c as No. 569 by the P&R Reading shops in March 1905, rebuilt as class L4-e by the P&R in May 1908, and scrapped in October 1940. (Reading Railroad Heritage Museum collection)

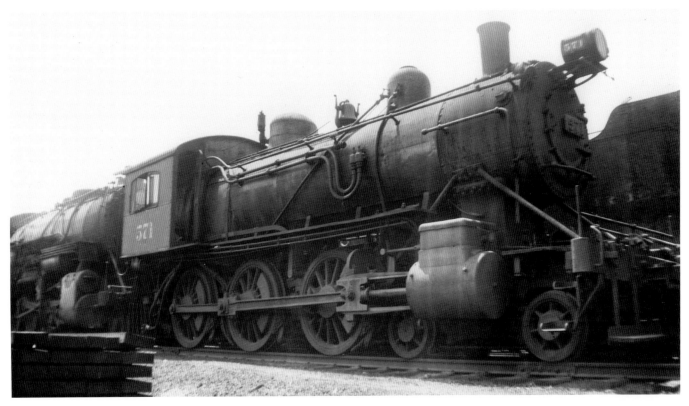

Reading Company class L4-f steam locomotive No. 571, with a 4-6-0 wheel arrangement, is at Reading, Pennsylvania, in September 1939. This locomotive was built in July 1900 as class L4-b by the Baldwin Locomotive Works. It was rebuilt by the P&R Reading shops to class L4-d in July 1904, later rebuilt to class L4-f in June 1905, and was scrapped in June 1945. (Reading Railroad Heritage Museum collection)

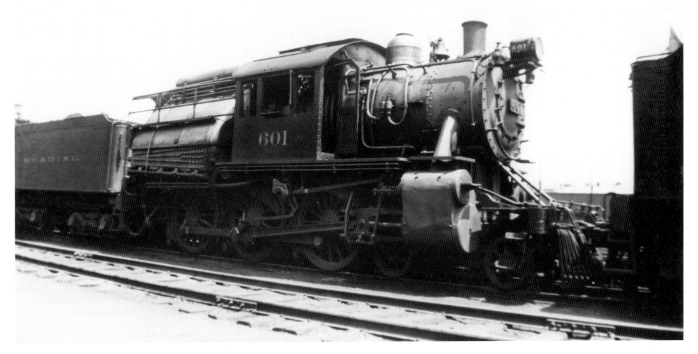

Reading Company class L5-sc camelback steam locomotive No. 601 with a 4-6-0 wheel arrangement is at Reading, Pennsylvania, in May 1939. This locomotive was built by Baldwin Locomotive Works in June 1903 as class L5-a. It was rebuilt by the P&R Reading shops in 1905 as class L5-b, later rebuilt in 1917 as class L5-sc, and scrapped in July 1946. (Reading Railroad Heritage Museum collection)

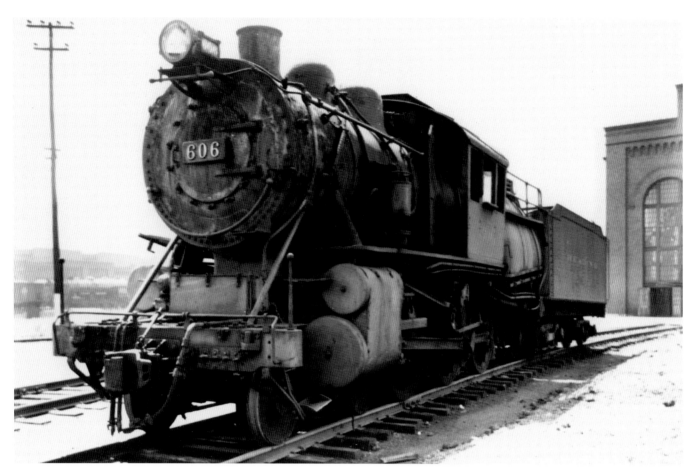

In July 1948, class L7-sb camelback steam locomotive No. 606 with a 4-6-0 wheel arrangement is waiting for the next assignment. This was originally built by the P&R as class L7-a in August 1910, rebuilt in 1918 as class L7-b by the P&R, rebuilt in 1920 by the P&R as class L7-sb, and scrapped in July 1948. (Reading Railroad Heritage Museum collection)

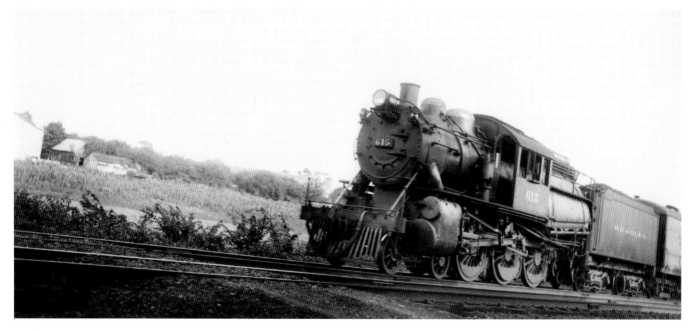

Reading Company class L7-sb Camelback steam locomotive No. 615 with a 4-6-0 wheel arrangement is travelling through Royersford, Pennsylvania in August 1940. This locomotive was built as a class L7-a at the P&R Reading shops in September 1910. It was rebuilt as a class L7-b at the P&R shops in 1917-1918, later rebuilt at the P&R shops in 1920 as a class L7-sb, and was scrapped in July 1948. (Reading Railroad Heritage Museum collection)

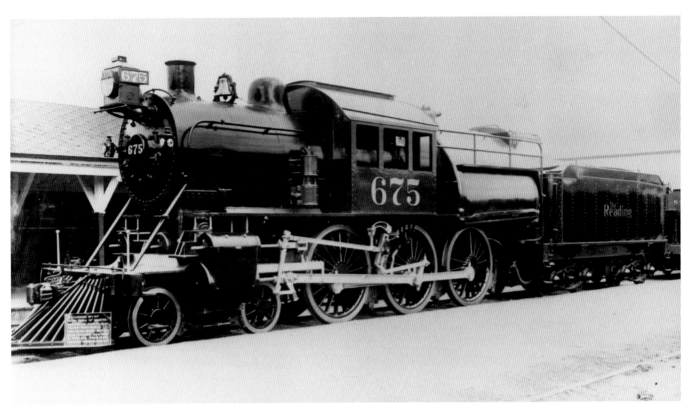

Reading Company camelback class L10-sb steam locomotive No. 675, with a 4-6-0 wheel arrangement, is ready for duty. This locomotive was built as class L10-a in June 1911 by the P&R, rebuilt in July 1916 as class L10-b by the P&R, rebuilt in July 1923 as class L10-sb by the P&R, and scrapped in March 1948. (Reading Railroad Heritage Museum collection)

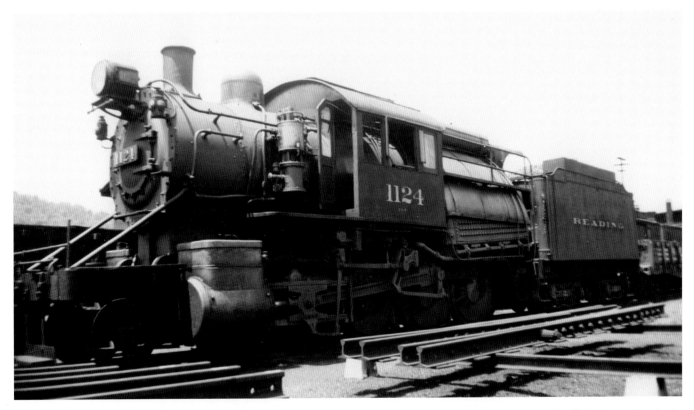

Reading Company Class I6-d camelback steam locomotive No. 1124, with a 2-8-0 wheel arrangement, is at St. Clair, Pennsylvania, in June 1939. This was built as a class I6-c locomotive by Baldwin Locomotive Works in January 1907, was rebuilt by the P&R as class I6-d in 1921, and was scrapped in May 1941. (Reading Railroad Heritage Museum collection)

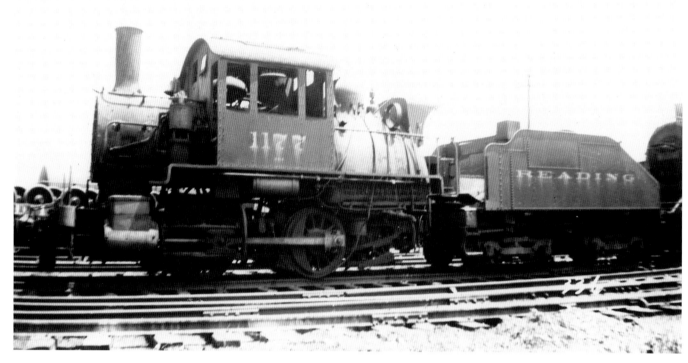

In May 1939, Reading Company class A5-a camelback steam locomotive switcher No. 1177, with a 0-4-0 wheel arrangement, is at Reading, Pennsylvania. This locomotive was built by Baldwin Locomotive Works in May 1907 and was scrapped by 1950. (Reading Railroad Heritage Museum collection)

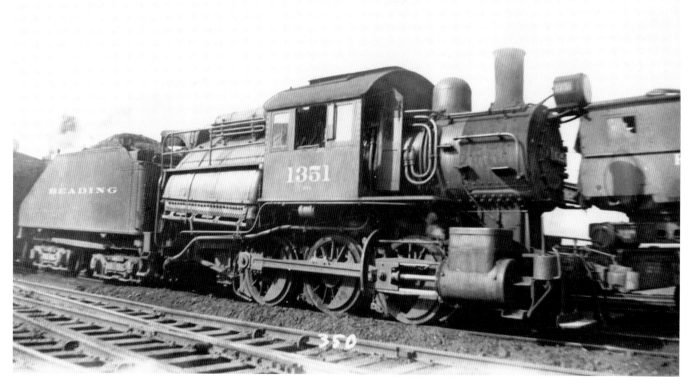

In April 1939, class B7-a Reading Company camelback steam switcher locomotive No. 1351 with a 0-6-0 wheel arrangement is at Bridgeport, Pennsylvania. This locomotive was built by the P&R Reading shops in January 1912 and was scrapped by 1952. (Reading Railroad Heritage Museum collection)

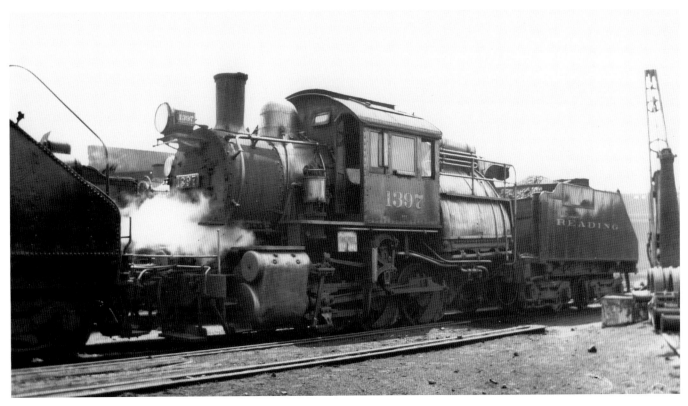

Reading Company camelback class B8-b steam switcher locomotive No. 1397, with a 0-6-0 wheel arrangement, is at Erie Avenue in Philadelphia in October 1939. This locomotive was built by the P&R Reading shops in September 1921 and was scrapped by 1952. (Reading Railroad Heritage Museum collection)

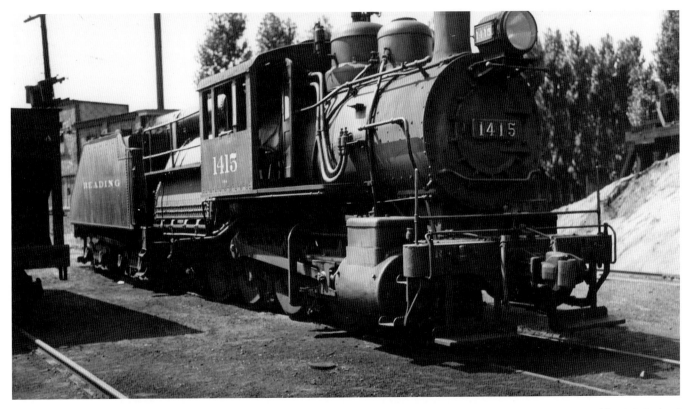

Wilmington, Delaware, is the location of Reading Company class E4-a camelback steam switcher locomotive No. 1415, with a 0-8-0 wheel arrangement in August 1938. This was one of 26 locomotives, Nos. 1410-1429, 1431-1434, and 1436-1437, built by the Baldwin Locomotive Works in 1892. (Reading Railroad Heritage Museum collection)

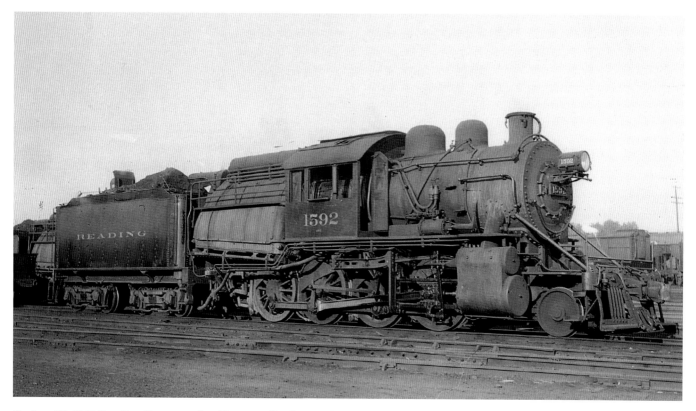

On June 22, 1947, Reading Company class I8-a camelback steam locomotive No. 1592 with a 2-8-0 wheel arrangement is waiting for the next assignment at Philadelphia. This locomotive was built in November 1912 at the P&R Reading shops and was scrapped in June 1947. (C. R. Scholes collection)

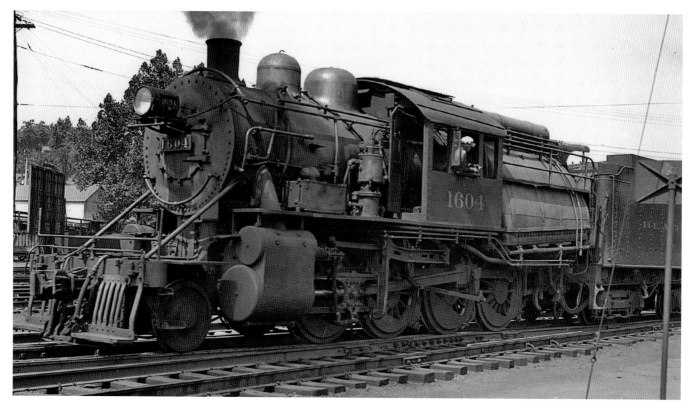

In 1941, class I8-sb camelback steam locomotive No. 1604 with a 2-8-0 wheel arrangement is backing up in the Philadelphia yard. This locomotive was built in December 1912 as class I8-b at the P&R shops. It was rebuilt as class I8-sb in 1919 at the P&R Reading shops and was scrapped in October 1948. (C. R. Scholes collection)

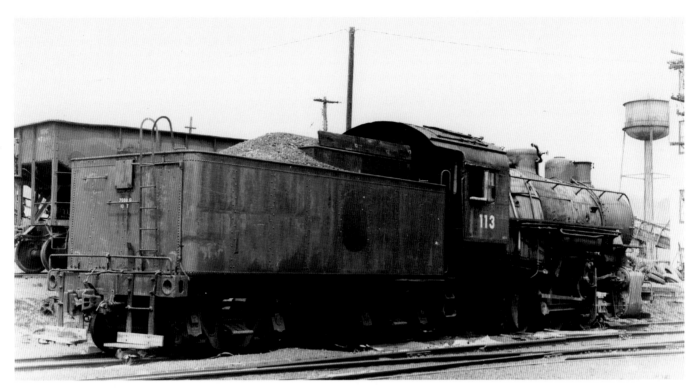

Central Railroad of New Jersey class 6S-46 steam locomotive switcher No. 113 with a 0-6-0 wheel arrangement is waiting for the next yard assignment. This was one of five locomotives, Nos. 111-115, built by the Schenectady Works of the American Locomotive Company (ALCO) in June 1923. In 1951, the locomotive was replaced by a diesel. The Philadelphia & Reading Coal & Iron Company purchased it in 1953 and used it at Locust Summit until 1960. (Reading Railroad Heritage Museum collection)

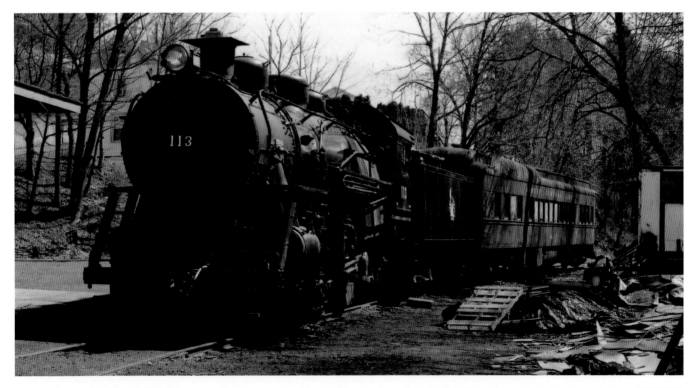

Former Central Railroad of New Jersey steam locomotive No. 113 is parked on the Reading Blue Mountain & Northern Railroad (RBMN) siding at Minersville, Pennsylvania, on April 3, 2016. This locomotive was purchased by Robert Kimmel Sr. in 1986, and it was moved to Minersville. Restoration work began in 1999, and it operated along with RBMN steam locomotive No. 425 for the September 28, 2013, Schuylkill Haven Borough Day. The locomotive has 51-inch diameter drive wheels and a maximum tractive effort of 45,800 pounds. (Kenneth C. Springirth photograph)

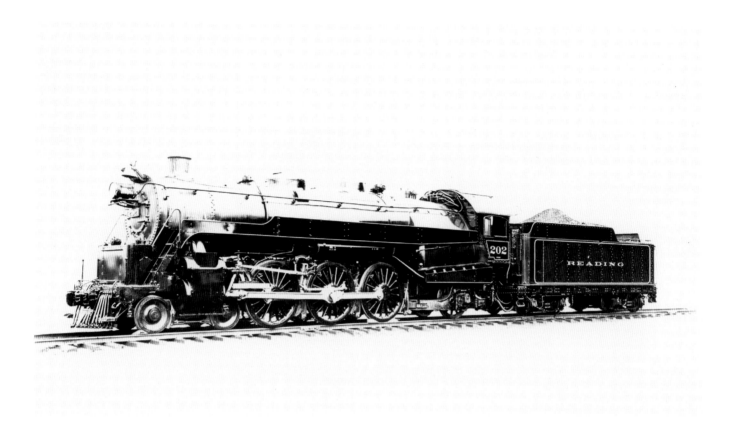

Pacific type class G1-sb steam locomotive No. 202 (built in March 1925, rebuilt in 1947, and scrapped in August 1953) looks sharp in this builders photograph. This was one of five locomotives, Nos. 200-204, built by Baldwin Locomotive Works for the Reading Company in 1925 with 74-inch diameter drive wheels and a tractive effort of 44,200 pounds. (Reading Railroad Heritage Museum collection)

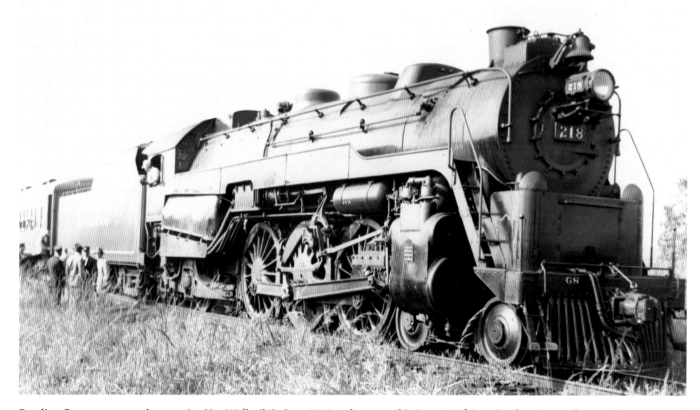

Reading Company steam locomotive No. 218 (built in June 1948 and scrapped in June 1957) is at Gordon, Pennsylvania. This was one of ten class G3 Pacific type locomotives, Nos. 210-219, built by the Reading shops in 1948. (Reading Railroad Heritage Museum collection)

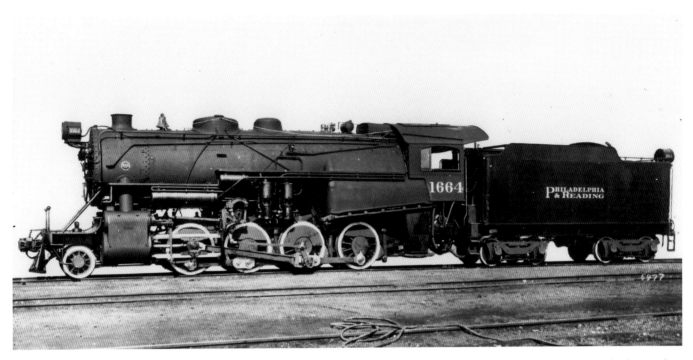

Philadelphia & Reading Railroad consolidation type steam locomotive No. 1664, with a 2-8-0 wheel arrangement, was built as a class I9-sa by Baldwin Locomotive Works in January 1919 with 55.5-inch diameter drive wheels and a tractive effort of 64,300 pounds. This locomotive was reclassified in 1945 as I9-sb and was scrapped in May 1951. (Reading Railroad Heritage Museum collection)

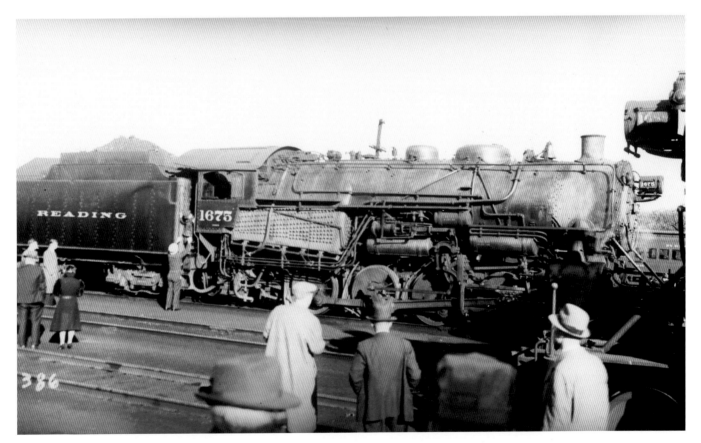

In October 1940, West Milton, Pennsylvania, is the location of class I9-sb Consolidation type steam locomotive No. 1675, built in November 1919 by the Baldwin Locomotive Works for the Reading Company with 55.5-inch diameter drive wheels and a tractive effort of 64,300 pounds. It was scrapped in July 1952. (Reading Railroad Heritage Museum collection)

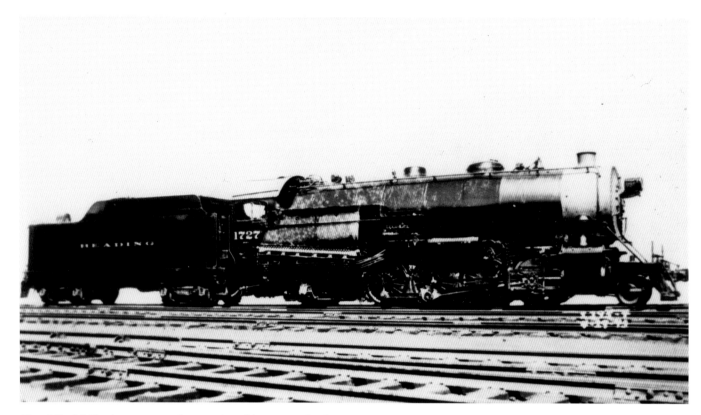

Class M1-sb Mikado type steam locomotive with a 2-8-2 wheel arrangement No. 1727 is ready for action in this April 1943 view. This was one of 3 locomotives, Nos. 1727-1729, built by the Baldwin Locomotive Works for the Reading Company in January 1916. It was scrapped in July 1949. (Reading Railroad Heritage Museum collection)

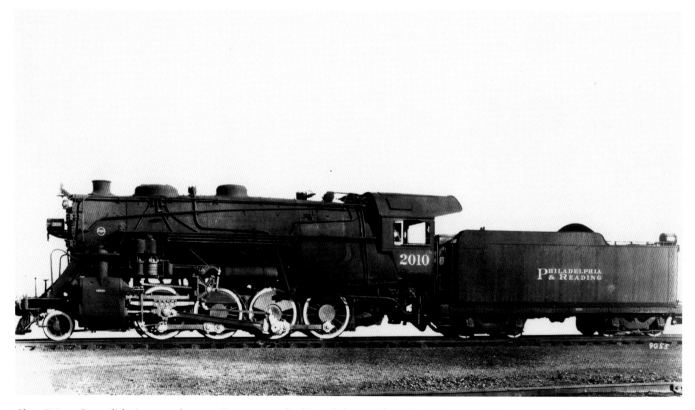

Class I10-sa Consolidation type locomotive No. 2010 looks well designed in this 1923 scene. This was one of ten locomotives, Nos. 2009-2018, built by Baldwin Locomotive Works in November 1923 with 61.5-inch diameter drive wheels and a tractive effort of 71,000 pounds. This locomotive was scrapped in December 1953. (Reading Railroad Heritage Museum collection)

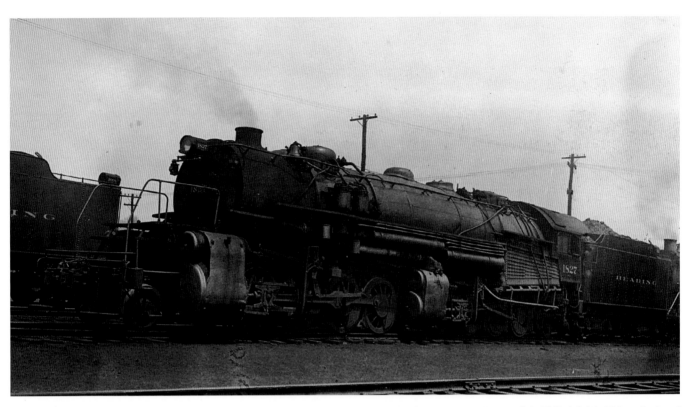

In 1941, Reading Company Mallet type steam locomotive No. 1827 with a 2-8-8-2 wheel arrangement is at work in Philadelphia. This articulated locomotive with a two-wheel leading truck, two sets of eight driving wheels, and a two-wheel trailing truck was built in June 1919 as class N1-sb by Baldwin Locomotive Works. It was rebuilt at Reading in July 1945 as class N1-sd and was scrapped by 1955. (C. R. Scholes collection)

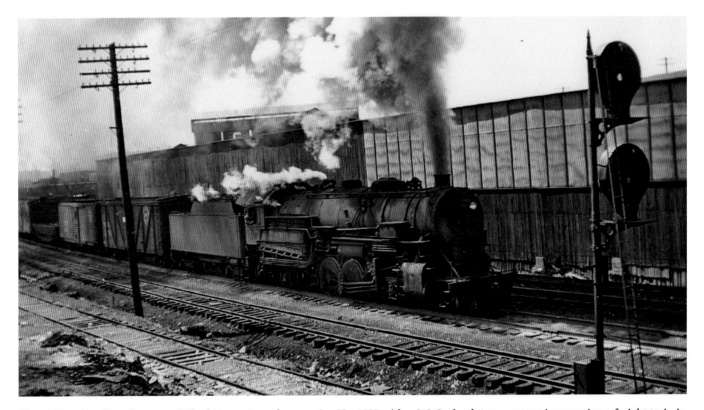

Class M1-sa Reading Company Mikado type steam locomotive No. 1707 with a 2-8-2 wheel arrangement is powering a freight train in Philadelphia in 1948. This locomotive was built by the Baldwin Locomotive Works in December 1915. It was rebuilt in 1924, later rebuilt in 1941, and was scrapped in July 1949. (C. R. Scholes collection)

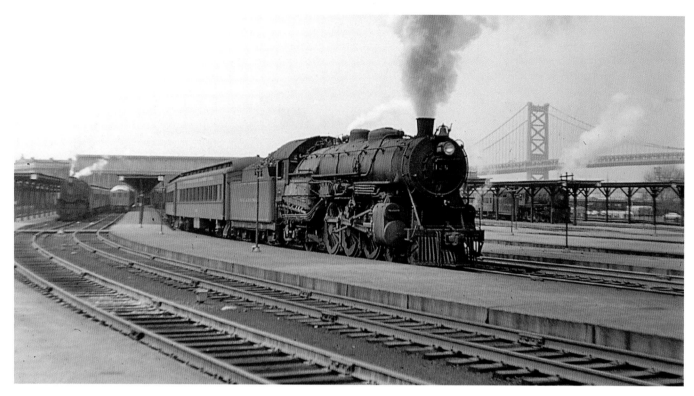

On March 29, 1952, Reading Company No. 126 class G1-sa steam locomotive with a 4-6-2 wheel arrangement is leaving the Camden, New Jersey, station. This locomotive was built in June 1923 by the Baldwin Locomotive Works and was scrapped in September 1952. (C. R. Scholes collection)

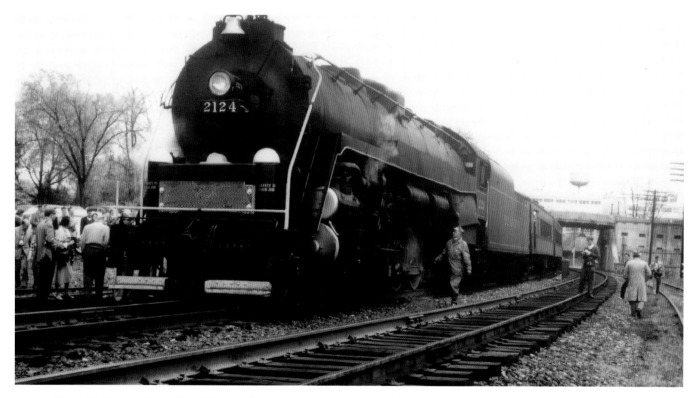

On the May 1, 1960, Iron Horse Ramble, Reading Company class T1 Northern type steam locomotive No. 2124 with a 4-8-4 wheel arrangement is at Hershey Park in Hershey, Pennsylvania. This was one of 30 locomotives, Nos. 2100-2129, built during 1945-1947 at the Reading shops from class I10-sa Consolidation type locomotives that were built by Baldwin Locomotive Works in December 1923. All of the T1 locomotives were replaced by diesels and placed in storage by 1958. Four T1s (Nos. 2100, 2101, 2102, and 2124) were used on the 1959 to 1964 Reading Iron Horse Rambles. (Kenneth C. Springirth photograph)

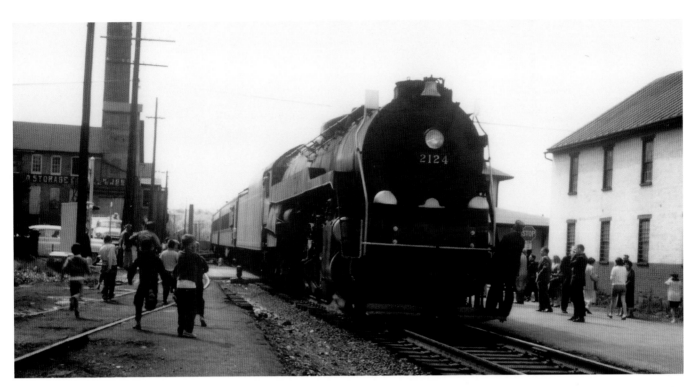

Gettysburg, Pennsylvania, is the location of Reading Company steam locomotive No. 2124 on a May 1, 1960, Iron Horse Ramble. The locomotive and tender had a total length of 110.125 feet. With a driving wheel diameter of 70 inches, the 5,500 horsepower locomotive had a top speed of 70 miles per hour. Tender capacity was 26 tons of coal and 19,000 gallons of water. This locomotive pulled the Iron Horse Rambles from 1959 to 1961 and was sold to Steamtown USA at Bellows Falls, Vermont, in 1962. It later became a static display for the Steamtown National Historic Site at Scranton, Pennsylvania. (Kenneth C. Springirth photograph)

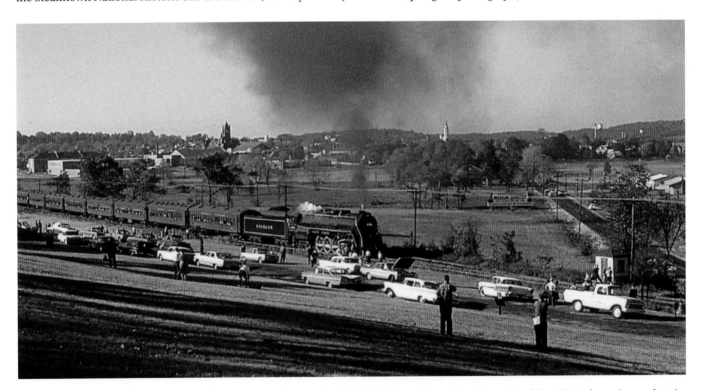

On October 6, 1963, Reading Company class T1 steam locomotive No. 2102 is powering an Iron Horse Ramble at Gettysburg, Pennsylvania. This was originally class I10-sa Consolidation type locomotive No. 2044, built by Baldwin Locomotive Works in September 1925. The Reading shops rebuilt it into class T1 in October 1945. It handled freight service until the mid-1950s and powered Iron Horse Rambles from 1962 to 1964. After it was sold to Steam Tours in 1966, it operated under many sponsors and railroads. In 2016, under Reading & Northern Railroad ownership, it is being restored at the Port Clinton, Pennsylvania, engine house. (Bob Crockett photograph—C. R. Scholes collection)

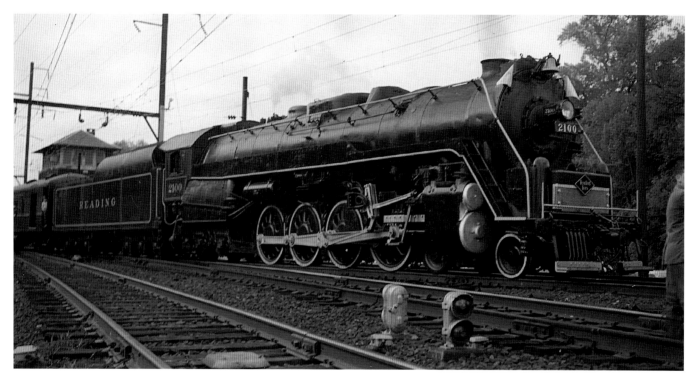

Reading Company class T1 Northern type steam locomotive No. 2100 is powering an Iron Horse Ramble at Jenkintown, Pennsylvania, on May 12, 1963. This was originally class I10-sa Consolidation type locomotive No. 2045, built by Baldwin Locomotive Works in March 1925 and rebuilt into No. 2100 class T1 at the Reading shops in September 1945, handling freight service until the mid-1950s. With its classic Reading look of arched cab windows and a deeply curved cab roof, it was used on 50 Reading Iron Horse Rambles from the first one on October 25, 1959, until the last one on October 17, 1964. In 1967, it was sold to Streigel Supply & Equipment Company. (C. R. Scholes collection)

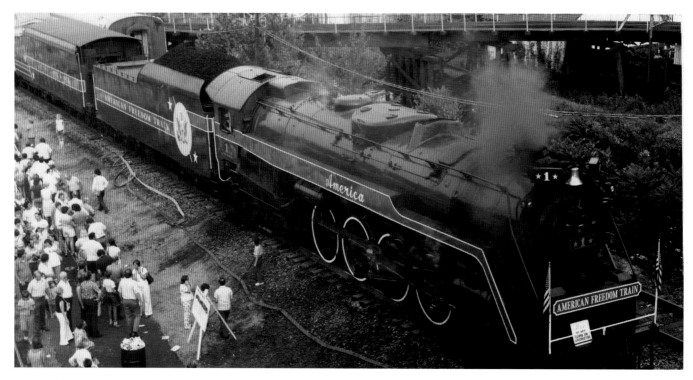

In September 1976, *American Freedom Train* headed by locomotive No. 1 is at Bethlehem, Pennsylvania. This was actually former class T1 Reading Company No. 2101 Northern type steam locomotive with a 4-8-4 wheel arrangement. The other two locomotives involved with the *American Freedom Train* were Northern type Southern Pacific Railroad No. 4449 and Texas & Pacific Railroad No. 610, a Texas type locomotive with a 2-10-4 wheel arrangement. The *American Freedom Train* was a nationwide celebration of the Bicentennial of the United States. Over a 24-month period, more than 7 million people visited the train during its tour in 48 states. (Reading Railroad Heritage Museum collection)

Chapter 2

Reading Diesel Locomotive Era

The Reading Company acquired its first diesel No. 50, a 300-horsepower box cab unit, in 1926, with the body built by the American Locomotive Company (ALCO), generator and traction motors by General Electric, and the diesel engine by Ingersoll Rand. This was the second diesel locomotive in revenue service in the United States. The first diesel locomotive was Central Railroad of New Jersey No. 1000, which went into service in 1925. The Reading Company's second diesel order went to Electro Motive Corporation (later Electro-Motive Division of General Motors Corporation) for six type SW (S = 600 horsepower and W = welded frame) locomotives, Nos. 10-15. These locomotives were rebuilt twice and were in service until 1989. By World War II, the Reading Company had 38 diesels for switching service, mainly around Philadelphia.

In 1942, the Reading Company made a decision to diesel-ize switching operations for a number of reasons. There is virtually little maintenance on diesels when they are not in use when compared with a steam locomotive. The Reading Company purchased ten type FT diesels, Nos. 250A/B – 259 A/B, from Electro-Motive Division of General Motors Corporation (EMD) in 1945. A = 1,350 horsepower cab unit, and B = 1,350 horsepower cabless unit. The two units together had 2,700 horsepower. This type of diesel locomotive had been tested throughout the United States and convinced many railroads that the diesel locomotive could handle rugged service. Purchases of diesel locomotives continued from American Locomotive Company (ALCO), Baldwin, and EMD.

In 1950, six type FP7 passenger diesel units, Nos. 900-905, were purchased from EMD, followed by an additional two, Nos. 906-907, in 1952. These locomotives were used on the Philadelphia to New York and Philadelphia to Reading and Pottsville trains. During 1951, the Reading Company purchased diesel road switcher units, type RS3 from ALCO, and type AS16 from Baldwin Lima Hamilton. Seven type GP7 road switcher diesels, Nos. 600-606, were purchased from EMD in 1952. There were 64 diesel units added in 1952 and 51 in 1953. In 1953, nine type H-24-66 Trainmaster diesel road switcher units, Nos. 800-806 and 860-861, were purchased from Fairbanks-Morse. At its time, this six-axle, 2,400-horse-power locomotive was the most powerful single-engine diesel locomotive available. During 1955-1956, eight more type

H-24-66 Trainmaster locomotives, Nos. 807-808 and 862-867, were purchased. This completed dieselization of the Reading Company.

Improved reliability and higher horsepower diesel locomotives were promoted by locomotive builders to encourage railroads to modernize their diesel fleet. Twenty 2,250-horsepower GP30 diesel locomotives, Nos. 5501-5520, were purchased from EMD in 1962. During 1963-1964, these locomotives were repainted and renumbered 3600-3619. In 1963, the Reading Company purchased ten type C424 diesel locomotives, Nos. 5201-5210, from ALCO. This four-axle, 2,400-horsepower locomotive was ALCO model DL640-A. The Reading purchased 37 GP35 diesel locomotives rated 2,500 horsepower, Nos. 6501- 6506 in 1963 and 3626-3656 in 1964. In 1966, the Reading Company was the first rail-road to purchase the ALCO type C430 diesel locomotive Nos. 5211 and 5212; however, both locomotives experienced a high failure rate. Seven ALCO type C630 diesel locomotives, Nos. 5300-5306, were purchased in 1966, followed by five more, Nos. 5307-5311, in 1967. Five 3,600-horsepower type SD45 locomotives built by EMD, Nos. 7600-7604, were acquired by the Reading Company in 1967. General Electric Company sold five 3,000-horsepower type U30C locomotives, Nos. 6300-6304, to the Reading Company in 1967. In 1973, the Reading Company received five 3,000-horsepower GP40-2 locomotives, Nos. 3671-3675, from EMD, and these were assigned to the Joanna ore trains. EMD delivered ten 1,500-horsepower MP15 diesel locomotives, Nos. 2771-2780, to the Reading Company in 1974. Twenty 2,300-horsepower type GP39-2 road diesels, Nos. 3401-3420, were purchased from EMD in 1974.

As passenger ridership declined, the self-propelled rail diesel car (RDC) produced by the Budd Company of Philadelphia began to replace Reading Company locomotive hauled passenger trains. The Passenger Service Improvement Corporation (PSIC) in Philadelphia provided the funding for 12 RDCs for the Reading in 1961. Four additional RDCs were purchased second hand. SEPTA took over the Reading Company's RDC fleet in 1974. All commuter train service operating beyond the electrified lines was discontinued by SEPTA on July 29, 1981.

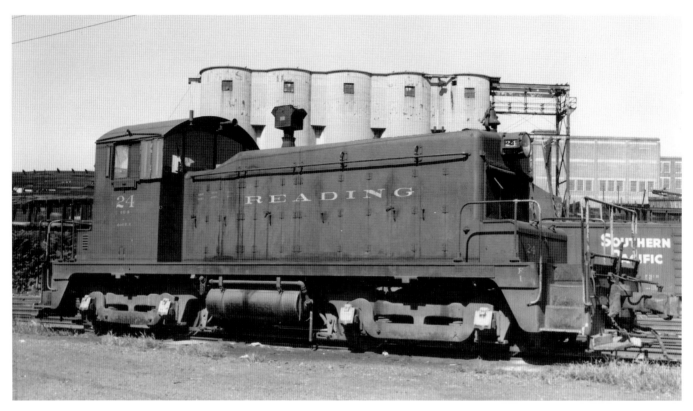

In September 1967, Reading Company class OE-5 type SW1 diesel switcher No. 24 is in Philadelphia. This was one of nine 600-horsepower diesel switchers, Nos. 16-24, built by the Electro-Motive Division of General Motors Corporation for the Reading Company in 1939. The locomotive had a single exhaust stack. (Reading Railroad Heritage Museum collection)

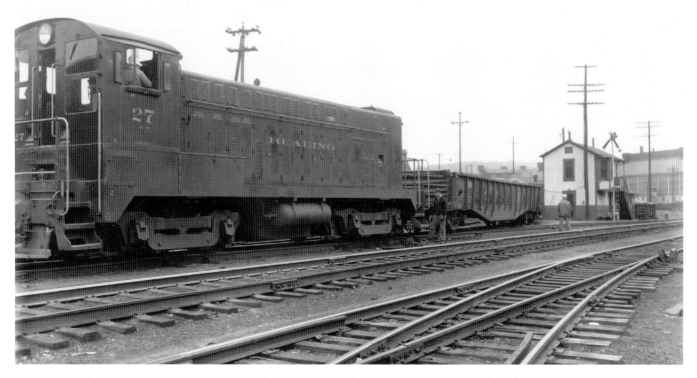

On May 11, 1956, class OE-10 type DS4-4-1000 diesel locomotive No. 27 is at Coatesville, Pennsylvania. This was one of 14 diesel locomotives, Nos. 26-39, built by Baldwin Locomotive Works for the Reading Company during 1946-1947. The four-axle 1,000-horsepower locomotive had a tractive effort of 57,500 pounds. (Reading Railroad Heritage Museum collection)

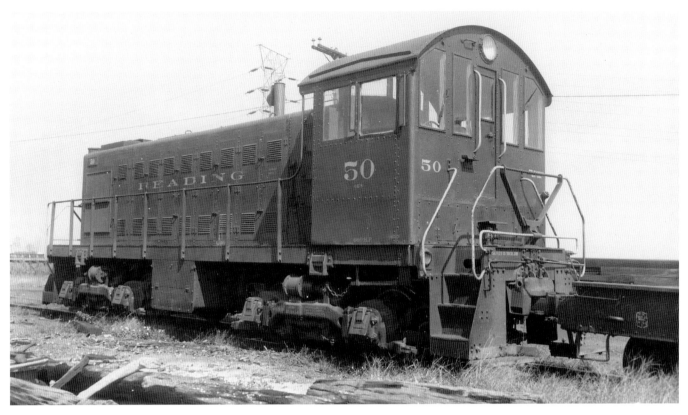

Equipped with four General Electric type 731 traction motors, class OE-8 type S1 diesel switcher No. 50, rated 660 horsepower, is waiting for the next assignment on September 28, 1955. This was one of five locomotives, Nos. 50-54, built during 1940-1941 for the Reading Company by the American Locomotive Company. (Reading Railroad Heritage Museum collection)

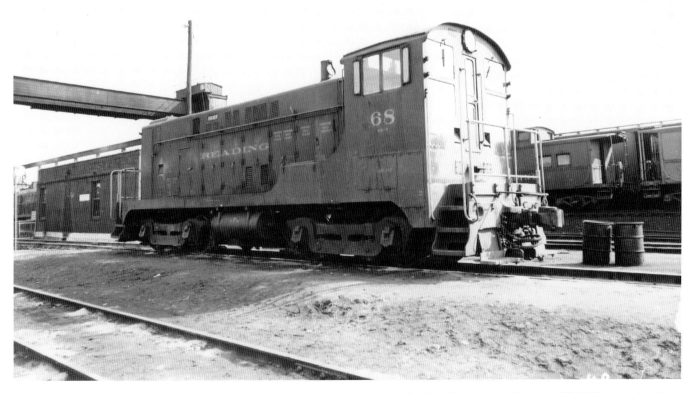

On March 28, 1957, class OE-7 diesel switcher No. 68, rated 660 horsepower, is ready for duty. This was one of ten type VO-660 locomotives, Nos. 61-70, built during 1941-1942 by the Baldwin Locomotive Works for the Reading Company. (Reading Railroad Heritage Museum collection)

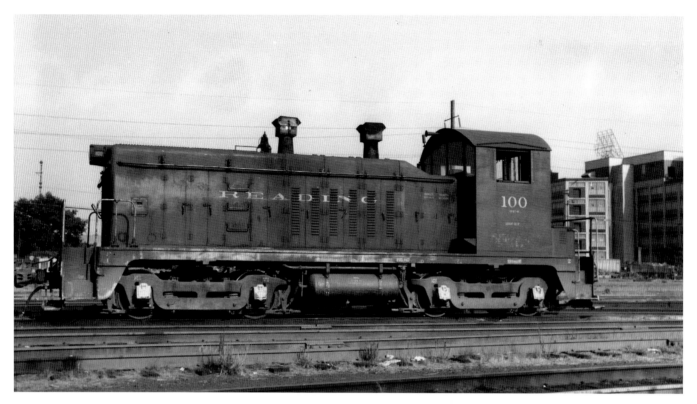

Philadelphia is the location of 1,000-horsepower class OE-9 type NW2 diesel switcher No. 100. This was one of five locomotives, Nos. 100-104, built by the Electro-Motive Division of General Motors Corporation in 1947 for the Reading Company. (Reading Railroad Heritage Museum collection)

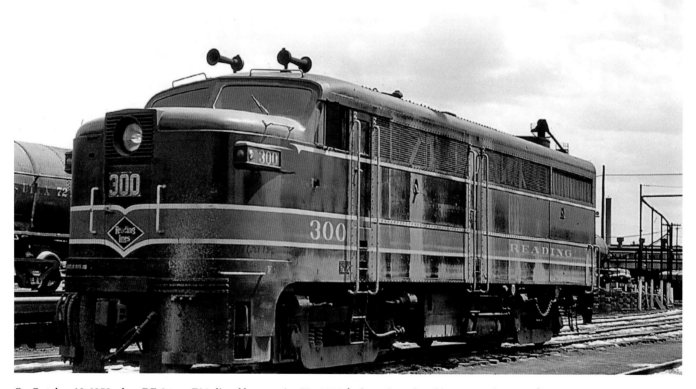

On October 16, 1958, class DF-3 type FA1 diesel locomotive No. 300A (cab equipped and known as the A unit) is at Hagerstown, Maryland. This was one of six locomotives, Nos. 300A-305A, built for the Reading Company by the American Locomotive Company in June 1948. With a top speed of 65 miles per hour, the 1,500-horsepower locomotive was primarily used in freight service. This locomotive was retired on December 18, 1962. (Bob Crockett photograph—C. R. Scholes collection)

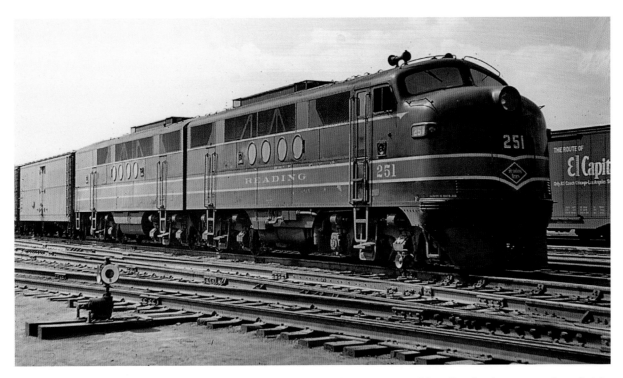

Reading Company class DF-1 type FTA No. 251 cab diesel unit and No. 251 FTB cabless diesel unit are powering a freight train on the Western Maryland Railroad at Hagerstown, Maryland, on August 13, 1957. There were ten cab units, Nos. 250A-259A, and ten cabless units, Nos. 250B-259B, built by the Electro-Motive Division of General Motors Corporation for the Reading Company in 1945. The locomotive came as a two-unit set, with each unit rated 1,350 horsepower, resulting in the set having a 2,700 horsepower rating. (Bob Crockett photograph—C. R. Scholes collection.)

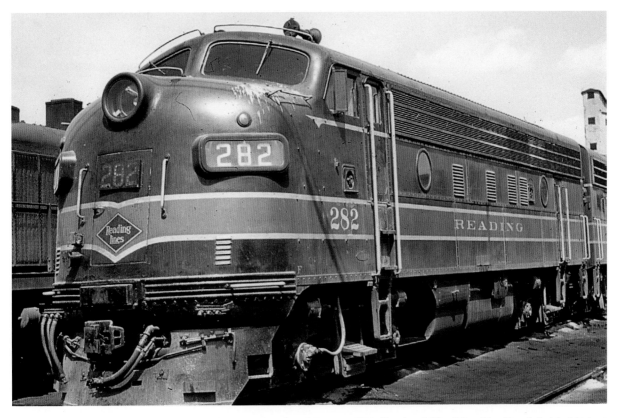

On April 3, 1964, Reading Company 1,500 horsepower class DF-4 type F7A diesel unit No. 282, with a B unit behind it, is at Philadelphia. There were 18 type F7A cab units, Nos. 266-283, and 6 type F7B cabless units, Nos. 266-271, built by Electro-Motive Division of General Motors Corporation for the Reading Company in 1950. (C. Parsons photograph—C. R. Scholes collection.)

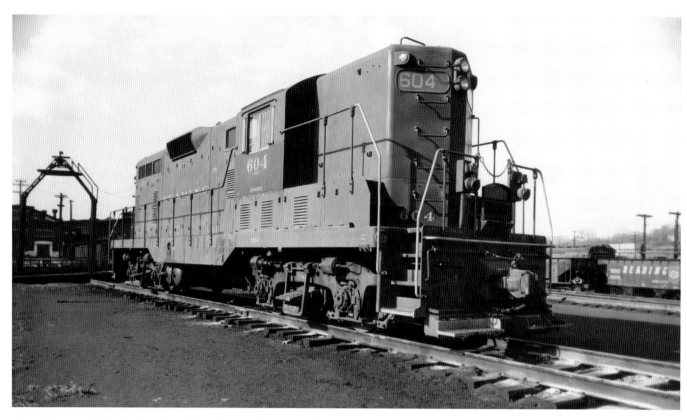

Class RS-3 type GP7 diesel road switcher No. 604 is ready for duty on November 21, 1958. This was one of 37 locomotives, Nos. 600-636, built for the Reading Company by the Electro-Motive Division of General Motors Corporation during 1952-1953. The 1,500-horsepower four-axle GP (General Purpose) locomotive had three sets of ventilation grills under the cab. (Reading Railroad Heritage Museum collection)

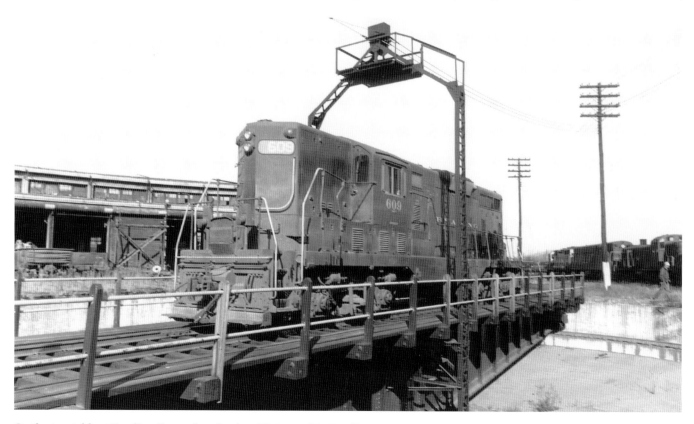

On the turntable at Reading, Pennsylvania, class RS-3 type GP7 Reading Company diesel locomotive No. 609 is ready to be positioned to the proper track in November 1964. (Reading Railroad Heritage Museum collection)

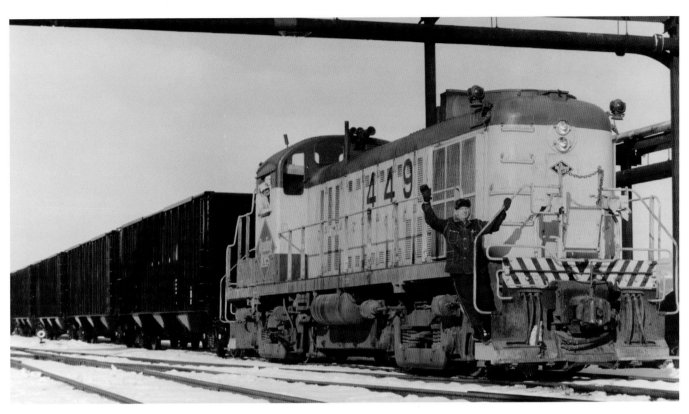

Class RS-1 type RS3 road switcher diesel locomotive No. 449 is at Reading, Pennsylvania. This was one of seven locomotives, Nos. 444-450, built by ALCO for the Reading Company in 1953. The 1,600-horsepower locomotive was equipped with four General Electric type 752 traction motors. (Reading Railroad Heritage Museum collection)

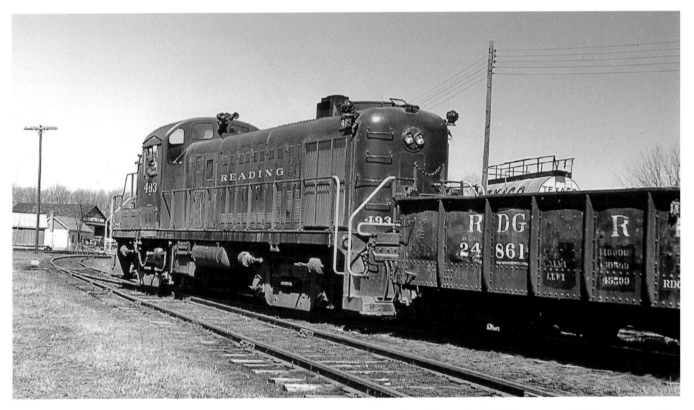

On March 28, 1959, class RS-1 type RS3 diesel road switcher No. 493 is at Gettysburg, Pennsylvania. This was one of 44 locomotives, Nos. 481-524, built by the American Locomotive Company (ALCO) for the Reading Company during 1951-1953. At one time, the classy looking 1,600-horsepower type RS-3 locomotive was the most commonly seen ALCO locomotive in the United States. (C. R. Scholes collection)

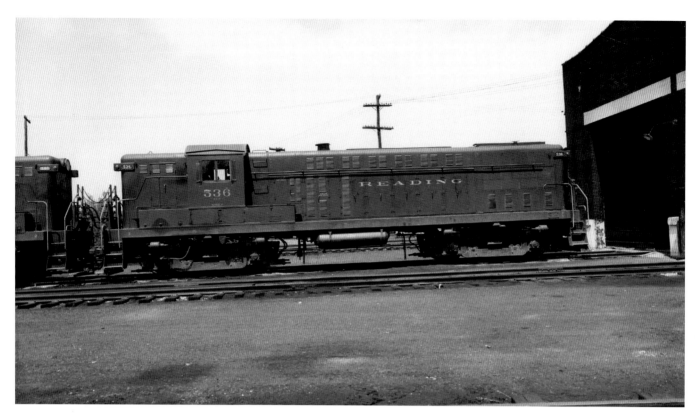

Shoemakersville, Pennsylvania, is the location of four-axle 1,600-horsepower Reading Company class RS-2 type AS-16 diesel locomotive No. 536 in May 1962. This was one of 25 locomotives, Nos. 530-554, built during 1951-1953 for the Reading Company by the Baldwin Lima Hamilton Corporation, which ended all locomotive production in 1956. (Reading Railroad Heritage Museum collection)

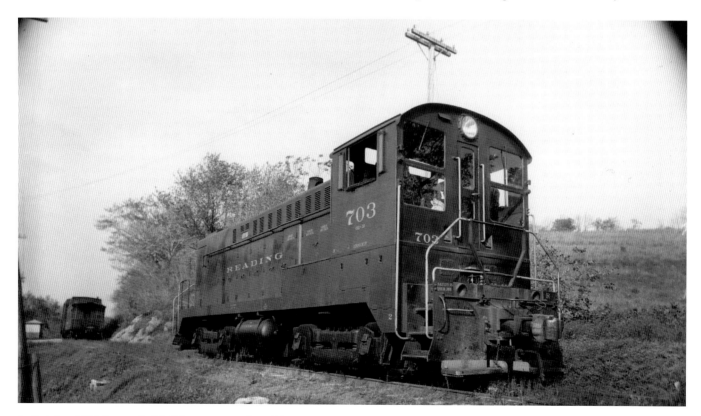

In October 1958, four-axle 1,000 horsepower class OE-12 type DS4-4-1000 diesel locomotive No. 703 is ready for the next assignment. This is one of 30 locomotives, Nos. 700-729, built by the Baldwin locomotive Works during 1948-1949 for the Reading Company. (Reading Railroad Heritage Museum collection.)

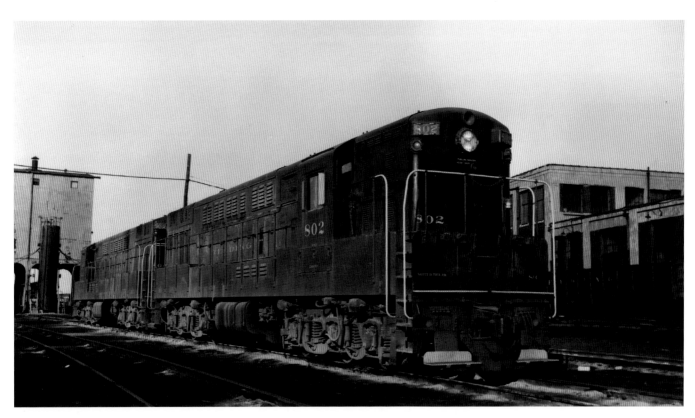

Class RS-4 type H24-66 Train Master diesel locomotive No. 802 is at Philadelphia in February 1964. This is one of nine locomotives, Nos. 800-808, built by Fairbanks-Morse Company during 1953 and 1956. The six-axle 2,400-horsepower locomotive was the most powerful single-engine diesel locomotive at its time. (Reading Railroad Heritage Museum collection)

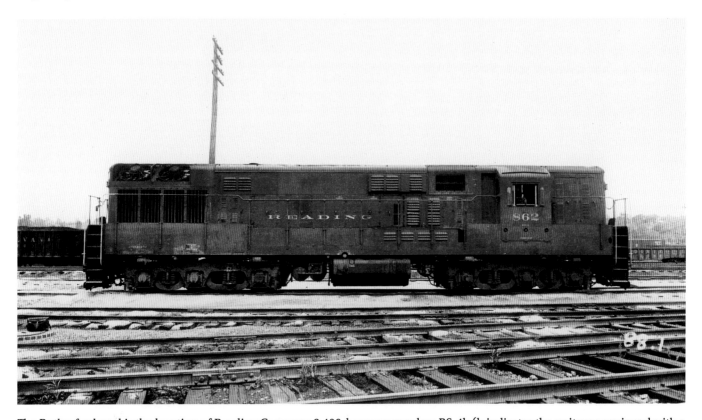

The Rutherford yard is the location of Reading Company 2,400-horsepower class RS-4b (b indicates the unit was equipped with a steam generator for passenger service) type H24-66 Train Master diesel locomotive No. 862 in September 1961. This was one of eight locomotives, Nos. 860-867, built by Fairbanks-Morse Company during 1953 and 1955. (Reading Railroad Heritage Museum collection)

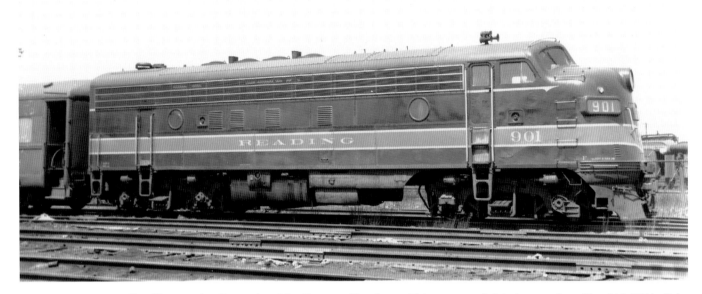

Class DP-1 type FP7A diesel locomotive No. 901 is at West Trenton, New Jersey. This was one of eight locomotives, Nos. 900-907, built by the Electro-Motive Division of General Motors Corporation for the Reading Company in 1950. The 1,500-horsepower locomotive was designed for both passenger and freight service. (Reading Railroad Heritage Museum collection)

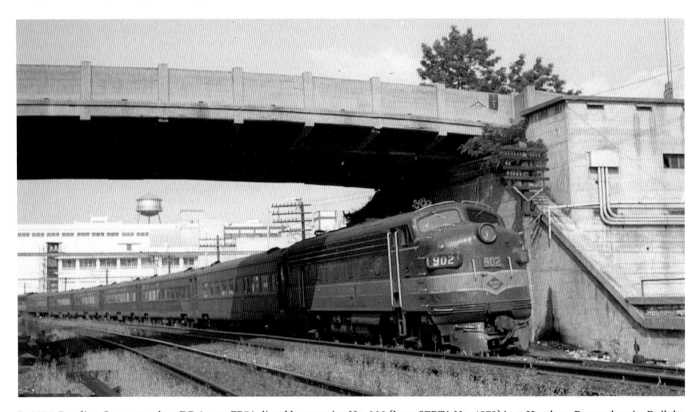

In 1972, Reading Company class DP-1 type FP7A diesel locomotive No. 902 (later SEPTA No. 4372) is at Hershey, Pennsylvania. Built by the Electro-Motive Division of General Motors Corporation for the Reading Company in 1950, the FP7A was four feet longer than a F7A, to provide greater water capacity for the steam generator to heat passenger trains. This was a push-pull train with a locomotive at each end of the train. (C. R. Scholes collection)

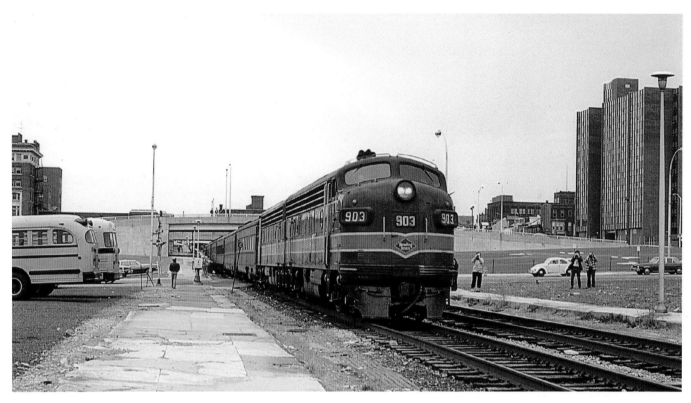

On March 21, 1976, a Reading Company passenger train powered by class DP-1 type FP7A diesel locomotive No. 903 is at a Reading, Pennsylvania, passenger station. Under the April 1, 1976, takeover of the Reading Company by Conrail, this became No. 4373. In February 1978, this locomotive was repainted in the SEPTA red, white, and blue paint scheme. (W. Hoffman photograph—C. R. Scholes collection)

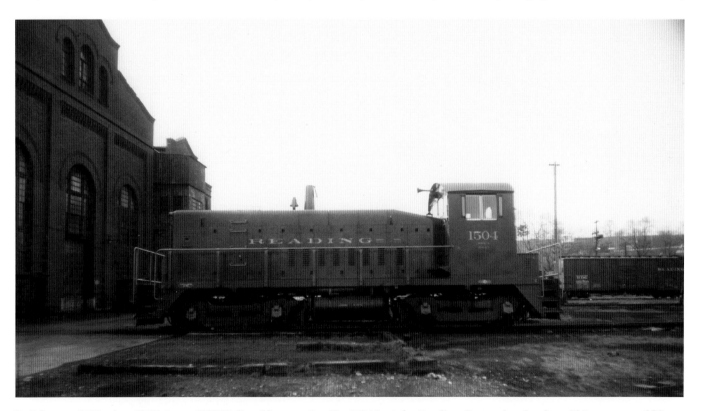

In February 1962, class SWE-4 type SW900 diesel locomotive No. 1504 is at the Reading, Pennsylvania, shop. This was one of fifteen locomotives, Nos. 1501-1515, rated 900 horsepower and built by Electro-Motive Division of General Motors Corporation for the Reading Company in 1961. (Reading Railroad Heritage Museum collection)

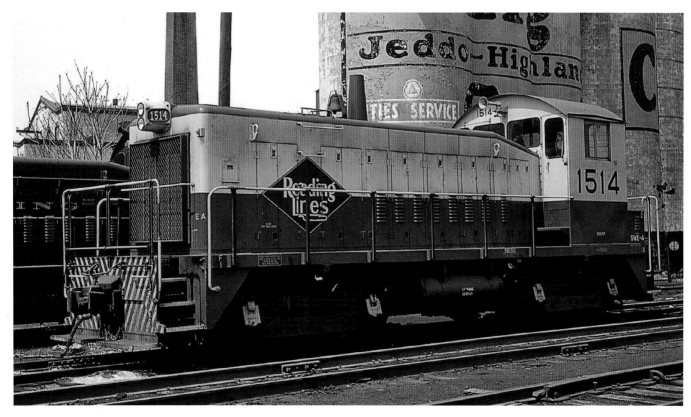

Wayne Junction in Philadelphia is the location of Reading Company class SWE-4 type SW900 diesel switcher No. 1514 on May 2, 1965. This type of locomotive had a tapered hood near the cab and a single exhaust stack. (C. Parsons photograph—C. R. Scholes collection)

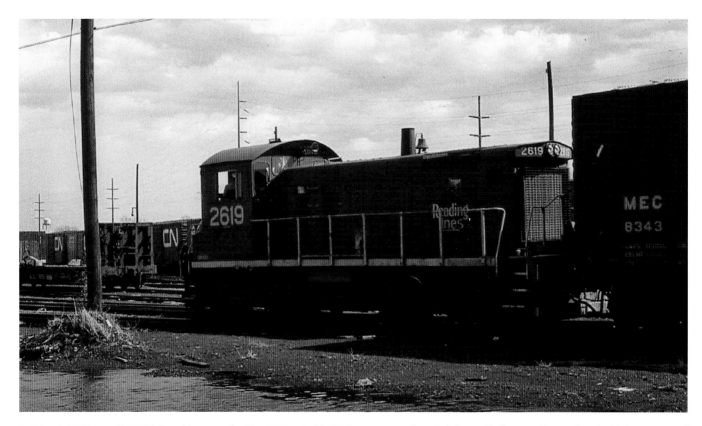

In March 1977, type SW1001 diesel locomotive No. 2619, rated 1,000 horsepower, is switching at Essington, Pennsylvania. This was one of 25 locomotives, Nos. 2601-2625, built by the Electro-Motive Division of General Motors Corporation in 1973 for the Reading Company. (T. Hoover photograph—C. R. Scholes collection)

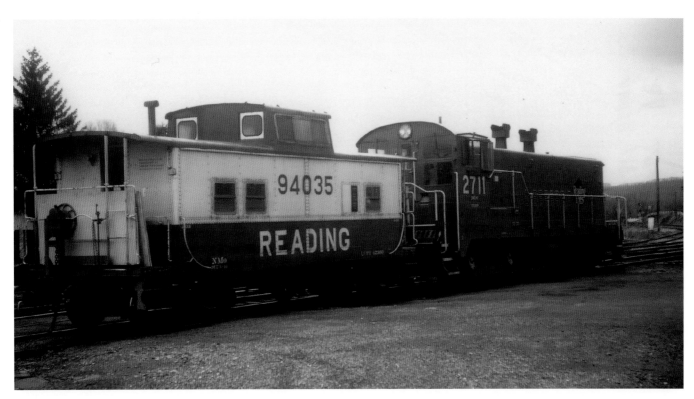

On April 15, 1971, class SWE-1 type SW1200m diesel switcher No. 2711, along with class NMo caboose No. 94035 (built in August 1944 by the Reading shops, this later became Conrail class N-4a caboose No. 18805), are at Rupert, Pennsylvania. The locomotive was originally Reading Company No. 57 type VO1000, built by the Baldwin Locomotive Works in August 1944. It was rebuilt in 1959 by the Electro-Motive Division of General Motors Corporation and became No. 2711. The Reading shops built 50 of the above cabooses, Nos. 94000-94049, during July and August 1944 with an average weight of 41,600 pounds. (Kenneth C. Springirth photograph)

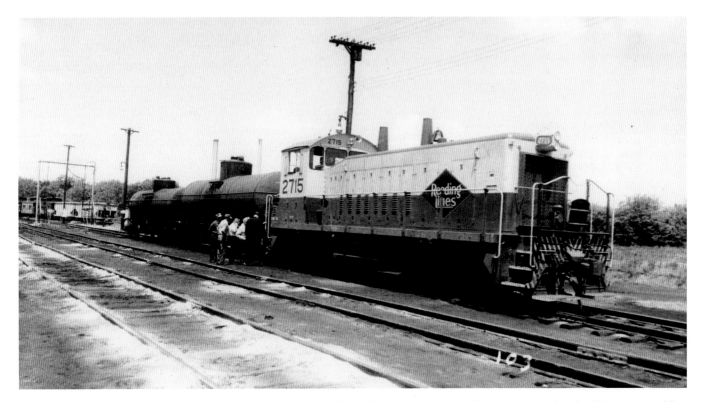

In May 1964, 1,200-horsepower class SWE-14 type SW1200 diesel switcher No. 2715 is at Bridgeport, Pennsylvania. This was one of five locomotives, Nos. 2715-2719, built for the Reading Company in 1963 by the Electro-Motive Division of General Motors Corporation. (Reading Railroad Heritage Museum collection)

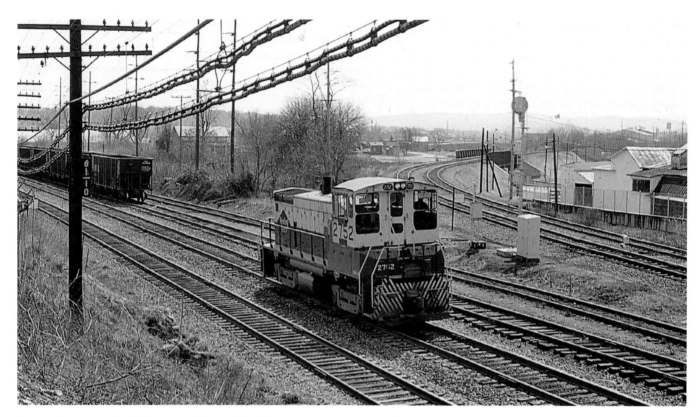

On March 20, 1976, class SWE-14 type SW1500 diesel locomotive No. 2752 is on duty at Reading, Pennsylvania. This was one of 21 locomotives, Nos. 2750-2770, built for the Reading Company in 1966 and 1969 by the Electro-Motive Division of General Motors Corporation. The 1,500-horsepower locomotive was built for switching service and was often used for branch line service. (W. Hoffman photograph—C. R. Scholes collection)

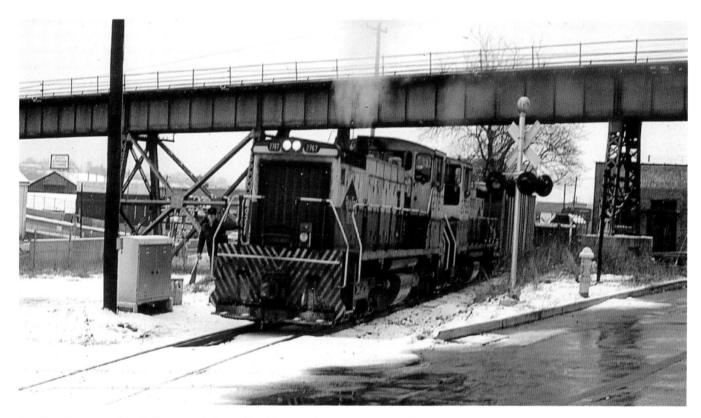

Reading Company class SWE-14 type SW1500 diesel locomotives Nos. 2767 and 2766 are in Bridgeport, Pennsylvania, on a snow-covered February 1, 1975. (W. Hoffman photograph—C. R. Scholes collection)

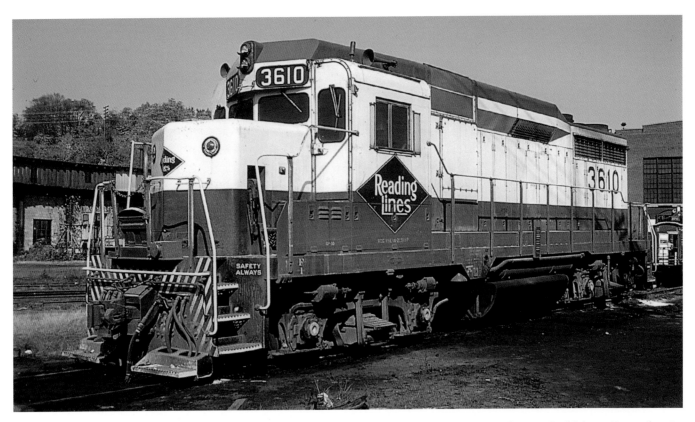

On October 26, 1973, class RSE-14 type GP30 diesel locomotive No. 3610 is at Reading Company shops at Bethlehem, Pennsylvania. This was one of 20 locomotives, originally Nos. 5501-5520, built by the Electro-Motive Division of General Motors Corporation in 1962 for the Reading Company. Very recognizable with its stepped-cab roof and bulge behind and above the cab along the roof line, these four-axle, 2,250-horsepower locomotives were later renumbered 3600-3619 and under Conrail became Nos. 2168-2187. The (J. M. Seidl photograph—C. R. Scholes collection)

Class RSE-14 type GP35 diesel locomotive No. 3623 is at Klapperthal Junction near Reading, Pennsylvania. This was one of six locomotives, Nos. 3620-3625, originally numbered 6501-6506, built by the Electro-Motive Division of General Motors Corporation in 1963 for the Reading Company. The 2,500-horsepower locomotive with its sloped-off cab was considered a second-generation diesel, designed with higher horsepower to work with fewer diesel locomotives needed. (Reading Railroad Heritage Museum collection)

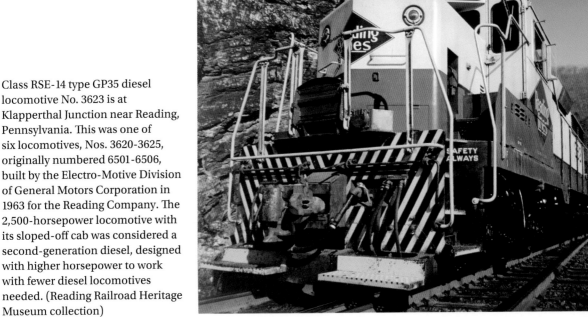

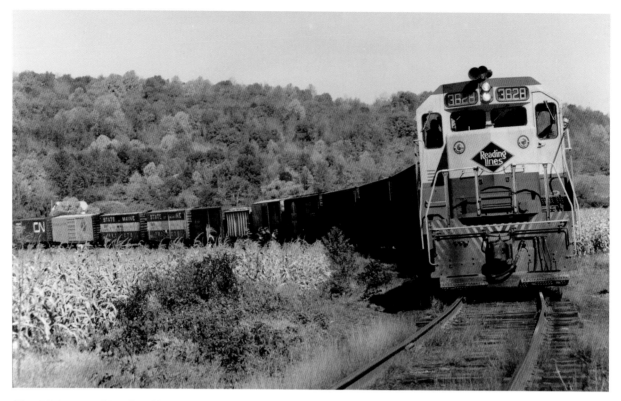

Class RSE-14 type GP35 diesel locomotive No. 3628 is powering a freight train around the curve along the scenic Wilmington & Northern branch of the Reading Company. This was one of 31 locomotives, Nos. 3626-3656, rated 2,500 horsepower and built by the Electro-Motive Division of General Motors Corporation in 1964 for the Reading Company. (Reading Railroad Heritage Museum collection)

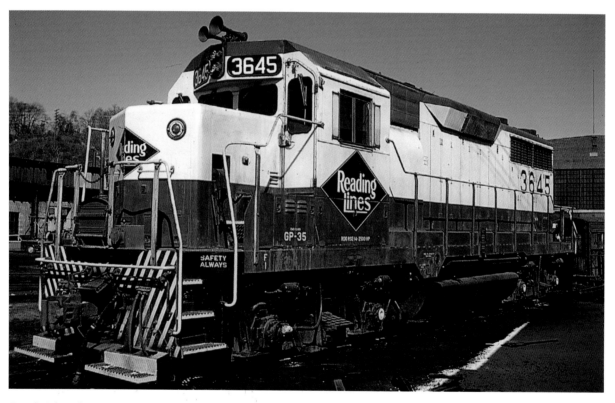

On a bright February 15, 1974, Reading Company class RSE-14 type GP35 diesel locomotive No. 3645 is at the Bethlehem, Pennsylvania, shops. The GP35 had an airtight hood that kept out dust and dirt from reaching internal components, and had one air intake for electrical cooling. (J. M. Seidl photograph—C. R. Scholes collection)

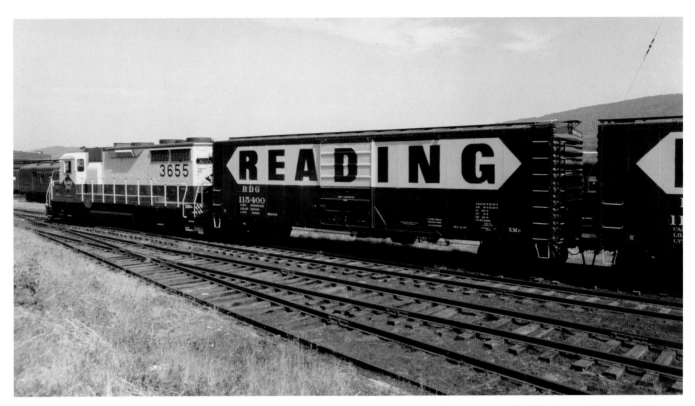

In 1964, class RSE-14 type GP35 diesel locomotive No. 3655 is at Reading, Pennsylvania, pulling some nicely painted boxcars. The Reading Company had 37 GP35 locomotives on its roster, and they were used just about everywhere on the railroad. (Reading Railroad Heritage Museum collection)

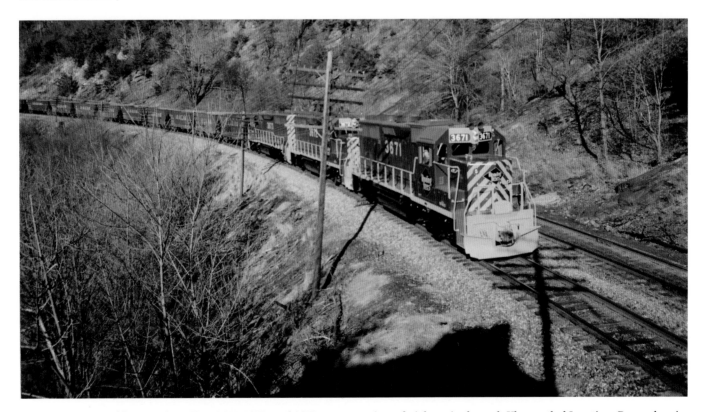

Type GP40-2 Diesel locomotives, Nos. 3671, 3672, and 3673, are powering a freight train through Klapperthal Junction, Pennsylvania. These are three of five diesel locomotives, Nos. 3671-3675, built by the Electro-Motive Division of General Motors Corporation in 1973 for the Reading Company. This four-axle, 3,000-horsepower locomotive had a slant roof and three large radiator fans at the rear of the hood. (Reading Railroad Heritage Museum collection)

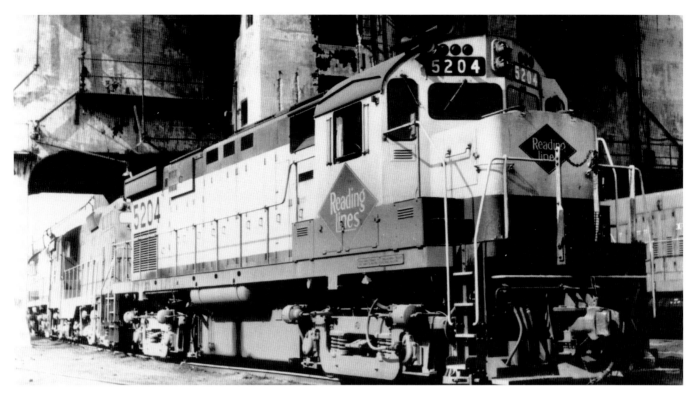

Class RSA-14 type C424 diesel locomotive No. 5204 is heading a lineup of locomotives. This was one of ten locomotives, Nos. 5201-5210, built in 1963 by the American Locomotive Company (ALCO) for the Reading Company. The four-axle locomotive was rated at 2,400 horsepower and was noted for its ruggedness and reliability, as evidenced by the all-ALCO fleet of the Western New York & Pennsylvania Railroad, which has No. 426, an Alco type C424 built in May 1966, still on its roster in 2016. (Reading Railroad Heritage Museum collection)

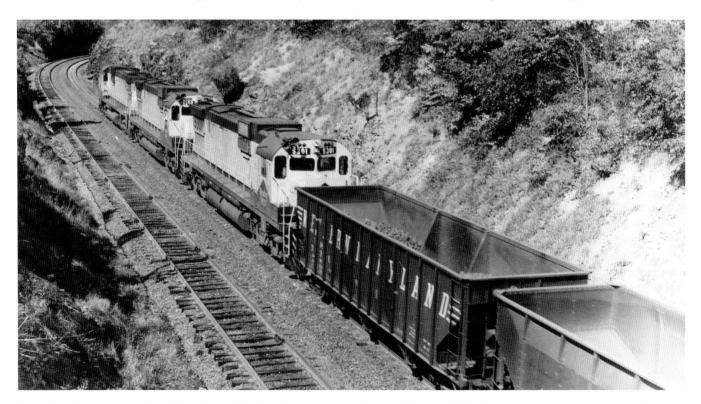

Three Reading Company class RSA-14 type C630 diesel locomotives with Nos. 5302 and 5301 in the rear are pushing an ore train. This was one of twelve locomotives, Nos. 5300-5311, built by ALCO for the Reading Company in 1967. The six-axle locomotive was rated at 3,000 horsepower. As an example of ALCO ruggedness, the Western New York & Pennsylvania Railroad operates No. 630, type C630M (similar and upgraded compared to the C630) that was built by Montreal Locomotive Works in July 1968. (Reading Railroad Heritage Museum collection)

Three diesel locomotives headed by class RSA-14 type C630 diesel locomotive No. 5304, built by ALCO in 1967, are powering a Reading Company ore train. These locomotives were designed to handle heavy ore and coal trains. (Reading Railroad Heritage Museum collection)

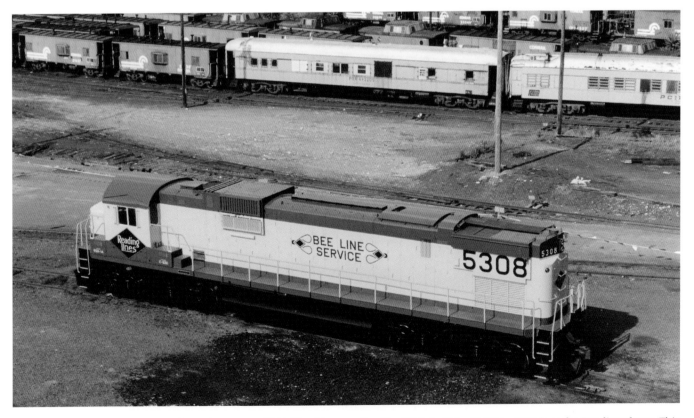

In June 1987, Reading Company class RSA-14 type C630 diesel locomotive No. 5308, built by ALCO in 1967, is at the Reading shops. This locomotive had "Bee Line Service" painted on each side of the long hood. Under "Bee Line Service," the Reading dispatched a locomotive on demand to a customer wanting to ship more than five cars. (Reading Railroad Heritage Museum collection)

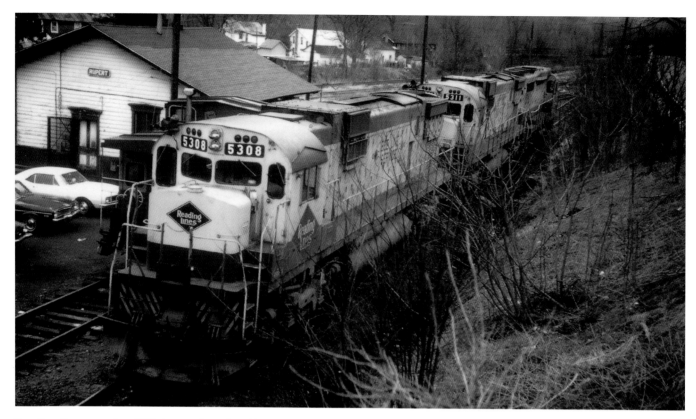

Reading Company class RSA-14 type C630 diesel locomotives Nos. 5308 and 5311 (built by ALCO in 1967) are in the lineup of locomotives at Rupert in Columbia County, Pennsylvania, on April 15, 1974. (Kenneth C. Springirth photograph)

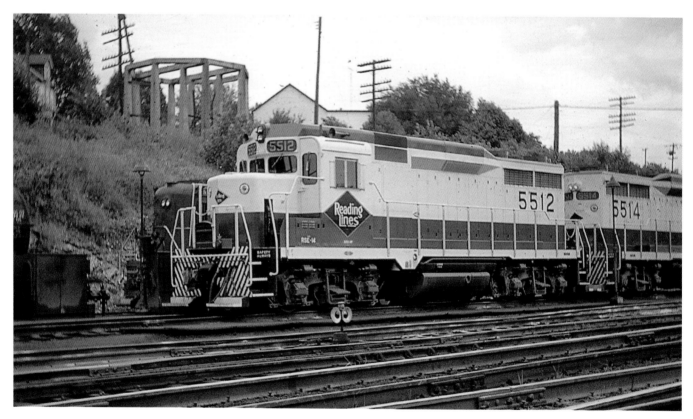

In 1964, class RSE-14 type GP30 diesel locomotives No. 5512 and 5514 are waiting for the next assignment at Reading, Pennsylvania. These were two class RSE-14 type GP30 diesel locomotives of 20, Nos. 5501-5520, built by the Electro-Motive Division of General Motors Corporation in 1962 and renumbered 3600-3619 in 1964. (Bob Crockett photograph—C. R. Scholes collection)

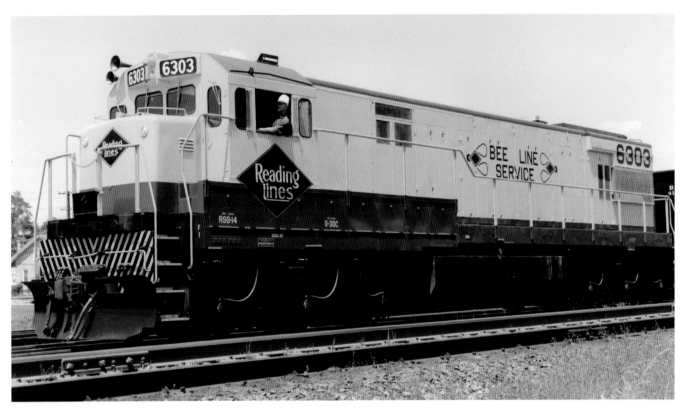

Class RSG-14 type U30C diesel locomotive No. 6303 clearly shows "Bee Line Service" lettered on its long hood side. This was one of five locomotives, Nos. 6300-6304, built by the General Electric Company in 1967 for the Reading Company. The six-axle locomotive was rated 3,000 horsepower. (Reading Railroad Heritage Museum collection)

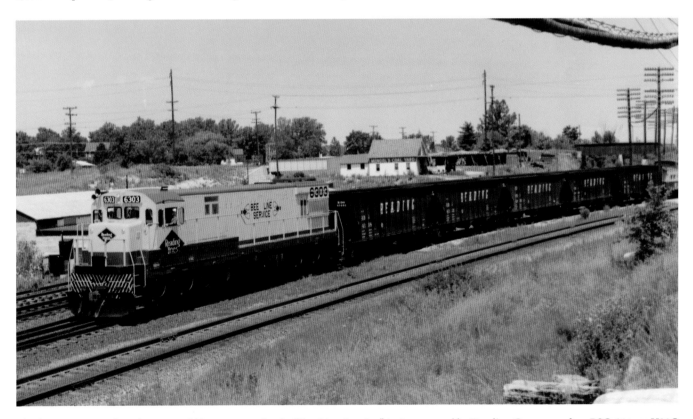

Five hopper cars and a caboose could be an example of a "Bee Line Service" train powered by Reading Company class RSG-14 type U30C diesel locomotive No. 6303, built by the General Electric Company. (Reading Railroad Heritage Museum collection)

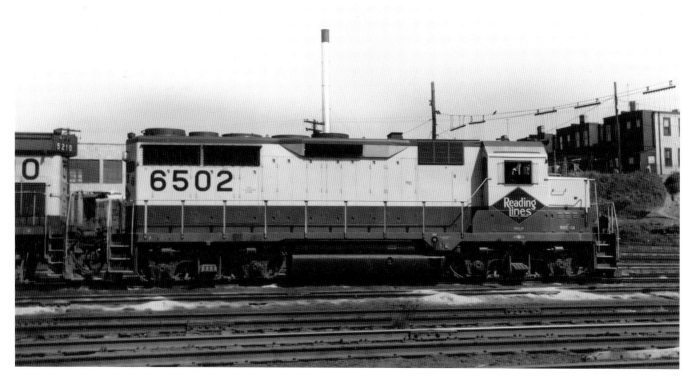

Class RSE-14 type GP35 diesel locomotive No. 6502 is at the Philadelphia yard in May 1964. The four-axle, 2,500-horsepower locomotive, originally No. 3621, was built in 1963 by the Electro-Motive Division of General Motors Corporation for the Reading Company. (Reading Railroad Heritage Museum collection)

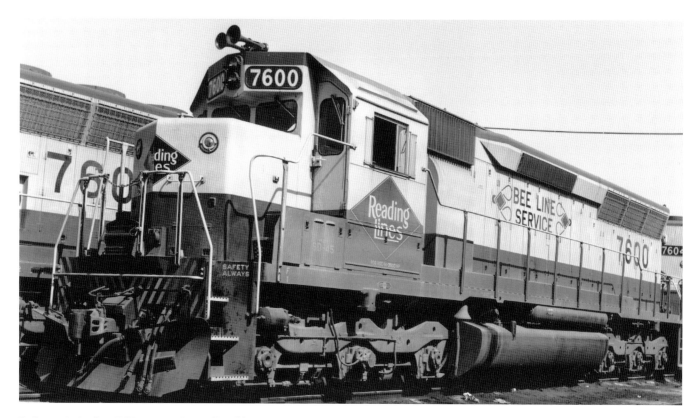

In June 1968, class RSE-14 type SD45 diesel locomotive No. 7600 is at the Philadelphia yard. This was one of five locomotives, Nos. 7600-7604, built in 1967 for the Reading Company by the Electro-Motive Division of General Motors Corporation. The 3,600-horsepower, six-axle locomotive featured a rear flared radiator. (Reading Railroad Heritage Museum collection)

Chapter 3

Reading Blue Mountain & Northern Railroad

In September 1983, the Blue Mountain & Reading Railroad (BM&R) began operating thirteen miles of the former Pennsylvania Railroad line between Hamburg and Temple, Pennsylvania. In 1985, the BM&R began passenger excursion service using ex-Gulf Mobile & Northern Railroad steam locomotive No. 425 and ex-Reading Company steam locomotive No. 2102. Within a few years, BM&R began operating three additional state owned lines. The BM&R acquired and began operating 150 miles of branch lines in the anthracite coal regions north of Reading, Pennsylvania, on December 15, 1990, and the name was changed to Reading Blue Mountain & Northern Railroad (RBMN). In 1995, the RBMN headquarters was moved from Hamburg to Port Clinton. During the 1990s, the RBMN acquired more railroad lines in northeastern Pennsylvania. On August 20, 1996, RBMN acquired over 100 miles of Consolidated Rail Corporation's (Conrail) mostly ex-Lehigh Valley Railroad trackage from Lehighton through Wilkes-Barre, Scranton, and into Wyoming County, Pennsylvania. This became the Lehigh Valley Division of the RBMN. To connect this division with the Reading Division, trackage rights were obtained via the eighteen-mile Carbon County owned railroad between Hometown and Jim Thorpe, Pennsylvania.

On October 14, 1996, CSX Transportation offered to purchase Conrail for $8.4 billion and Norfolk Southern Railway made a counteroffer of $9.1 billion. This led to a bidding war that resulted in an agreement for Conrail to be sold for $10.2 billion, with CSX Transportation receiving about 42 percent of the system (a large portion of the former New York Central Railroad) and Norfolk Southern Railway the remainder (former Pennsylvania Railroad mainline across Pennsylvania as well as Reading Railroad lines to Philadelphia and Allentown, Lehigh Valley Railroad mainline to north Jersey plus the New York Central Railroad line from Cleveland to Chicago). When this plan went into effect on June 1, 1999, Norfolk Southern Railway took over all of the sections of Conrail that connected with RBMN. A fleet of 265 freight cars was purchased by RBMN in 1995, dedicated to the Quebec Iron & Titanium Service. By the end of 2013, the RBMN had a fleet of over 1,000 freight cars. After completing negotiations with Norfolk Southern Railway and Procter & Gamble, in August 2001, RBMN began providing rail service to the Proctor & Gamble manufacturing facility at Mehoopany, Pennsylvania. In November 2001, RBMN obtained ownership of the track in the Crestwood Industrial Park and began serving customers at that location. To provide a direct physical connection between the Reading and Lehigh Divisions without using any other railroad, the RBMN entered into a long term lease of two abandoned Lehigh River bridges from the Pennsylvania Department of Conservation and Natural Resources. The bridge and rail restoration work was completed in November 2003.

Passenger excursion service was established in May 2005, on the RBMN's Lehigh Division from Jim Thorpe to the Lehigh River Gorge. Known as the Lehigh Gorge Scenic Railway, the line carried 72,295 passengers in 2014. With a growing freight and passenger business, the RBMN renovated steam locomotive No. 425, which went back into passenger service by the end of 2007. In 2012, the RBMN entered into an agreement to purchase 7.5 miles of track in the Humboldt Industrial Park in Hazleton, Pennsylvania, and took over service to the customers at the park on January 1, 2016. *Railway Age* magazine has named the RBMN the Regional Railroad of the Year in 2002, 2011, and 2015, because as *Railway Age* Managing Editor Douglas John Bowen noted, "Not only does it keep going and growing, but it keeps adapting and innovating, in good times and bad." Bowen continued about how the railroad tries to advance its role as service provider not only to secure a profit, "but to truly benefit its customers, its employees, and the very region it serves."

In a November 4, 2016 news release, the RBMN announced that in the last 60 days the railroad added four EMD MP15 locomotives for freight service and two EMD GP39RN locomotives primarily for passenger excursion service bringing the total active feet of locomotives to 36. The RBMN, also known as the Reading and Northern Railroad (R&N), purchased 156 used steel open-top hopper cars which will bring their total freight fleet to 1,179 cars. A January 18, 2017 news release stated, "R&N grew its merchandise traffic by 16 percent in 2016 with almost 20,000 carloads. Its tourist operations handled well over 100,000 visitors, the second time in its history that it reached the 100,000 passengers mark." In 2017, the RBMN has over 70 customers in nine eastern Pennsylvania counties (Berks, Bradford, Carbon, Columbia, Lackawanna, Luzerne, Northumberland, Schuylkill, and Wyoming).

This well run railroad has operated a variety of passenger excursions. The railroad's website www.rbmnrr.com is an excellent information source on future events.

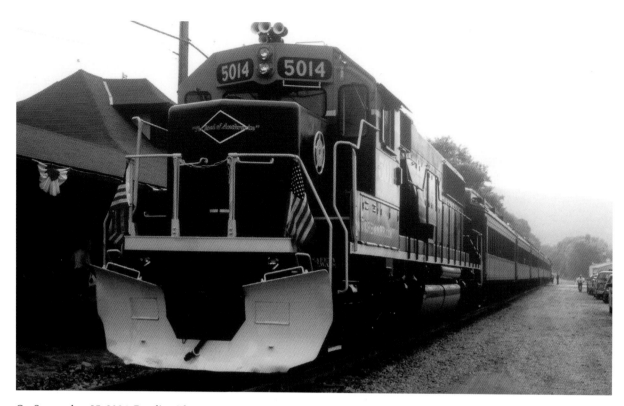

On September 25, 2004, Reading Blue Mountain & Northern Railroad (RBMN) displayed a passenger train at the Schuylkill Haven passenger station for the Schuylkill Haven Borough Day. At this end of the train was six-axle, 3,500-horsepower type SD50 diesel locomotive No. 5014, built by the Electro-Motive Division of General Motors Corporation in November 1984 for the Missouri Pacific Railroad. The handsome 40 foot by 100 foot station was built in 1901 at a cost of about $15,000 with a waiting room, ticket office, baggage room, express room, and restrooms. (Kenneth C. Springirth photograph)

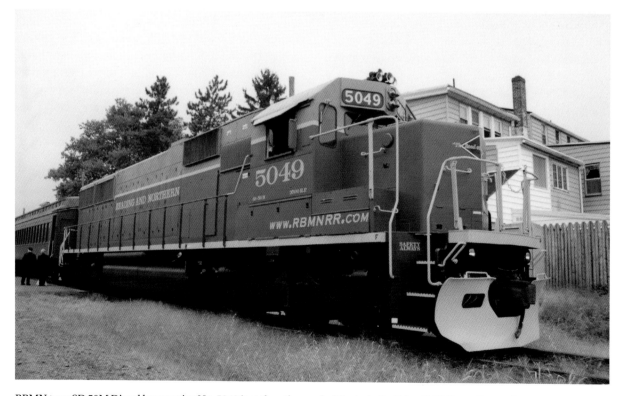

RBMN type SD 50M Diesel locomotive No. 5049 is at the other end of the train for Schuylkill Haven Borough Day on September 25, 2004. This locomotive was built by the Electro-Motive Division of General Motors Corporation for the Missouri Pacific Railroad as No. 5049 in December 1984. It was later acquired by the Union Pacific Railroad. (Kenneth C. Springirth photograph)

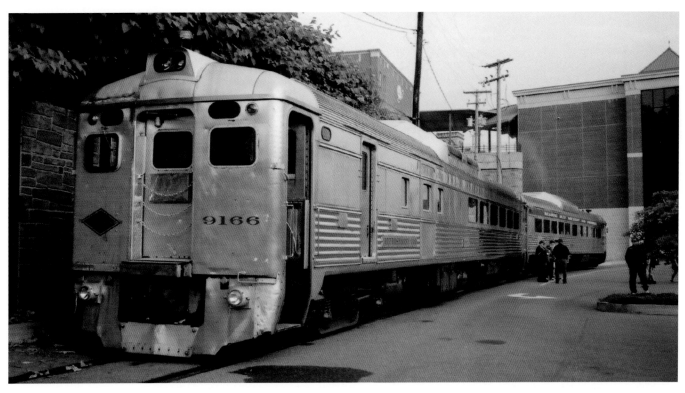

RBMN rail diesel cars Nos. 9166 type RDC-3, built in February 1958 (seating 48 passengers and a baggage compartment converted into a dining facility), and 9168 type RDC-1, built in April 1951 (a passenger coach seating 90 passengers), are at the Pottsville (Pennsylvania) Union Station on June 11, 2016, on a rail excursion from Pottsville via Port Clinton to North Reading. Both 85-foot-long cars were built by the Budd Company of Philadelphia. (Kenneth C. Springirth photograph)

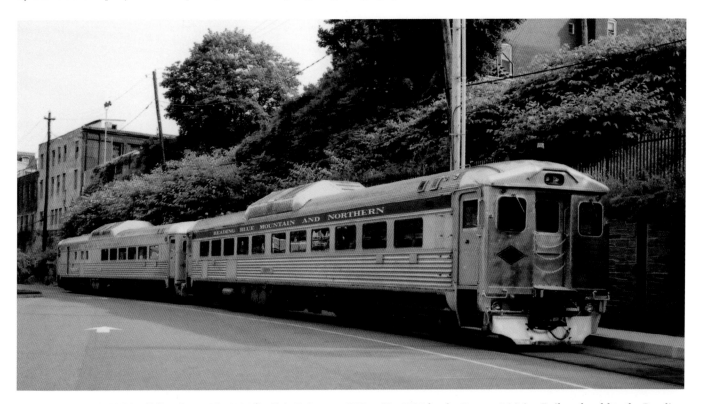

On June 11, 2016, RBMN rail diesel cars No. 9166 (built in February 1958 as No. 6305 for the Boston & Maine Railroad, sold to the Reading Company in August 1966, acquired by the Southeastern Pennsylvania Transportation Authority in May 1976, and went to the Blue Mountain & Reading Railroad in 1984) and No. 9168 (built in April 1951 for the New York Central Railroad) are at the Pottsville (Pennsylvania) Union Station. (Kenneth C. Springirth photograph)

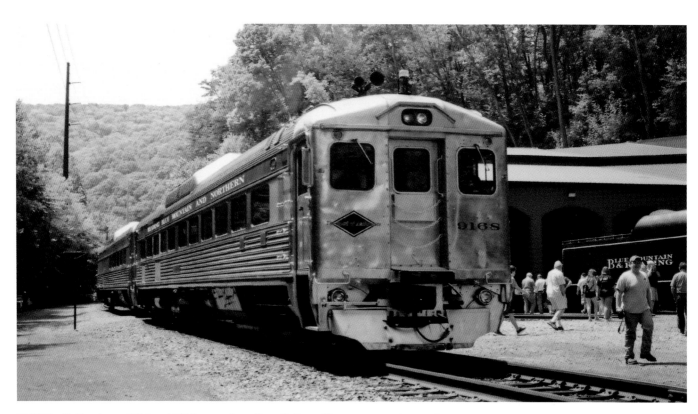

RBMN rail diesel cars 9166 and 9168 are at the railroad's Port Clinton, Pennsylvania, locomotive facility. This excursion provided a nice opportunity to view the facility and the work in process on steam locomotives Nos. 425 and 2102 on the June 11, 2016, rail excursion from Pottsville to North Reading. The well-run RBMN shows that with carefully scheduled events, visitors can safely be accommodated on railroad property. (Kenneth C. Springirth photograph)

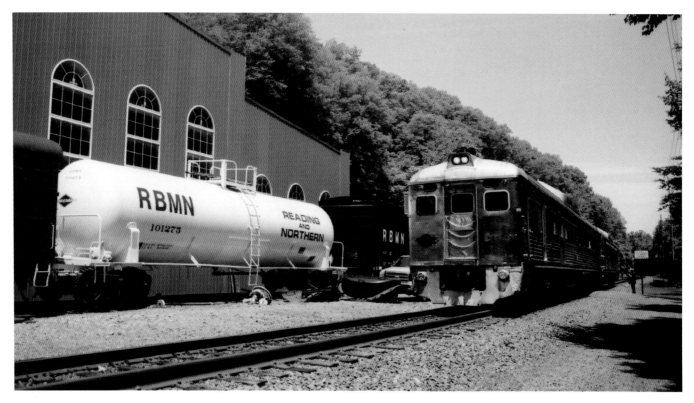

On a sunny June 11, 2016, the RBMN rail excursion, featuring rail diesel cars 9166 and 9168, has made a stop at the railroad's Port Clinton facility to allow the passengers on the Pottsville to North Reading excursion to view locomotives and rolling stock such as RBMN water tank car No. 101275. (Kenneth C. Springirth photograph)

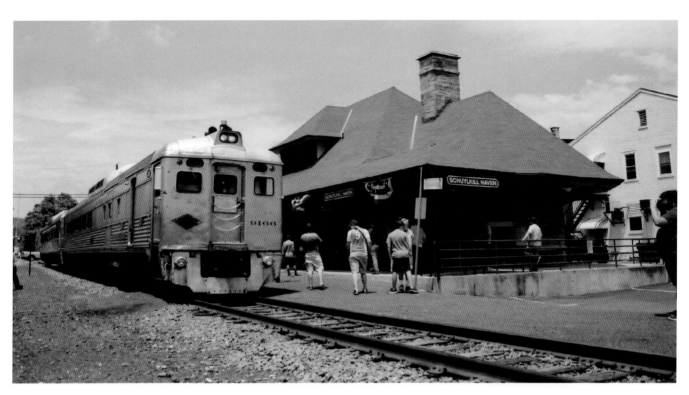

RBMN rail diesel cars Nos. 9166 and 9168 are making a passenger stop at the Schuylkill Haven station on the return rail excursion trip to Pottsville on June 11, 2016. This stone passenger station was built in 1901 by the Philadelphia & Reading Railroad, which became the Reading Company in 1924. When SEPTA discontinued passenger service to Pottsville in 1981, the station was taken out of service. It has been refurbished by the RBMN and is used as an office building with an inside passenger waiting area. (Kenneth C. Springirth photograph)

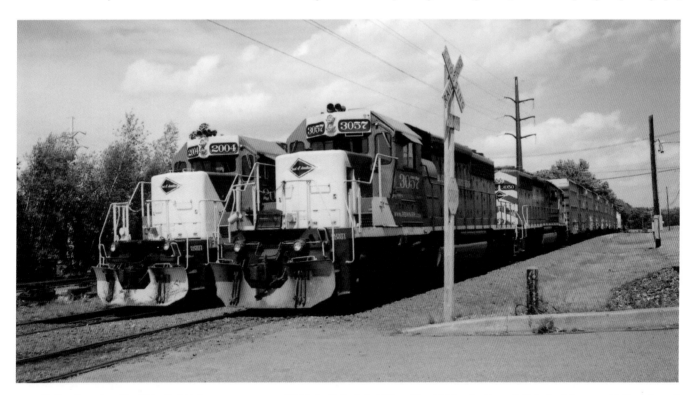

RBMN diesel engine No. 2004 (2,000-horsepower type SD38, built in July 1971 as No. 254 for the Detroit Toledo & Ironton Railroad, and later became No. 6254 for the Grand Trunk & Western) and No. 3057 (3,000-horsepower type SD40-2 built in January 1975 as No. 6901 for the Chicago & Northwestern Railway, and later became No. 3066 for the Union Pacific Railroad) are heading the lineup awaiting the next assignment at the Humboldt Industrial Park in West Hazleton, Pennsylvania, on June 11, 2016. The Electro-Motive Division of General Motors Corporation built both locomotives. (Kenneth C. Springirth photograph)

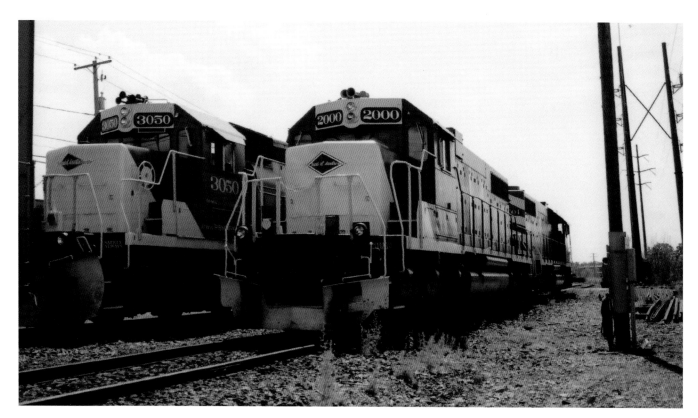

On a quiet June 11, 2016, RBMN diesel locomotive No. 3050 (type SD40-2 built in March 1979 as No. 3550 for the Union Pacific Railroad) and No. 2000 (type SD38 built in April 1970 as No. 6941 for Penn Central and later transferred to Consolidated Rail Corporation) are at the Humboldt Industrial Park in West Hazleton on June 11, 1960. (Kenneth C. Springirth photograph)

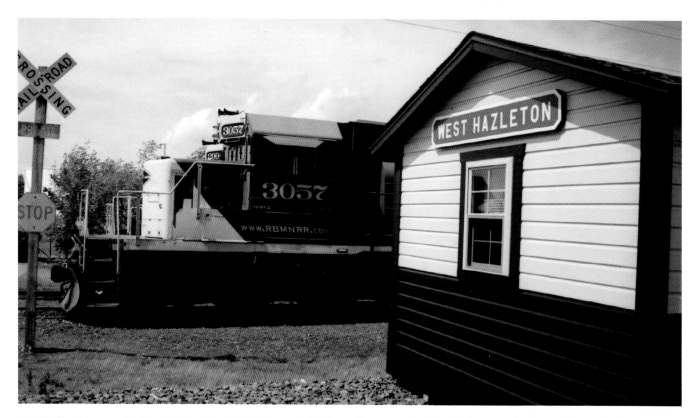

RBMN diesel locomotive No. 3057 on June 11, 1960, is ready for duty adjacent to the West Hazleton yard office at the Humboldt Industrial Park. On January 1, 2016, the RBMN took over ownership of 7.5 miles of track from the Norfolk Southern Railway inside the Humboldt Industrial Park. (Kenneth C. Springirth photograph)

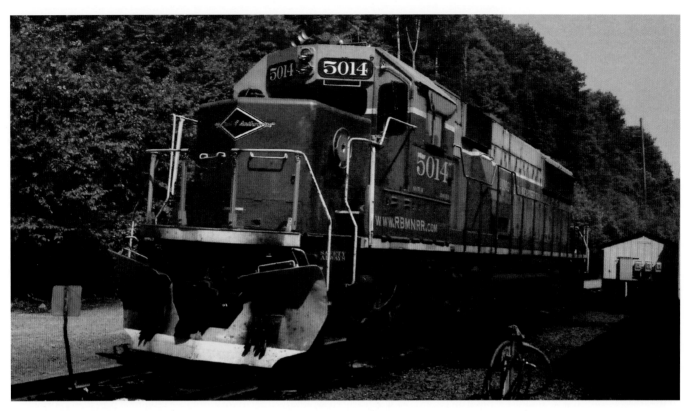

On June 11, 2016, RBMN six-axle, 3,500-horsepower type SD50 diesel locomotive No. 5014 (built by the Electro-Motive Division of General Motors Corporation in November 1984 for the Missouri Pacific Railroad) is at the Port Clinton engine terminal. This facility handles locomotive maintenance and repainting. (Kenneth C. Springirth photograph)

Port Clinton engine terminal on April 11, 2016, is the location of RBMN type SD40-2 diesel locomotive No. 3052 (built by the Electro-Motive Division of General Motors Corporation for the Missouri Pacific Railroad in April 1980 as No. 6072, it later became No. 3972 for the Union Pacific Railroad). (Kenneth C. Springirth photograph)

At the RBMN Port Clinton engine terminal on June 11, 2016, Beverly Hess, RBMN director of employee relations, provides information on the history of the railroad and the extensive maintenance activities performed at the facility. In the background is RBMN type SD38 diesel locomotive No. 2003 (built by the Electro-Motive Division of General Motors Corporation in July 1971 as No. 253 for the Detroit Toledo & Ironton Railroad and later became Grand Trunk & Western Railroad No. 6253). (Kenneth C. Springirth photograph)

On June 11, 2016, newly painted type SD40-2 diesel locomotive No. 3055 (built by the Electro-Motive Division of General Motors Corporation in October 1979 as No. 3621 for the Union Pacific Railroad) is at the RBMN Port Clinton engine terminal. On the right is a portion of Lehigh Gorge Scenic Railway type SD50M diesel locomotive No. 426 (built by the Electro-Motive Division of General Motors Corporation in December 1984 as No. 5033 for the Union Pacific Railroad). (Kenneth C. Springirth photograph)

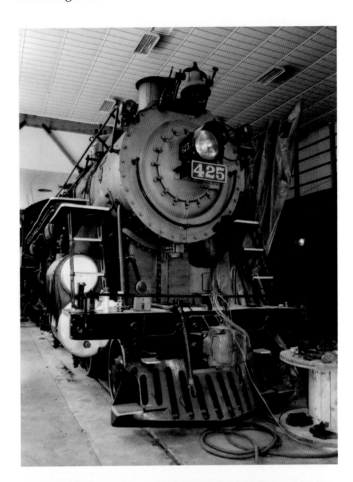

RBMN stream locomotive No. 425 is undergoing maintenance at the Port Clinton engine house on June 11, 2016. Baldwin Locomotive Works in Eddystone, Pennsylvania, built this locomotive for the Gulf, Mobile & Northern Railroad in January 1928 and later became Gulf, Mobil & Ohio Railroad No. 580. It was retired in 1950 and was purchased by the Louisiana Eastern Railroad and renumbered No. 4 and later No. 2. The Valley Forge Scenic Railroad acquired it in 1962 and renumbered it No. 425. In 1983, it began excursion service on the Blue Mountain & Reading Railroad. (Kenneth C. Springirth photograph)

On June 11, 2016, RBMN bay-window caboose No. 92846 is at the Humboldt Industrial Park. Since the 1980s, cabooses have been largely replaced by an end-of-train device to report any problems to the engineer in the locomotive. However, cabooses are still useful in switching service where it is convenient to have a crew at the rear of the train. (Kenneth C. Springirth photograph)

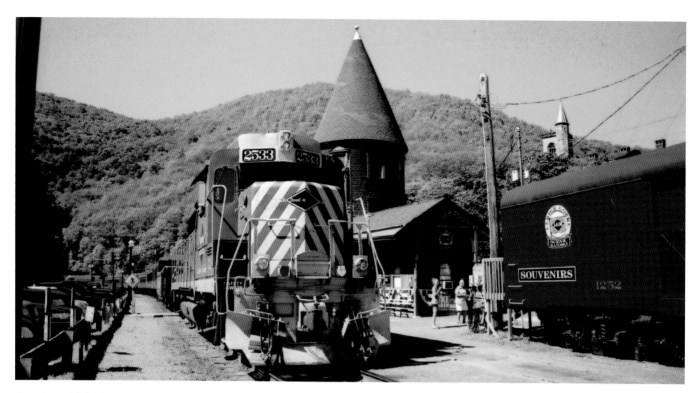

On a beautiful July 23, 2016, RBMN diesel locomotive No. 2533 is preparing to power the 11 a.m. Lehigh Gorge Scenic Railway train at Jim Thorpe. This type GP39RN diesel locomotive was built by the Electro-Motive Division of General Motors Corporation in April 1963 as No. 1267 for the Atchison Topeka & Santa Fe (ATSF), rebuilt in February 1984 as ATSF No. 3267, renumbered ATSF No. 2767, rebuilt as Burlington Northern Santa Fe No. 2465 type GP30U, and became LTEX No. 2465. Behind the locomotive, the cylindrical corner tower with the conical roof is the former Central Railroad of New Jersey station that was built in 1888 and now serves as a tourist information center. (Kenneth C. Springirth photograph)

RBMN diesel switcher locomotive No. 803 is on the siding at Jim Thorpe on July 23, 2016. This 800-horsepower type SW8m diesel switcher locomotive was built in September 1951 by the Electro-Motive Division of General Motors Corporation as No. 270 type SW8 for the Lehigh Valley Railroad, became Conrail No. 8684, and was later rebuilt as type SW8m. (Kenneth C. Springirth photograph)

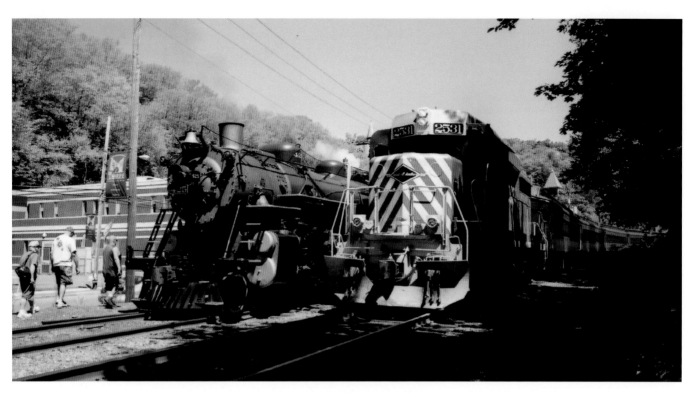

On July 23, 2016, the special Rotary Club train excursion from Mountain Top, Pennsylvania, is at Jim Thorpe using RBMN steam locomotive No. 425 and RBMN diesel locomotive No. 2531. The steam locomotive backed around and later was turned at the turn table for the return trip to Mountain Top. Type GP39RN diesel locomotive No. 2531 was built by the Electro-Motive Division of General Motors Corporation in January 1963 as No. 1238 for the ATSF, renumbered ATSF No. 3238, renumbered 2738, rebuilt as Burlington Northern Santa Fe No. 2438 type GP30U, and became LTEX No. 2438. (Kenneth C. Springirth photograph)

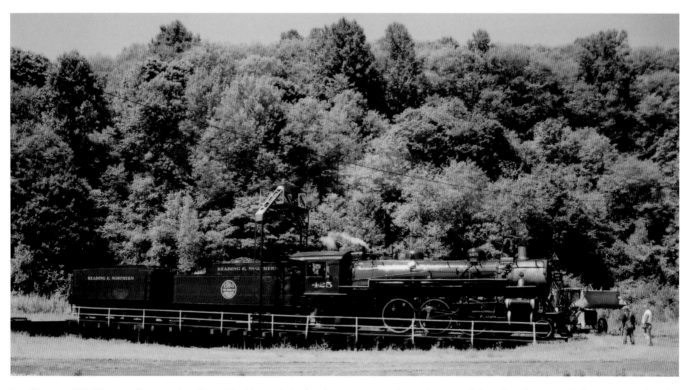

Pacific type RBMN steam locomotive No. 425 with a 4-6-2 wheel arrangement is on the turntable at Jim Thorpe on July 23, 2016. After the October 13, 1996, Tamaqua Fall Fest, locomotive No. 425 was placed in storage, later restored, and returned to excursion service in June 2008. The locomotive was taken out of service for the rebuilding of the pilot and trailing trucks, rebuilding of the air compressor, and replacing of the bottom part of the smokebox. By the end of August 2013, No. 425 was back in excursion service. (Kenneth C. Springirth photograph)

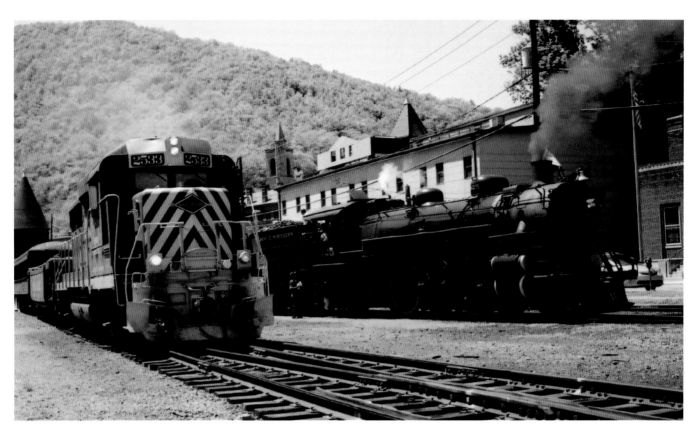

The 1 p.m. July 23, 2016, Lake Gorge Scenic Railway train headed by RBMN diesel locomotive No. 2533 is passing by RBMN steam locomotive No. 425 that later will accompany RBMN diesel No. 2531 locomotive for the return trip to Mountain Top. (Kenneth C. Springirth photograph)

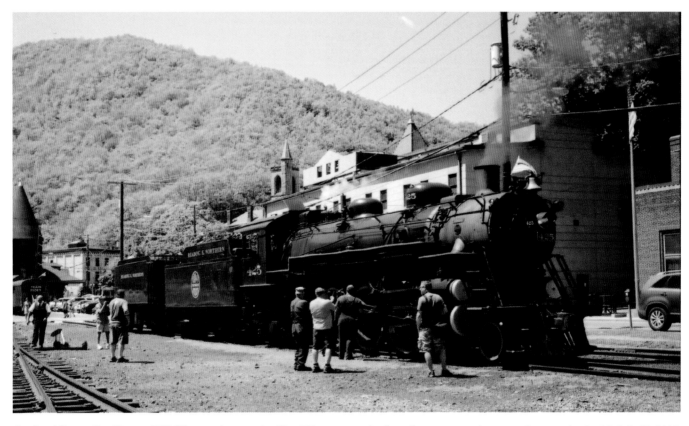

On the siding at Jim Thorpe, RBMN steam locomotive No. 425 attracts onlookers, happy to see the steam locomotive in this July 23, 2016, scene in this picturesque region. (Kenneth C. Springirth photograph)

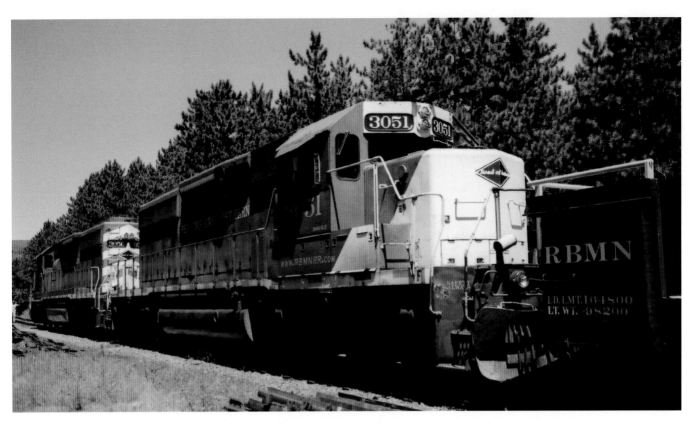

Basking in the July 23, 2016, sunshine at Jim Thorpe, RBMN type SD40-2 Electro-Motive Division of General Motors Corporation diesel locomotives No. 3051 (built in September 1979 as Missouri-Kansas-Texas Railroad No. 611) and behind it No. 3056 (built in April 1978 as Union Pacific Railroad No. 3440) are waiting for the next assignment. (Kenneth C. Springirth photograph)

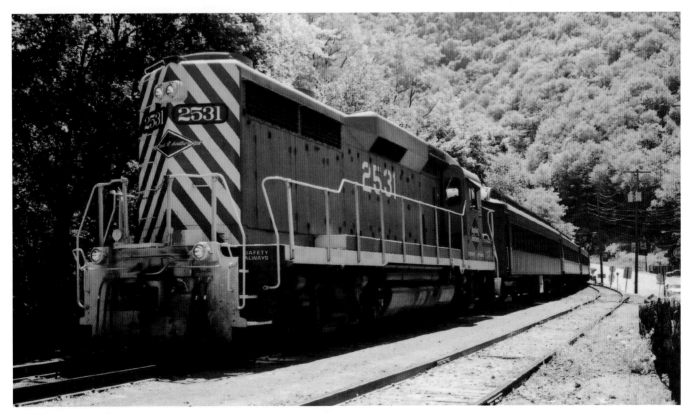

On July 23, 2016, RBMN diesel locomotive No. 2531 is at Jim Thorpe waiting for the appointed time to be joined by RBMN steam locomotive No. 425 to load passengers for the return excursion to Mountain Top. (Kenneth C. Springirth photograph)

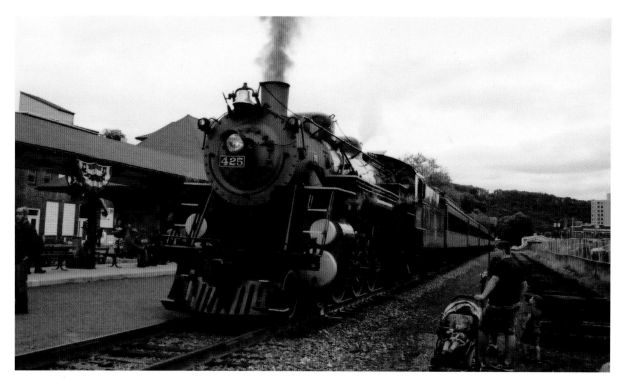

RBMN steam locomotive No. 425 is at the former Reading Company Schuylkill Haven train station powering a passenger train for the September 24, 2016, Borough Day. At the other end of the train was RBMN diesel locomotive No. 2530. "Borough day wows crowds in Schuylkill Haven" in the September 30, 2016, *Pottsville Republican Herald* newspaper, which noted, "Celeste Geschwindt, a member of the Schuylkill Haven Borough Day Committee and one of the organizers, estimated between 10,000 and 12,000 attended." (Kenneth C. Springirth photograph)

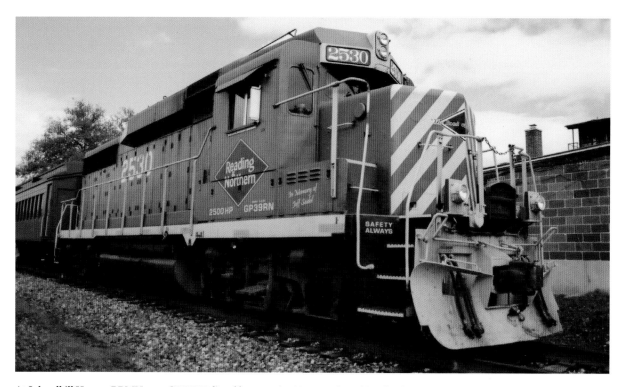

At Schuylkill Haven, RBMN type GP39RN diesel locomotive No. 2530 is waiting for the 11 a.m. departure time for the September 24, 2016, Borough Day excursion with steam locomotive No. 425 at the other end of the train. The diesel locomotive was built as No. 1281 type GP30 in June 1963 by the Electro-Motive Division of General Motors Corporation for the Atchison Topeka, & Santa Fe Railway (ATSF). It was renumbered ATSF No. 3281, ATSF No. 2781, Burlington Northern Santa Fe Railway (BNSF) No. 2430, LTEX No. 2430, and RBMN No. 2530. The locomotive was rebuilt as type GP39RN. (Kenneth C. Springirth photograph)

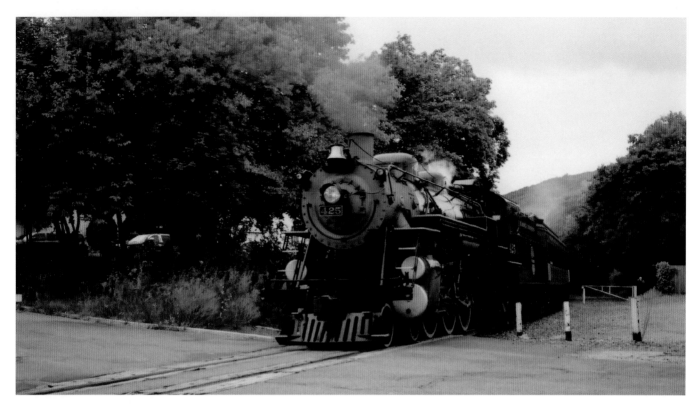

On September 24, 2016, RBMN steam locomotive No. 425 is on the rear of the 11 a.m. Borough Day passenger excursion crossing William Street in Schuylkill Haven. RBMN diesel locomotive No. 2530 is powering the seven-car southbound train at the other end. The train made an approximately 20-mile round trip to the Kernsville Dam and back to Schuylkill Haven. (Kenneth C. Springirth photograph)

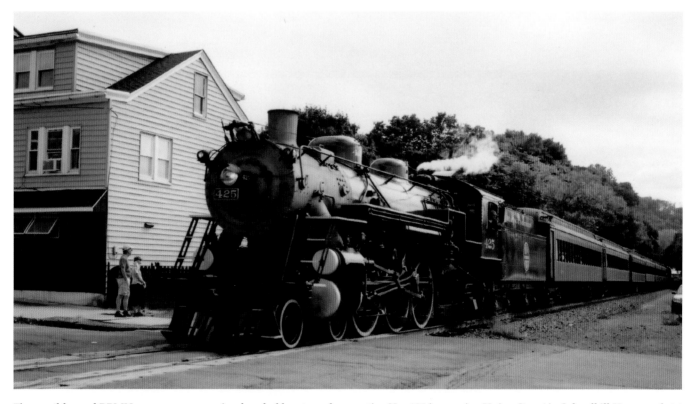

The northbound RBMN passenger excursion headed by steam locomotive No. 425 is crossing Union Street in Schuylkill Haven a short distance from the station that completed the first Borough Day round trip for September 24, 2016. Two additional train trips (1 p.m. and 3 p.m.) were conducted that day, which along with the excellent weather, food, entertainment, activities, and a variety of vendors, attracted many people to downtown Schuylkill Haven. (Kenneth C. Springirth photograph)

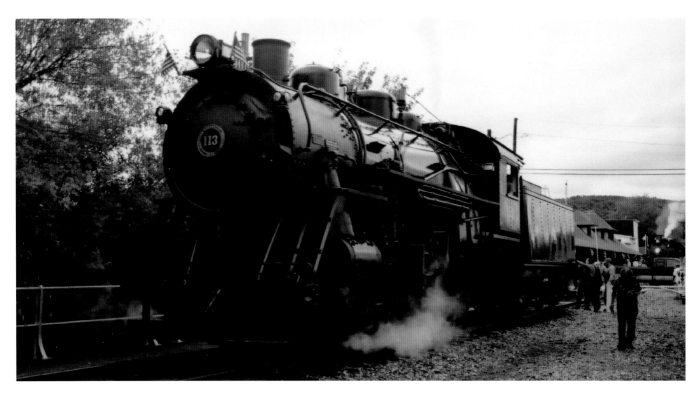

Former Central Railroad of New Jersey (CNJ) steam locomotive No. 113 (built by ALCO in 1923) has steamed in from Minersville for the September 24, 2016, Schuylkill Haven Borough Day on the RBMN track on the north side of Main Street, while RBMN steam locomotive No. 425 is shown on the south side of Main Street on the right side of the picture. CNJ No. 113 was purchased by Robert Kimmel Sr. in 1986. It was moved to Minersville and restoration began in 1999. (Kenneth C. Springirth photograph)

On September 24, 2016, CNJ No. 113 is parked across Main Street from the former Reading Company Schuylkill Haven passenger station. The "Railway Restoration Project 113" started by Robert Kimmel Sr. is now headed by Kimmel's son Robert E. Kimmel Jr. According to the project's website, it has taken "10 years, $600,000, and about 60,000 man hours by volunteers." This is the only remaining operable CNJ steam locomotive. The only other surviving CNJ steam locomotive is No. 592, an Atlantic Camelback with a 4-4-2 wheel arrangement, which is on static display at the B&O Railroad Museum in Baltimore, Maryland. (Kenneth C. Springirth photograph)

Chapter 4

Wanamaker, Kempton & Southern Railroad

The Wanamaker, Kempton & Southern Railroad operates excursion service over a portion of what started out as the 44-mile Berks County Railroad that opened on June 18, 1874, between Reading and Slatington, Pennsylvania. It expected to handle coal trains from the Lehigh Valley Railroad to factories in Reading, but that only lasted about ten days. In 1875, the railroad was reorganized as the Reading & Lehigh Railroad and was leased to the Philadelphia & Reading Railroad. Financial problems resulted in reorganizing into the Schuylkill & Lehigh Railroad in 1880. In 1883, it was again leased to the Philadelphia & Reading Railroad and became its Schuylkill & Lehigh branch. The Philadelphia & Reading Railroad, including its Schuylkill & Lehigh branch, became part of the Reading Company in 1923. On April 9, 1949, the last passenger train operated on that branch. By 1960, the line had been cut back to Germansville. With the section of the line from Kempton to Germansville next to be abandoned, a new excursion railroad was organized to buy the 11.5 miles of track from Kempton via Wanamaker to Germansville. Since the Reading Company had technically abandoned the line, it was necessary for the new railroad to negotiate with all of the landowners on the line. Agreement was reached with landowners between Kempton and Wanamaker, and the three-mile segment was purchased for its $65,000 scrap value. In May 1963, two saddle tank locomotives, Nos. 2 and 3, purchased from the Colorado Fuel & Iron Company, arrived. Rolling stock including passenger cars, freight cars, and cabooses were purchased. The Joanna Station was acquired from the Reading Company's Wilmington & Northern branch and was moved to Kempton where it has served as the ticket office, waiting room, and crew room.

The Wanamaker, Kempton & Southern Railroad (WK&S) opened on May 30, 1963. It was established as a for profit corporation owned by stockholders and was predominately a volunteer organization with a paid manager. During 1963, additional passenger and freight cars were purchased. Before the end of the 1963 season, steam locomotive No. 250 (purchased from the Bonhomie & Hattiesburg Southern Railroad, which operated in Mississippi between Hattiesburg and Beaumont) was in operation. A Reading Company freight station from West Catasauqua was purchased, moved, and became the WK&S gift shop. During 1964, the WK&S briefly operated a two-train schedule with locomotives Nos. 2 and 250. A gas-mechanical Whitcomb locomotive No. 1871 was purchased in 1964; around 1975, it was repainted and became No. 20. Ridership had reached about 40,000 in 1964. With a ridership decline reducing income, a decision was made to cease operation at the end of 1968. To the company's credit, they had taken an abandoned railroad and restored it with a significant investment in buying equipment and outside contractors, but could not maintain the financial momentum needed to keep it going. A decision was made to reopen the line as an all-volunteer operation with no outside contractors, and all work was done in-house when possible.

The line reopened in 1970, and by 1982 was debt free. In 1971, the home-built Berksy Trolley was constructed. Named after the *Berksy*, a passenger train that once operated between Reading and Slatington, the car was used when business did not justify operating the steam train. In 1971, steam locomotive No. 65 was donated to the WK&S by Safe Harbor Water & Power Company of Columbia, Pennsylvania, using the existing rail line to reach Kempton, and steam locomotive No. 250 was sold using the existing line to leave Kempton. Following these locomotive moves, trackage was abandoned from Kempton south to Evansville, and the WK&S no longer had a rail connection, but 1.2 miles of track between North Albany and Kempton was acquired from the contractor through a stock deal. After 25 years of service and in need of a major overhaul, the Berksy Trolley last operated in 1996. In February 1997, center cab locomotive No. 7258, built by the General Electric Company, was acquired. By the mid-2000s, track between Kempton and North Albany was no longer maintained. Steam locomotive operation ended in December 2009. A talented group of volunteers continues to do an enormous amount of work cleaning, painting, and maintaining equipment and buildings, using the revenue from ticket sales and gift shop purchases to keep the railroad in operation. The WK&S website is www.kemptontrain.com, and the train station address is 42 Community Center Drive, Kempton, PA 19529.

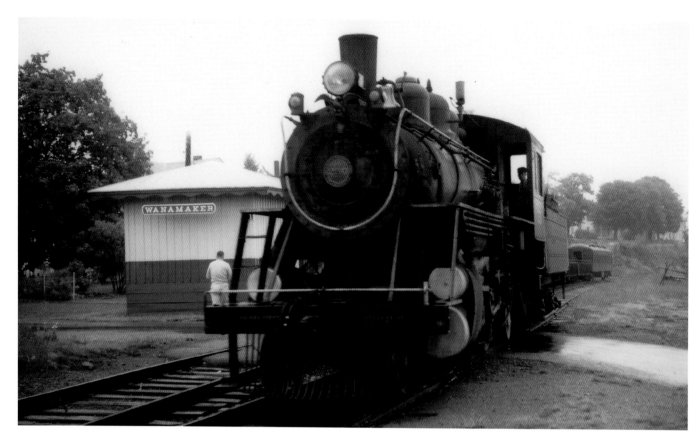

Wanamaker, Kempton & Southern Railroad (WK&S) steam locomotive No. 250, built by the Baldwin Locomotive Works in June 1926, is at Wanamaker on August 1, 1965. This Prairie type locomotive with a 2-6-2 wheel arrangement was purchased from the Bonhomie & Hattiesburg Southern Railroad in Mississippi and arrived at Kempton on August 29, 1963. Its trip north involved movement by rail from Mississippi to Louisiana, ocean going barge to Edgewater, New Jersey, Jersey Central Railroad to Allentown, and Reading Company via Reading to Kempton. (Kenneth C. Springirth photograph)

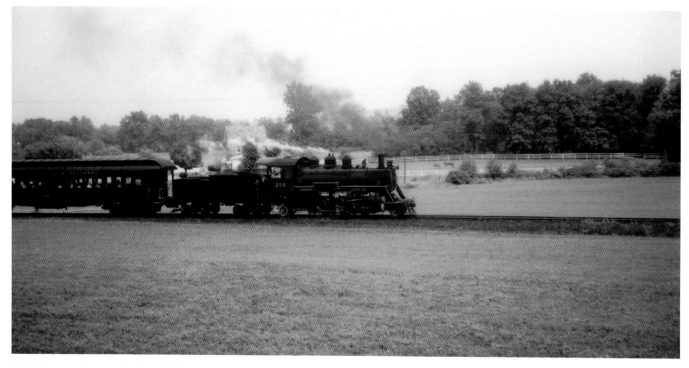

WK&S steam locomotive No. 250 is traversing picturesque countryside on August 1, 1965. The 3.5-mile line operates between Kempton in Berks County and Wanamaker in Lehigh County. (Kenneth C. Springirth photograph)

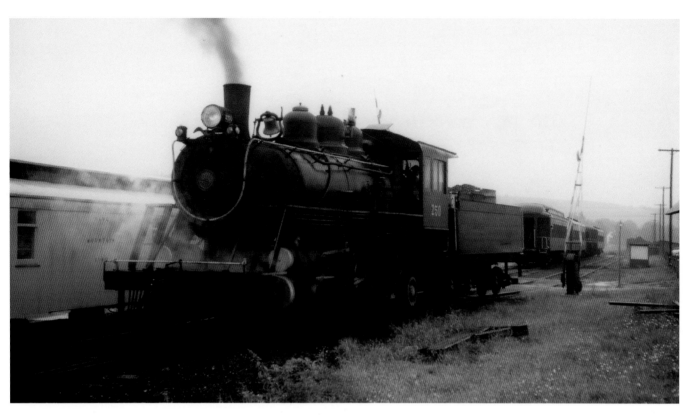

At the Wanamaker station on August 1, 1965, WK&S steam locomotive No. 250 is on the side track. The train is being switched around to be at the front end for the return trip to Kempton. (Kenneth C. Springirth photograph)

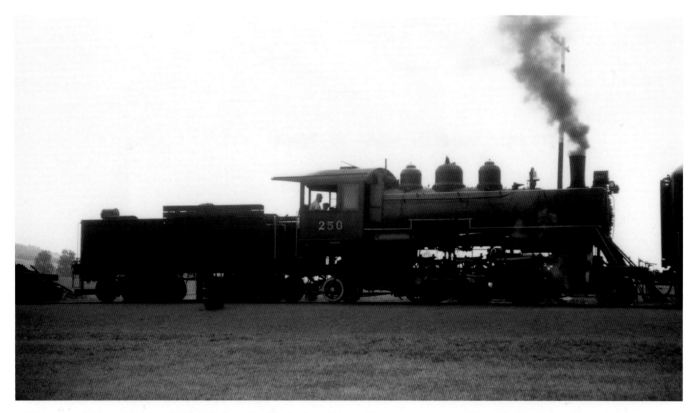

WK&S steam locomotive No. 250 blends in well with the beautiful Berks County countryside in this August 1, 1965, scene. Declining attendance resulted in financial problems, leading to the closure of the WK&S at the end of the 1968 season. When the WK&S resumed operation in 1970, locomotive No. 250 was out of service. It was sold and moved in February 1972 to the Wolfeboro Railroad in Wolfeboro, New Hampshire. (Kenneth C. Springirth photograph)

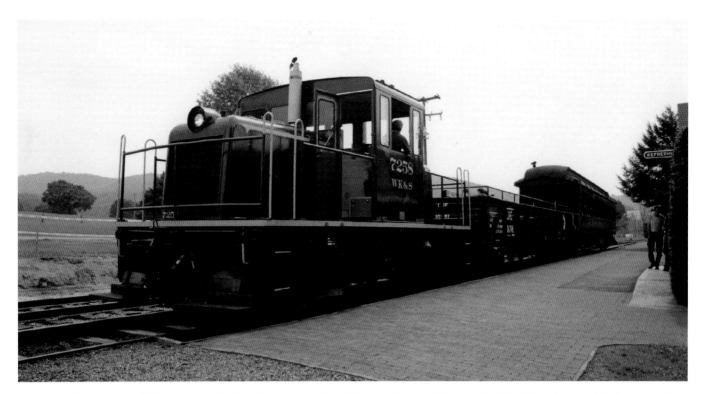

On September 25, 2004, WK&S center cab diesel locomotive No. 7258 is ready to pull former Lehigh & New England Railroad gondola car No. 10381 and former Delaware Lackawanna & Western Railroad passenger car No. 582. This locomotive was built by the General Electric Company in 1942 for the United States Army. It arrived at the WK&S in February 1997. During 1999, the locomotive was restored and rewired followed by repainting in 2000. All of the major work was done by WK&S volunteers. (Kenneth C. Springirth photograph)

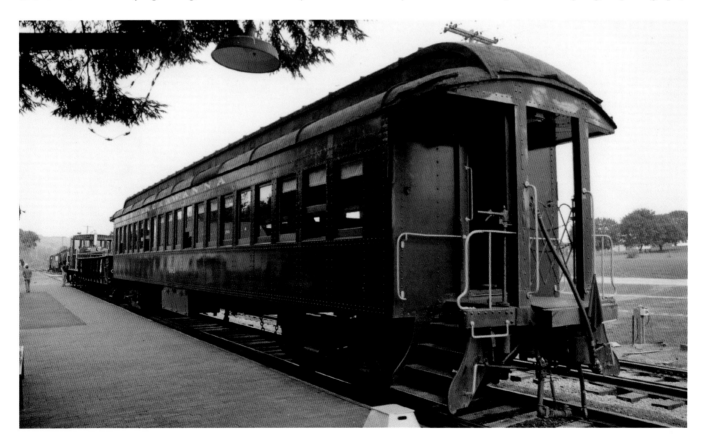

Nicely painted former Delaware Lackawanna & Western Railroad passenger car No. 582 is at the end of a WK&S train on September 25, 2004. (Kenneth C. Springirth photograph)

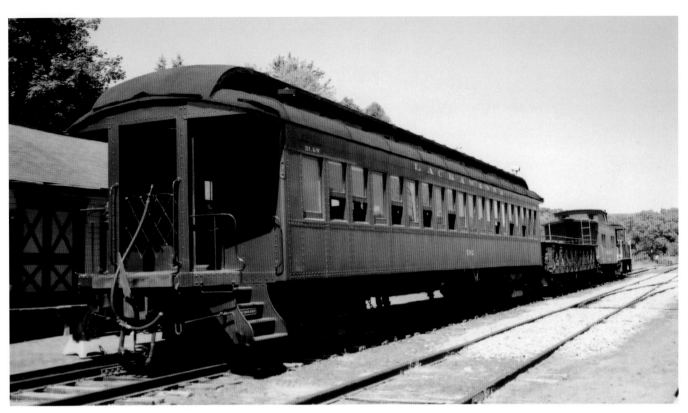

Almost 12 years later on August 28, 2016, WK&S locomotive No. 7258, former Reading Company caboose No. 92936, former Lehigh & New England Railroad gondola car No. 10381, and former Delaware Lackawanna & Western passenger car No. 582 are ready for a 1 p.m. departure. (Kenneth C. Springirth photograph)

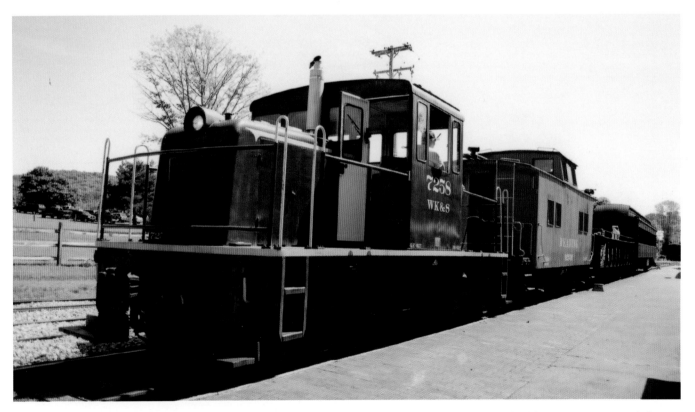

The 2 p.m. WK&S train is waiting for departure time at Kempton, Pennsylvania, on August 28, 2016. Behind locomotive No. 7258 is former Reading Company caboose No. 92936 that was built in September 26, 1942 and retired in June 1963. There were of 50 of these class NMn cabooses, Nos. 92930-92979, that were built in 1942, noted as composite with steel framing and wood sheathing. (Kenneth C. Springirth photograph)

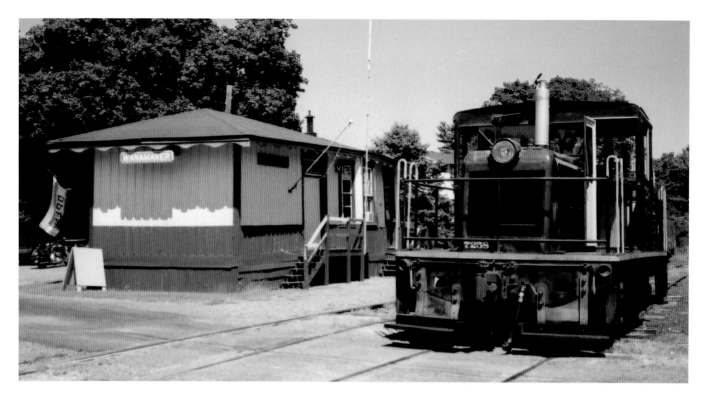

WK&S diesel locomotive No. 7258 is on the siding at Wanamaker to get to the other end of the train for the return trip to Kempton on August 28, 2016. The former Wanamaker station had been acquired by the local general store in the mid-1950s from the Reading Company and was purchased by the WK&S around 1963. It was the only WK&S station existing at its original location. The Kempton station buildings were transported by truck from other locations. (Kenneth C. Springirth photograph)

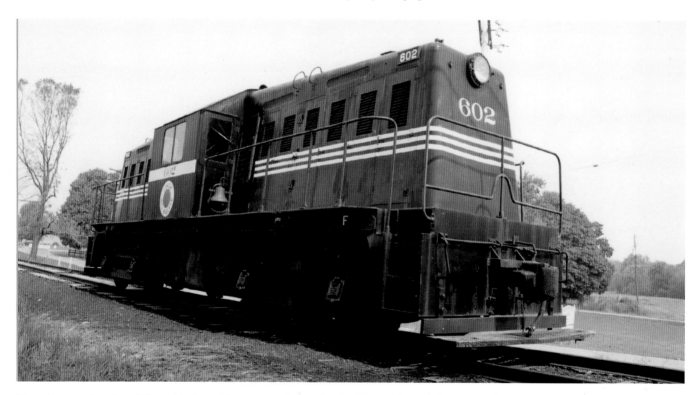

Diesel locomotive No. 602 is on display at Kempton on September 25, 2004. This model 65DE-19A locomotive was built by the Whitcomb Locomotive Works in 1944 for the United States Army as USATC No. 8467. After the war, it was purchased by the Gulf Oil Corporation. In 1984, it was donated to the Cornell Railway Historical Society. It was given to the Anthracite Roads Historical Society and is leased to the WK&S. The locomotive never served on the Lehigh & New England Railroad (L&NE), but the WK&S agreed to restore the locomotive in 1989 as L&NE No. 602, as it was similar to L&NE No. 601. (Kenneth C. Springirth photograph)

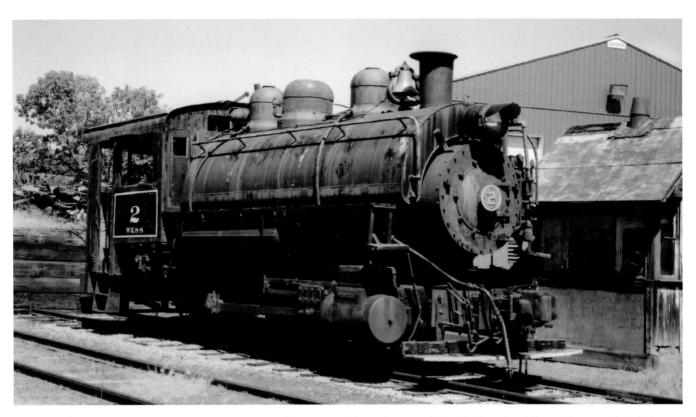

The original WK&S operating steam locomotive No. 2 (that opened the 1963 season) is parked on the siding at Kempton in this August 28, 2016, view. This locomotive (with a 0-4-0T wheel arrangement) was built in March 1920 by H. K. Porter Inc. for the Colorado Fuel & Iron Company of Birdsboro, Pennsylvania. (Kenneth C. Springirth photograph)

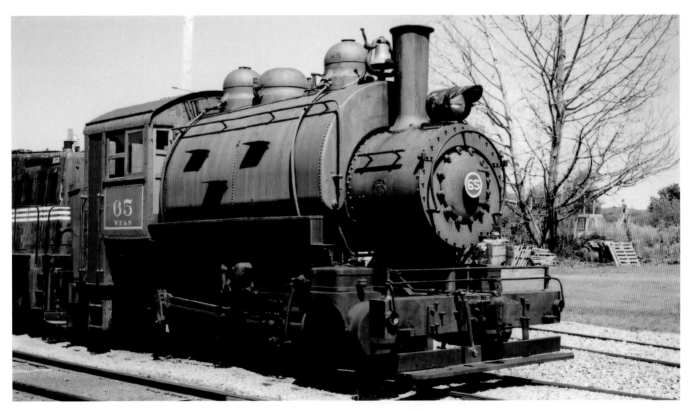

WK&S steam engine No. 65 is on display at Kempton on August 28, 2016. H. K. Porter Inc. built this locomotive with a 0-6-0T wheel arrangement in 1930. The locomotive was acquired from the Safe Harbor Water Power Company in Columbia in January 1972. It was shipped by rail to Kempton just before the track between Evansville and North Albany was removed. (Kenneth C. Springirth photograph)

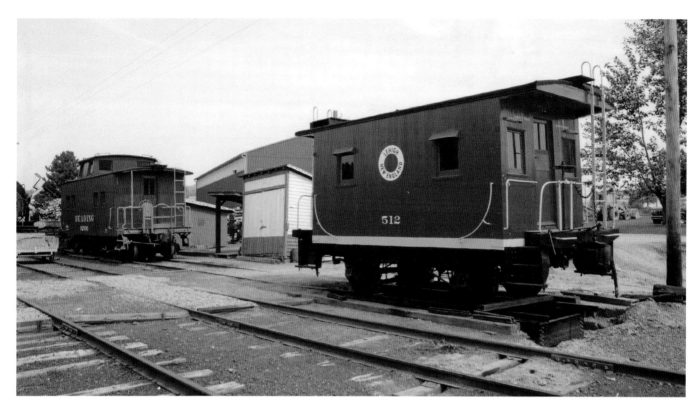

On October 17, 2004, former Reading Company class NMn caboose No. 92936 and Lehigh & New England Railroad (LNER) four-wheeled caboose No. 512 are on the siding at Kempton. LNER No. 512 was moved to the former Central Railroad of New Jersey station at Bethlehem, Pennsylvania, that was leased to the Jaycees. The caboose was shipped by rail and arrived at Kempton around May 1966 on loan to the WK&S, but was later acquired by the WK&S. (Kenneth C. Springirth photograph)

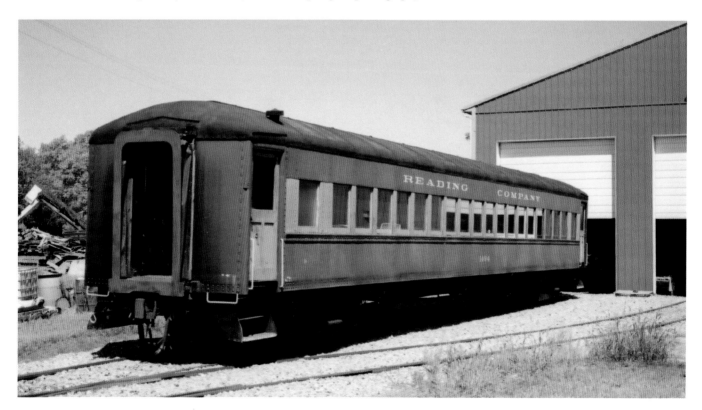

WK&S passenger car No. 1494 is ready for duty at Kempton on August 28, 2016. This car was purchased by the WK&S from the Reading Company for $2,200 around August 1963. The WK&S made a wise decision to purchase what is today a historic collection of rolling stock. (Kenneth C. Springirth photograph)

Chapter 5

Middletown & Hummelstown Railroad

The history of the Middletown & Hummelstown Railroad (M&H) began with the idea of a canal linking the Susquehanna and Delaware valleys in southwestern Pennsylvania, proposed in 1690 by William Penn. Between 1762 and 1770, David Rittenhouse and William Smith made the survey for the canal, which was the first survey for a canal in the United States. The Pennsylvania General Assembly chartered the Schuylkill & Susquehanna Canal Company and the Delaware & Schuylkill Canal Company to build the canal, and construction began in 1792. Experiencing slow progress, the two canal companies were reorganized and merged into the Union Canal Company. In 1825, Schuylkill Navigation opened a canal from Reading to Philadelphia. As a result, the Union Canal Company focused on a Middletown–Reading canal, which was completed in 1828. A 22-mile branch canal was constructed northward along Swatara Creek to Pine Grove in 1832. The completion of the Lebanon Valley Railroad in 1857 from Reading to Harrisburg resulted in a decline in canal revenues, and the canal went bankrupt in 1884. With 75 percent of the canal stock owned by the Philadelphia & Reading Railroad (P&R), the P&R offered to buy the canal for $105,000 in 1885, and it took five years for the court to approve the sale.

The Middletown & Hummelstown Railroad Company (M&H) was incorporated in 1885 by local businessmen. Construction began from Middletown, and it was completed to Stoverdale (south of Hummelstown) by August 1889. The bridge over Swatara Creek was completed and the last section to Hummelstown connecting with the P&R was completed in 1890. The P&R threatened to sue the M&H, because the line was built on the towpath (where horses were used to tow the boat) of the Union Canal, which was owned by the P&R. To resolve the legal issue, the seven-mile M&H was sold to the P&R for $175,000. The line had passenger service until 1939. Knowing that the Reading Company wanted to abandon the M&H, Wendell Dillinger had been in negotiation with the Reading Company. Hurricane Agnes hit the region in August 1972, and Swatara Creek flooded the area, severing the railroad line between Middletown and Hummelstown. The Reading Company made an agreement with the Pennsylvania Railroad to have the Pennsylvania Railroad serve Middletown, while the Reading Company would serve Hummelstown.

After Hurricane Agnes, the United States Federal government would rebuild main railroad lines, but not branch lines. However, a state government could obtain an option to buy a railroad branch line. Pennsylvania State Government purchased the M&H line and sold it to Wendell Dillinger on March 23, 1976. The M&H was the first line to be purchased before Conrail took over the Reading Company and other bankrupt railroads on April 1, 1976. Wendell Dillinger is an independent owner and not a designated operator.

The railroad began freight service in 1976. Passenger service began during 1986, using former Delaware Lackawanna & Western Railroad passenger cars that were built during 1916-1920 and used in New Jersey until 1984. With a vision for rail transportation, Wendell Dillinger has acquired an amazing variety of rail rolling stock, including a number of trolley cars from the Philadelphia area. In 1984, Wendell Dillinger purchased Rio De Janeiro, Brazil, open trolley car No. 441 from the Fox River Museum of South Elgin, Illinois. After a careful restoration, the car (originally built in 1909) was placed in special event service in October 2007. In September 2016, a former Southeastern Pennsylvania Transportation Authority Presidents' Conference Committee (PCC) trolley car is in the process of being expertly refurbished in its former Philadelphia Transportation Company green and cream paint scheme. The M&H station at 136 Brown St in Middletown is a short walk via Union and Brown Street to the Middletown Amtrak station located at Union and Mill Streets. Amtrak has daily Harrisburg via Middletown to Philadelphia and New York passenger service.

The M&H website is www.mhrailroad.com, and the mailing address is 136 Brown Street, Middletown, PA 17057-1703.

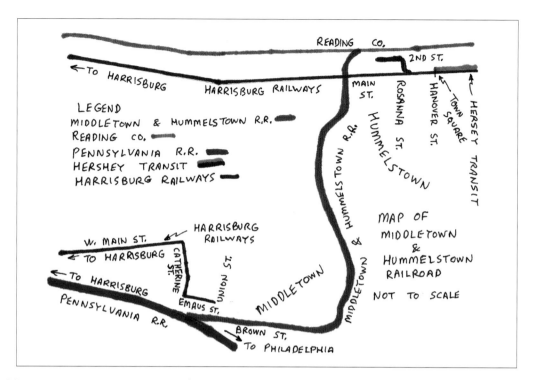

The Middletown & Hummelstown Railroad (a former Reading Railroad branch line) connects the former Pennsylvania Railroad (now Norfolk Southern Railway) in Middletown with the former Reading Railroad (now Norfolk Southern Railway) at Hummelstown. As shown on the map, both Middletown and Hummelstown each had Harrisburg Railways streetcar service to Harrisburg until July 16, 1939. Hershey Transit streetcar service from Main Street at Hanover Street (transfer point with Harrisburg Railways) in Hummelstown to Hershey and points east ended on December 21, 1946.

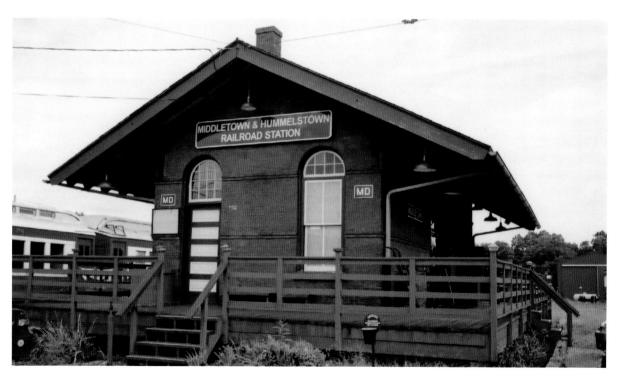

In this August 25, 2016, view, the original Philadelphia & Reading Railroad (P&R) freight station built in 1896 at 136 Brown Street is the starting point for Middletown & Hummelstown Railroad (M&H) passenger excursions in Middletown. The station features a gift shop and modern restroom facilities. This is the only tourist railroad operation in Pennsylvania that is a short walk from an Amtrak passenger station (Middletown) with daily passenger service. The railroad also provides freight service for local industries and interchanges with the Norfolk Southern Railway at Middletown via the Keystone Line and at Hummelstown via the Lebanon Valley line. (Kenneth C. Springirth photograph)

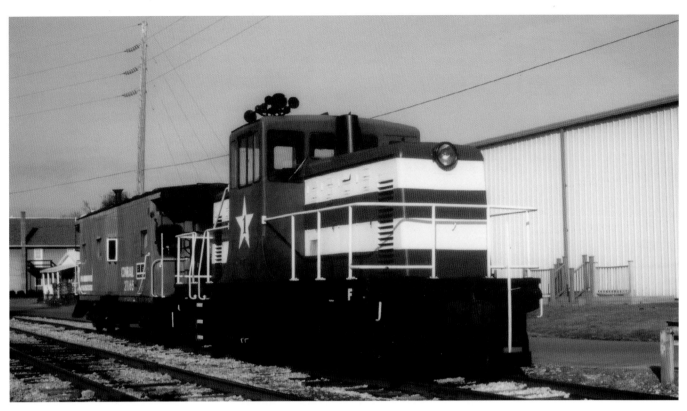

M&H diesel locomotive No. 1 with a Consolidated Rail Corporation (Conrail) caboose are at the Middletown yard on October 30, 2010. The 60-ton locomotive was originally No. 7272, built by the General Electric Company for the United States Army in 1941. (Kenneth C. Springirth photograph)

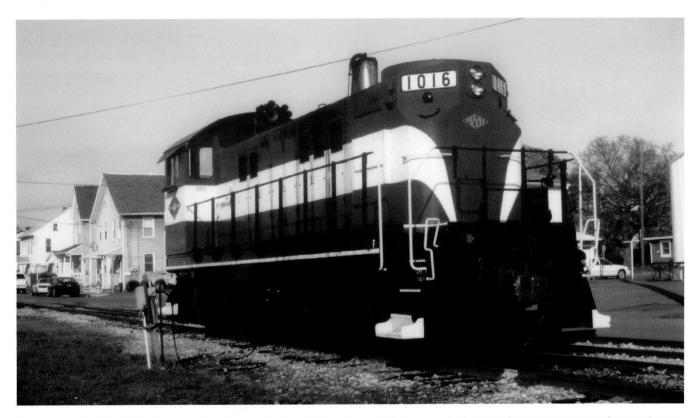

On October 30, 2010, M&H diesel switcher locomotive No. 1016 is at the Middletown yard. This 1,000-horsepower type T6 locomotive was one of two, Nos. 1016 and 1017, originally built for the Newburgh & South Shore Railroad in January 1969 by the American Locomotive Company (ALCO). (Kenneth C. Springirth photograph)

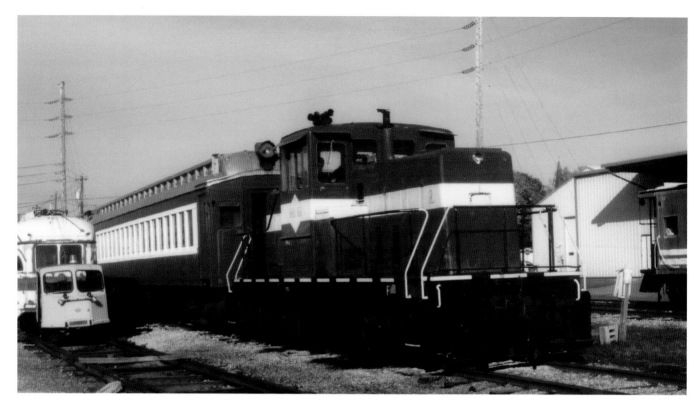

M&H 65-ton diesel locomotive No. 2 (built by the General Electric Company in April 1955 as No. 46 for the Standard Slag & Stone Company) is at Middletown on October 30, 2010. On the track to the left is a motorized speeder car that was designed for track inspection plus maintenance duties and behind it is a former Presidents' Conference Committee (PCC) car purchased from the Southeastern Pennsylvania Transportation Authority (SEPTA) in Philadelphia. (Kenneth C. Springirth photograph)

A former repainted Reading Company tank car No. 90980 is at the M&H Middletown yard on August 26, 2016. A lot of work has gone into acquiring and refurbishing railroad and trolley cars at this railroad. Much of the Philadelphia area trolley car heritage can be viewed at this site. (Kenneth C. Springirth photograph)

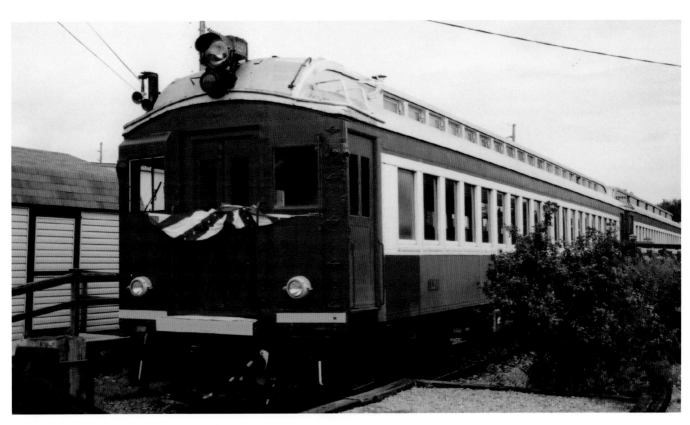

Former Delaware & Lackawanna & Western Railroad multiple unit trailer passenger car No. 329 is parked at the Middletown station waiting for departure time on August 25, 2016. (Kenneth C. Springirth photograph)

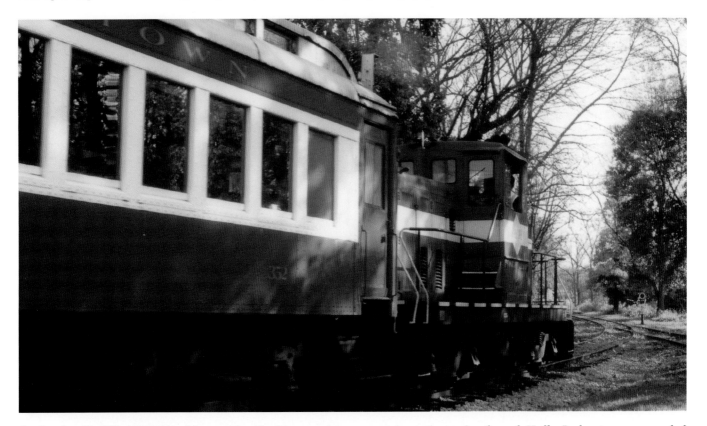

On October 30, 2010, M&H Diesel locomotive No. 2 is powering an excursion train passing through Hoffer Park, a ten-acre wooded area that includes a playground owned by the borough of Middletown. This scenic facility is located just east of the M&H railroad yard. (Kenneth C. Springirth photograph)

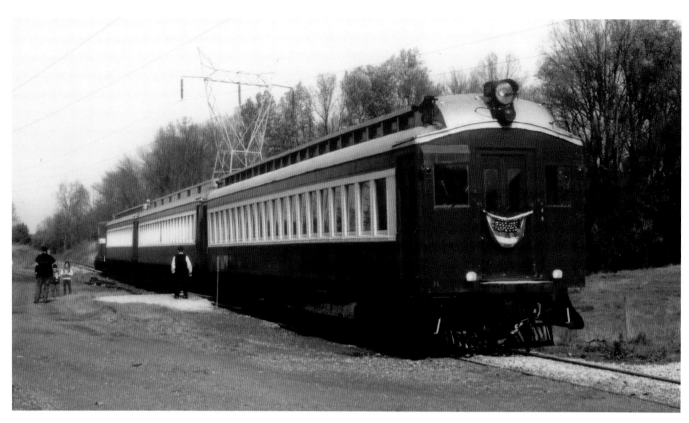

Echo Caverns is the location of this M&H excursion train powered by diesel locomotive No. 2 on October 30, 2010. The caverns, located south of the Hummelstown borough line, were originally used by the Susquehannock tribe, who lived and hunted in the area until the 1670s. In 1929, the caverns were opened to the public. (Kenneth C. Springirth photograph)

At the entranceway to Indian Echo Caverns in the crisp autumn air of October 30, 2010, a M&H passenger train is awaiting departure time with diesel locomotive No. 2 at the other end of the train. (Kenneth C. Springirth photograph)

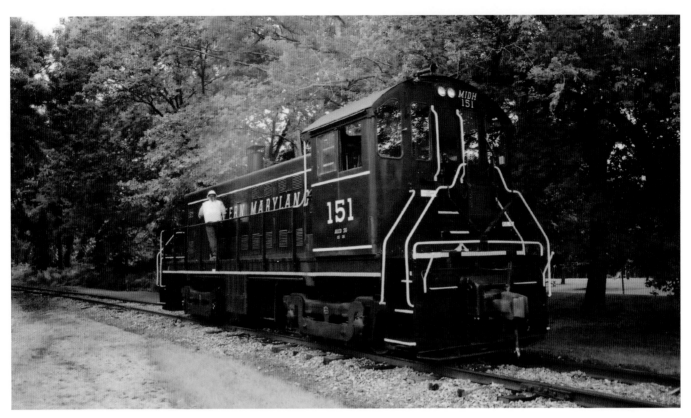

M&H diesel switcher locomotive No. 151 is entering Hoffer Park in Middletown, heading eastbound to pick up some empty cars on August 25, 2016. This 900-horsepower type S6 locomotive was one of two, Nos. 151 and 152, built at the Schenectady, New York, ALCO plant in 1956 for the Western Maryland Railroad. (Kenneth C. Springirth photograph)

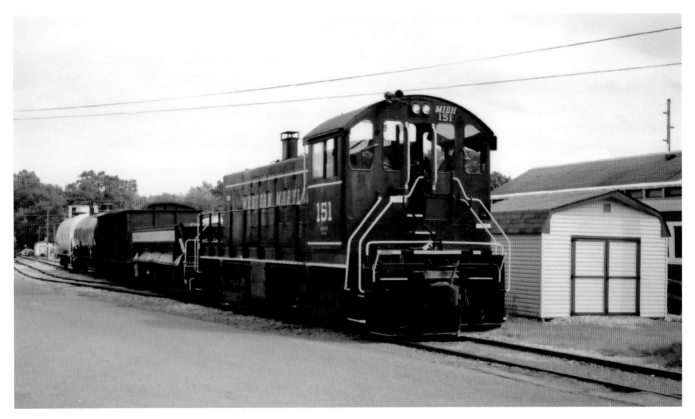

Westbound M&H locomotive No. 151 is leaving the Middletown yard with empty cars and is ready to enter the street running over Brown Street in Middletown to the Norfolk Southern Railway interchange at Middletown on August 25, 2016. (Kenneth C. Springirth photograph)

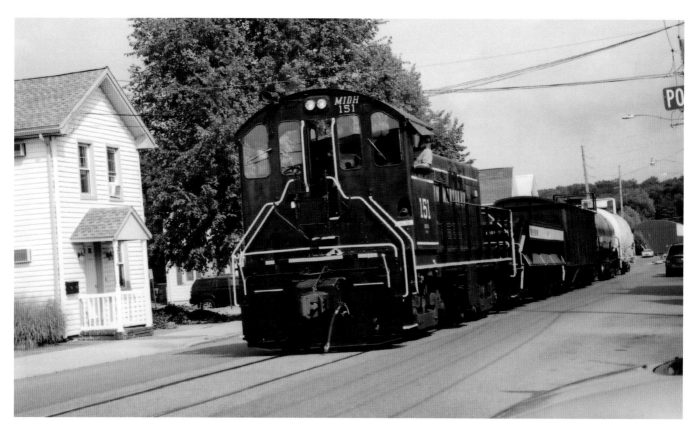

On August 25, 2016, M&H diesel locomotive No. 151 is westbound on Brown Street at Poplar Street in Middletown, with empty cars for the Norfolk Southern Railway interchange at Middletown. (Kenneth C. Springirth photograph)

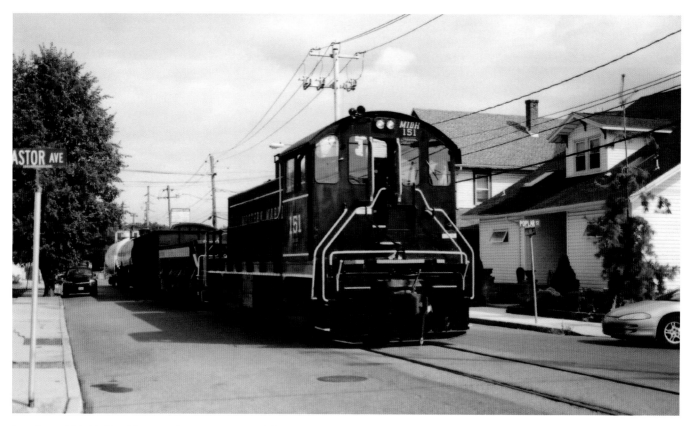

Westbound M&H diesel locomotive No. 151 is carefully travelling along Brown Street, approaching Astor Avenue on August 25, 2016, in Middletown. (Kenneth C. Springirth photograph)

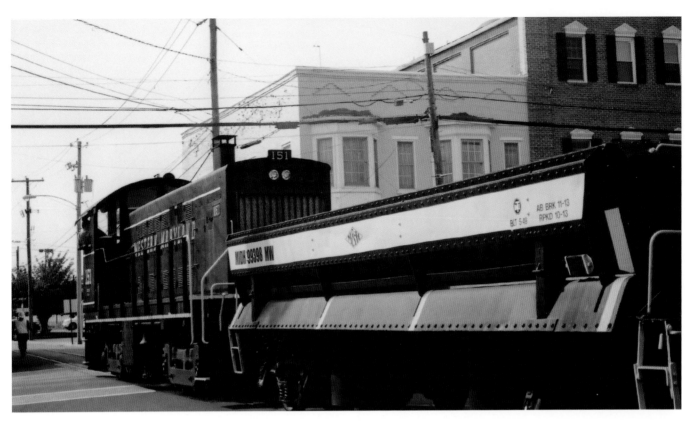

August 25, 2016, westbound M&H freight train powered by diesel locomotive No. 151 is on Brown Street at Union Street in Middletown. The first car behind the locomotive is M&H side dump car No. 99398, built by Difco (formerly Differential Car Company), which will be needed as a buffer car for the eastbound trip. (Kenneth C. Springirth photograph)

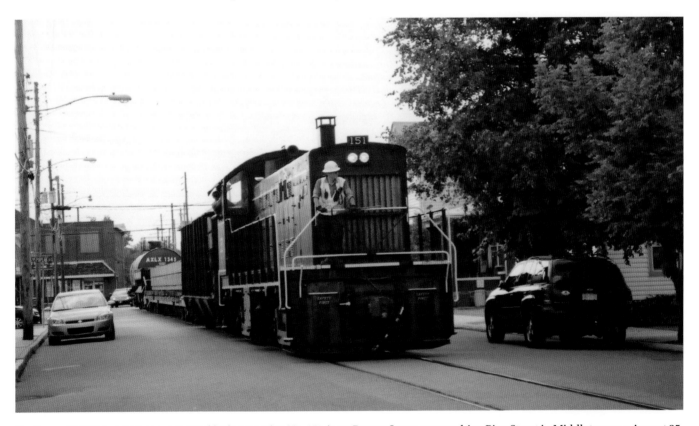

Eastbound M&H freight train, powered by locomotive No. 151, is on Brown Street approaching Pine Street in Middletown on August 25, 2016. (Kenneth C. Springirth photograph)

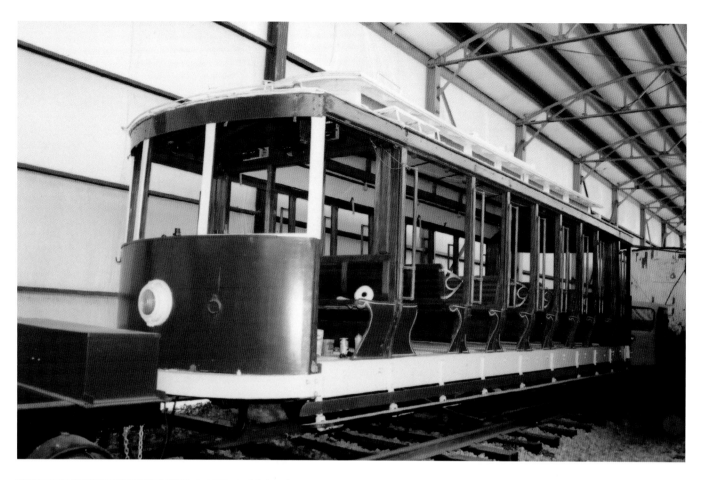

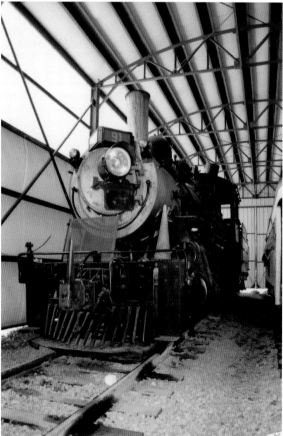

Above: Single truck trolley car No. 441 is normally kept in the car barn. This Rio De Janeiro Tram Company open trolley car was built in 1909 and is used on the M&H Railroad for special events. (Kenneth C. Springirth photograph)

Left: Former Canadian National Railway steam locomotive No. 91 is kept inside the M&H car barn. Built in February 1910 by the Canadian Locomotive Company for the Grand Trunk Railway, the Mogul type locomotive has a 2-6-0 wheel arrangement with two leading wheels on one axle, six powered and coupled driving wheels on three axles, and no trailing wheels. It was sold to the M&H in 1986. (Kenneth C. Springirth photograph)

Chapter 6

New Hope & Ivyland Railroad

In 1872, the North East Pennsylvania Railroad (NEPR) completed a 7.3-mile line from Glenside to Hatboro and reached Hartsville Station in 1874. The Philadelphia & Reading Railroad acquired the NEPR and agreed to extend the line to New Hope if local residents would contribute 25 percent of the construction cost in the form of stock. After that requirement was met, construction began in 1890, and the line was opened to New Hope, Pennsylvania, on January 18, 1891. Regular passenger service from New Hope to Philadelphia began on March 29, 1891, over what became known as the New Hope branch of the Reading Company. The section of the line from Philadelphia to Hatboro was electrified in 1931 and passengers would transfer from a multiple unit electric commuter train to a gas electric car at Hatboro. On June 7, 1952, the gas electric car service made its last run with service the next day replaced by a Reading Transportation Company bus. With the Reading Company anxious to abandon unprofitable branch lines, the 16.7 mile line from New Hope to Ivyland was sold to Steam Trains, Inc. for about $200,000 on June 20, 1966. It became known as the New Hope & Ivyland Railroad (NHIR). Steam locomotive No. 1533 with a 4-6-0 wheel arrangement was purchased from the Canadian National Railway, and No. 40 with a 2-8-0 wheel arrangement was purchased from the Cliffside Railroad in North Carolina. The NHIR acquired seven passenger cars from the Reading Company. With its classic witch's hat roof, the New Hope station, which had been relocated to a wooded area for use by a sportsmen's club, was moved back to the railroad. On August 6, 1966, locomotive No. 1533 operated the first public excursion from New Hope seven miles south to Buckingham Valley. The NHIR also operated freight service. When income could not keep up with expenses, Steam Trains Inc. declared bankruptcy on June 5, 1970.

To preserve railroad service through the center of Bucks County, the Bucks County Industrial Development Corporation (BCIDC) purchased the trackage from Steam Trains, Inc. in 1974. Bucks County chose McHugh Brothers Heavy Hauling, Inc. (MBHH) to operate freight service over the line via a lease agreement. In 1976, the railroad received funding to rehabilitate the line. Volunteers from the Buckingham Valley Trolley Association (BVTA) erected overhead wire south from Buckingham Valley on a mile of the NHIR main line. Passengers from New Hope could transfer to a trolley car for a short ride and return to take the NHIR train back to New Hope. On April 1, 1976, Conrail took over the Reading Company, and the NHIR purchased a mile of track from Ivyland to the Warminster SEPTA station. Summer passenger service was operated by NHIR from New Hope connecting with SEPTA's Warminster to Philadelphia commuter trains. As a result of a workplace accident, the NHIR was forced to end tourist operation in 1977. BVTA volunteers began operating the steam passenger train and trolley cars under the NHIR name in 1979. Insurance complications resulted in the BVTA ending both the train and trolley car operation. BVTA took down the wire and relocated to Philadelphia where they operated the Penn's Landing Trolley from September 5, 1982, to December 17, 1985. NHIR emerged from bankruptcy on June 30, 1979. In 1989, the MBHH lease of the NHIR ended, and the Morristown & Erie was chosen to operate the railroad. The BCIDC sold the railroad to the Bucks County Railroad Preservation & Restoration Corporation (BCRP&RC) on October 12, 1990. By late June 1991, the Morristown & Erie no longer operated the NHIR. Track was rehabilitated over the four-mile segment between New Hope and Lahaska. With refurbished infrastructure, well maintained rolling stock, and a reliable schedule, the NHIR is a showcase attraction in Bucks County. In 2016, all NHIR trains are diesel operated and operate hourly passenger excursion service to Lahaska. Locomotive No. 40 was in the shop for a rebuilding. This is a classy short line that also operates freight service and fits the delightful charm of New Hope. The NHIR website is www.newhoperailroad.com and the station address is 32 W. Bridge St., New Hope, PA 18939.

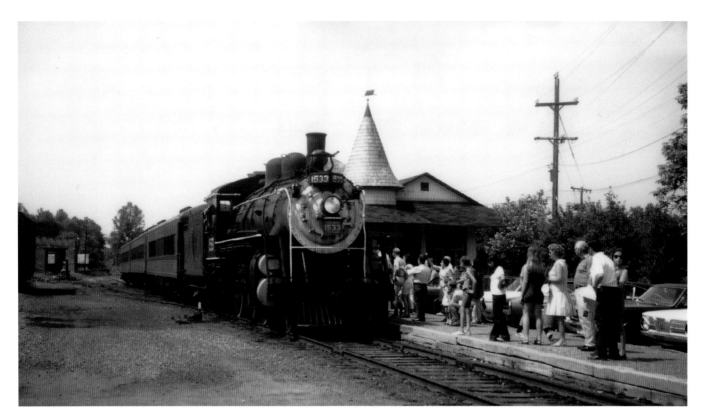

On July 12, 1970, New Hope & Ivyland Railroad (NHIR) steam locomotive No. 1533 is heading an excursion train at New Hope with passengers on the platform ready to board. This class H-6d Ten Wheeler type locomotive with a 4-6-0 wheel arrangement was built in June 1911 by the Montreal Locomotive Works and was acquired from the Canadian National Railway. (Kenneth C. Springirth photograph)

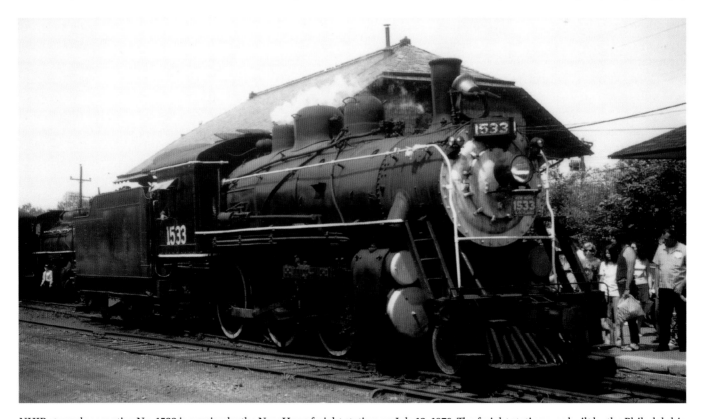

NHIR steam locomotive No. 1533 is passing by the New Hope freight station on July 12, 1970. The freight station was built by the Philadelphia & Reading Railroad in 1891. (Kenneth C. Springirth photograph)

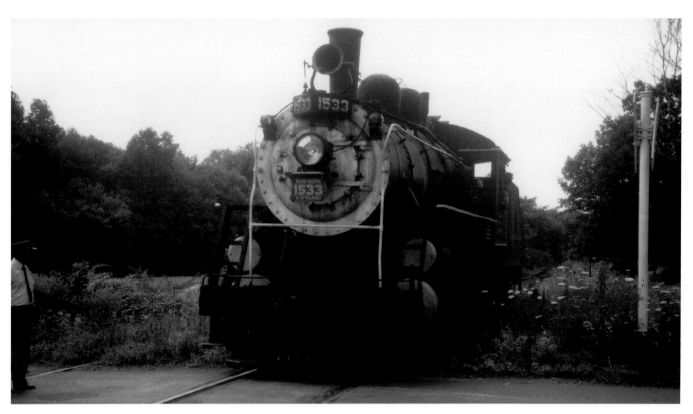

On July 12, 1970, NHIR steam locomotive No. 1533 is backing around to get to the other end of the train for the return trip to New Hope. (Kenneth C. Springirth photograph)

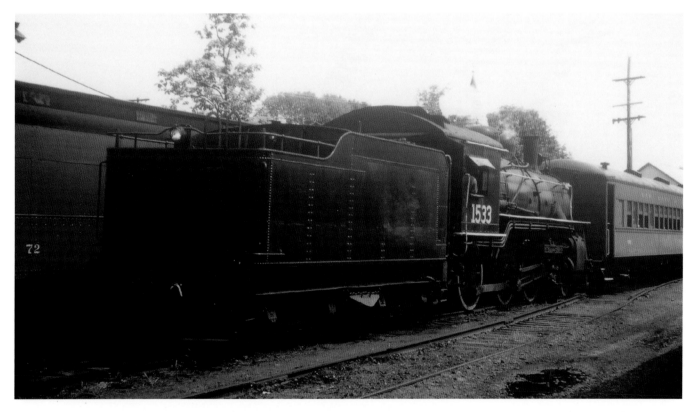

NHIR steam locomotive No. 1533 is shown behind a former Reading Company passenger car on July 20, 1970. The September 30, 1951, schedule shows numerous trains between Philadelphia's Reading Terminal and Hatboro. There were five trains from New Hope to Hatboro and four trains from Hatboro to New Hope. (Kenneth C. Springirth photograph)

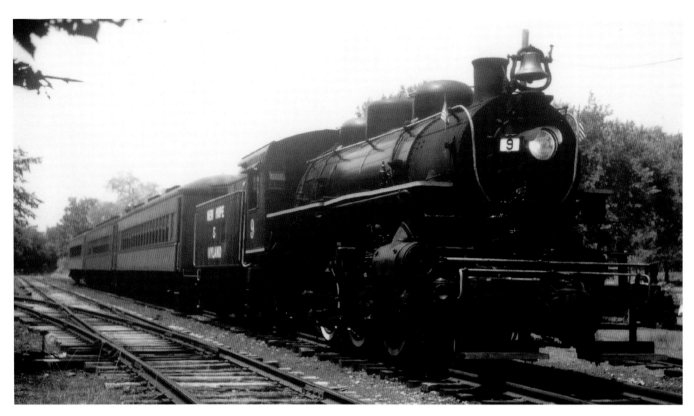

Buckingham Valley is the location of NHIR steam locomotive No. 9 on July 16, 1978. This switcher type locomotive with a 0-6-0 wheel arrangement was built by the American Locomotive Company (ALCO) in October 1942. It was used by both the U.S. Army and the Virginia Blue Ridge Railroad. (Kenneth C. Springirth photograph)

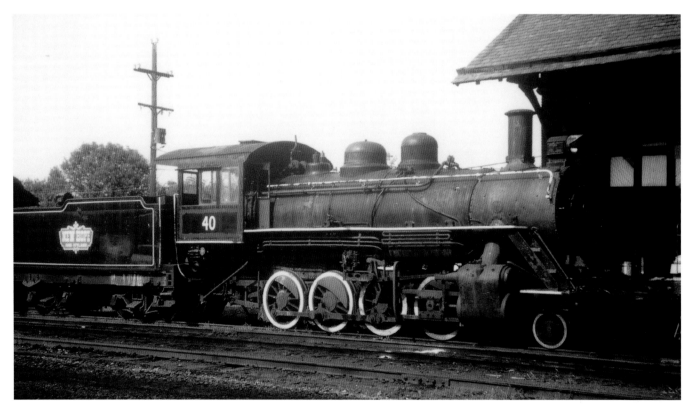

On July 12, 1970, NHIR steam locomotive No. 40 is waiting for the next assignment. This Consolidation type locomotive with a 2-8-0 wheel arrangement was built in November 1925 by the Baldwin Locomotive Works for the Lancaster & Chester Railroad and was sold to the Cliffside Railroad in 1947. (Kenneth C. Springirth photograph)

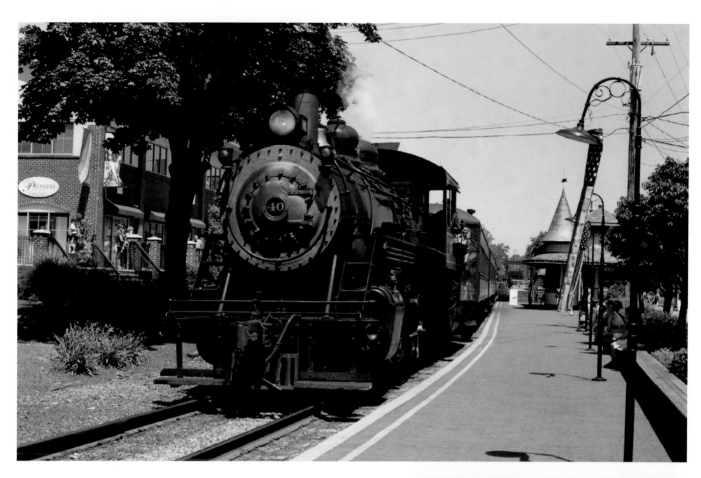

Above: On a sunny July 4, 2004, NHIR steam locomotive No. 40 is departing from New Hope station. (Kenneth C. Springirth photograph)

Right: NHIR steam locomotive No. 40 is in the shop at New Hope undergoing a major rebuilding in this August 27, 2016 scene. (Kenneth C. Springirth photograph)

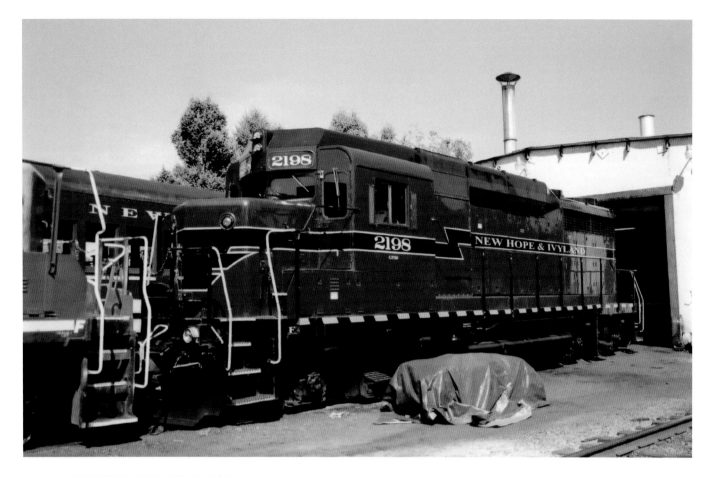

Above: Nicely painted NHIR type GP30 diesel locomotive No. 2198 is in front of the New Hope engine shop on August 27, 2016. This four-axle, 2,250-horsepower locomotive was built as No. 2250 in May 1963 by the Electro-Motive Division of General Motors Corporation (one of 52, Nos. 2200-2251) for the Pennsylvania Railroad. It became Penn Central No. 2198 and later was Conrail No. 2198. (Kenneth C. Springirth photograph)

Left: Pennsylvania Northeastern Railroad diesel locomotive No. 7010 is in the New Hope engine house of the NHIR on August 27, 2016. This was one of 126 type GP9 locomotives, Nos. 4228-4353, rated 1,750 horsepower and built by General Motors Diesel in Canada. It was rebuilt as a GP9RM in 1985 and was retired by the Canadian National in 2011. The Pennsylvania Northeastern Railroad interchanges with the NHIR at Warminster. (Kenneth C. Springirth photograph)

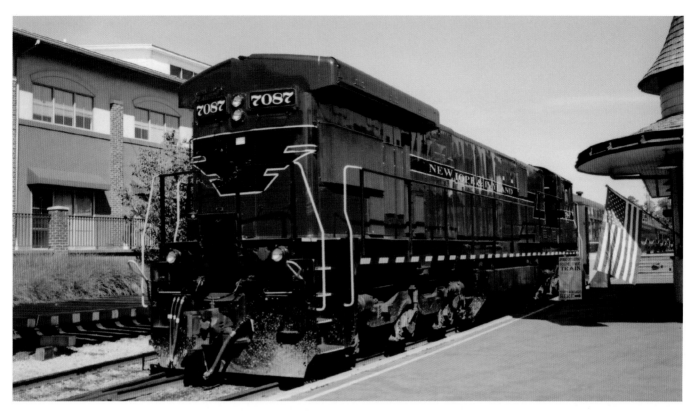

On August 27, 2016, six-axle 3,000-horsepower NHIR type C30-7 diesel locomotive No. 7087, built in November 1981, is at the New Hope station waiting for the 11:00 a.m. departure time. This was one of 51 locomotives, Nos. 7016-7031, 7052-7061, and 7070-7094, built by General Electric for the Seaboard Coast Line Railroad. It was later transferred to CSX Transportation. (Kenneth C. Springirth photograph)

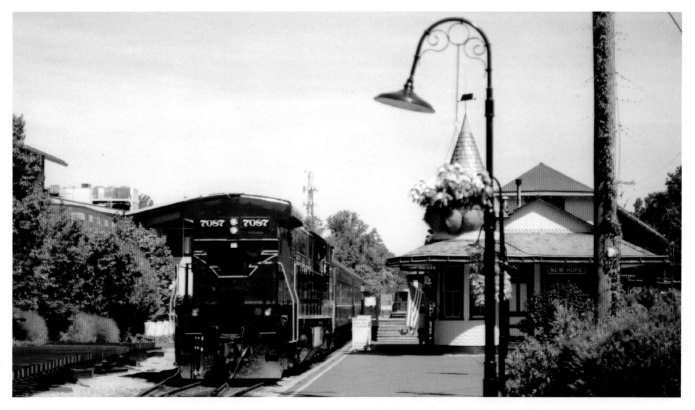

NHIR diesel locomotive No. 7087 is leaving the New Hope station with its picturesque peaked roof on August 27, 2016. This station was originally built in 1891 by the Philadelphia & Reading Railroad next to Bridge Street and was later moved into the woods as a meeting place for a local sportsmen's club. With a lot of work it was returned to its current location. (Kenneth C. Springirth photograph)

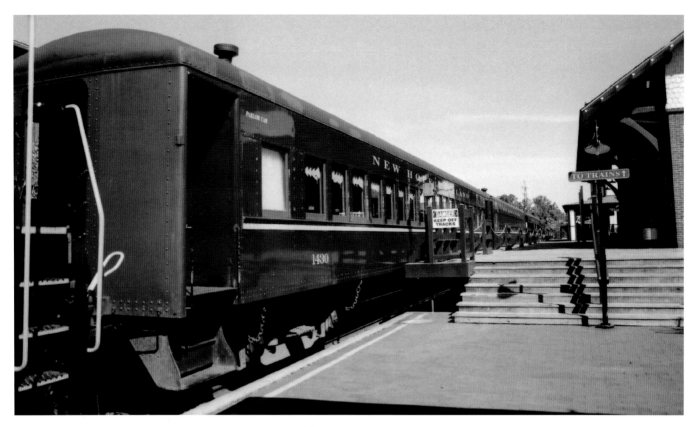

Former Reading Company passenger car No. 1430 is part of the 11:00 a.m. NHIR excursion train on August 27, 2016, at New Hope station. This attractive suburban steel class PBh coach was built in 1913 with a seating capacity of 76. (Kenneth C. Springirth photograph)

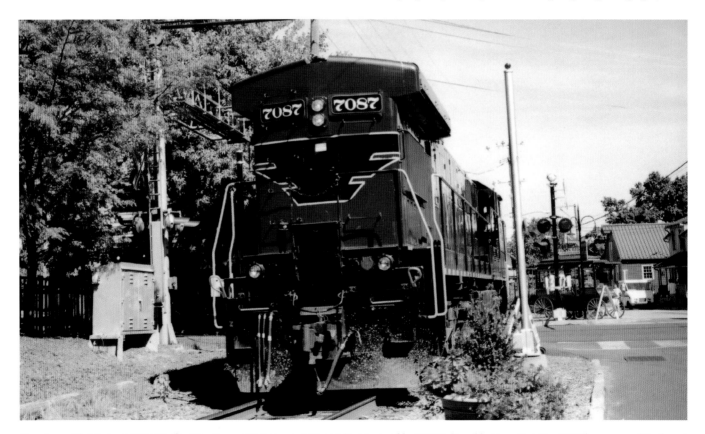

On a beautiful August 27, 2016, the 11 a.m. passenger excursion train powered by NHIR diesel locomotive No. 7087 has crossed Railroad Street heading out of New Hope. (Kenneth C. Springirth photograph)

Chapter 7

Allentown & Auburn Railroad

Chartered in 1853, the Allentown & Auburn Railroad was to move anthracite coal from Schuylkill County, Pennsylvania, to Lehigh Valley, New Jersey, and New York. In *The Reading Railroad: History of a Coal Age Empire Volume 1: The Nineteenth Century* by James L. Holton, page 125, it was reported that in 1853, "a group of New York and Allentown promoters received permission to incorporate for the purpose of building a railroad from Allentown and the Lehigh Valley to a point somewhere between Reading and Port Clinton on the P & R." A number of changes were made to the agreement such as "If the borough of Kutztown didn't happen to be on the new route a branch line would have to be built to it; the Allentown end of the road should be south of that city; the western end of the road was authorized to be at a junction with a company called the Auburn and Port Clinton Railroad." Railroad construction began in 1855. The proposed line was from Allentown southwesterly through Dorneyville, Wescoesville, Trexlertown, Breinigsville, Topton, Kutztown, Windsor Castle, Hamburg, and Port Clinton. Much of the grading had been completed; however, the 1857 financial panic ended construction with no rail laid.

Allentown was connected to Reading by the East Penn Railroad, and the line became part of the Philadelphia & Reading (P&R) Railroad on July 12, 1860. At an 1868 public meeting, Kutztown residents petitioned their Pennsylvania State legislators to have Kutztown connected to Topton by railroad. The P&R agreed, and the line was opened from Topton to Kutztown on January 10, 1870. The other two sections of the Allentown & Auburn Railroad built were the Catasauqua & Fogelsville line from Trexlertown via Breinigsville and Farmington to Klines Corner, and a spur from East Penn Junction to serve Mack Truck at Allentown. Although regular scheduled passenger service on the line ended in 1934, the Reading Company operated excursion trains from Kutztown to Hershey Park plus Church and Sunday School picnic trains operated from Reading and Allentown to Kutztown. These excursion trains ended in the 1957 summer. The railroad carried ammunition during World War II. Freight service continued into 2013. Customers included the Kutztown Foundry & Machine Corporation, feed/grain mills, farm equipment dealers, coal dealers, electric plants, stone quarries, cement plant, and a lumber yard.

By the early 1970s, with a number of northeast railroads including the Reading Company in bankruptcy, the United States Railway Administration (USRA) considered abandoning the line. Kutztown businesses sent letters to government officials to save the line. The line was included in the Final System Plan. Conrail took over the line's operation on April 1, 1976, for the new owner, the Pennsylvania Department of Transportation (PennDOT). With a decline in freight business, PennDOT put the line up for bid for a new operator, which became the Anthracite Railroad Company. With a continued business decline, in 1989, the Blue Mountain & Reading Railroad took over the line's operation and rebuilt the line. In 1994, the line again went up for bid, and the East Penn Railroad took over. PennDOT put the line up for sale in 2000. The Borough of Kutztown purchased the railroad and formed the Kutztown Transportation Authority headed by Jim Schlegel who played a key role in getting the line included in the Final System Plan and has had a lifelong interest in the railroad. Kutztown Borough purchased the railroad because for 1.75 miles, the Kutztown Borough's electric lines from its substation are along the railroad right of way, the borough's drinking water well heads and water treatment plant are along that right of way, and the railroad embankment also helps keep nitrates from farming areas from flowing into the water supply. The East Penn Railroad made its last run on April 4, 2013. On October 3, 2013, the Kutztown Transportation Authority approved the transfer of operation from the East Penn Railroad to the new Allentown & Auburn Railroad, effective October 18, 2013. Passenger excursion service was inaugurated on March 28, 2015, with seven Easter Rabbit roundtrip excursions from Kutztown to Topton.

The railroad's website is www.allentownandauburnrr.com, and the trains depart from the station at 298 Railroad Street, Kutztown, PA 19530.

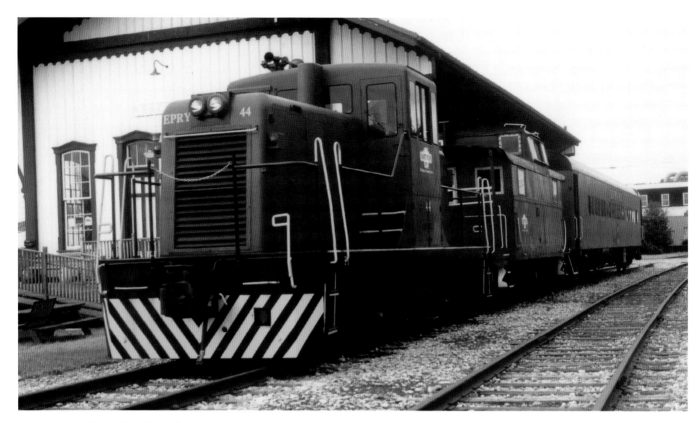

East Penn Railroad diesel switcher No. 44 is at the Kutztown station in the borough of Kutztown, in Berks County, Pennsylvania, on October 17, 2004. This 44-ton locomotive was built by General Electric in December 1951 as No. 55 for the New York Dock. (Kenneth C. Springirth photograph)

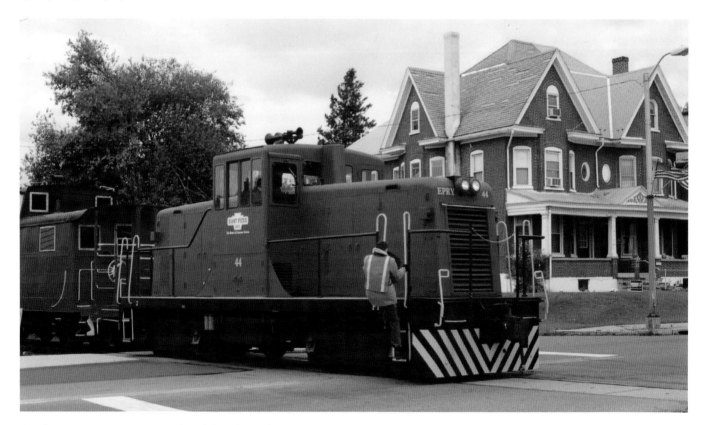

October 17, 2004, East Penn Railroad diesel switcher No. 44 is crossing Main Street in picturesque Kutztown, powering a passenger excursion. (Kenneth C. Springirth photograph)

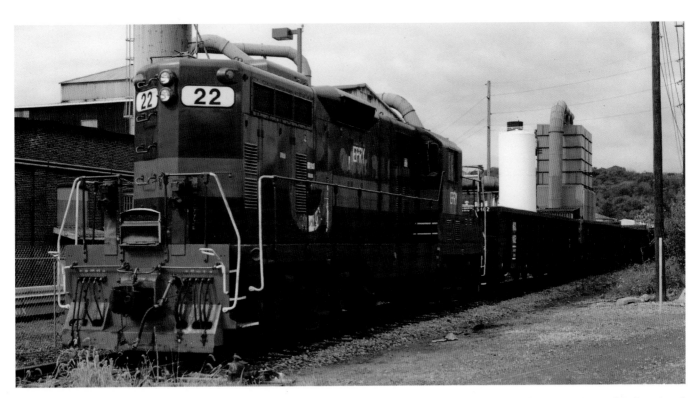

East Penn Railroad type GP7 diesel locomotive No. 22 (originally built as No. 561 in October 1950 for the Maine Central Railroad and served as Springfield Terminal No. 22 and later AF Railway Industries Incorporated No. 22) is at the McConway & Torey Foundry at Kutztown with a string of gondola cars on October 17, 2004. This four-axle, 1,500-horsepower locomotive was one of 24 locomotives (Nos. 561-569, 571-581, 590-593) built for the Maine Central Railroad by the Electro-Motive Division of General Motors Corporation. (Kenneth C. Springirth photograph)

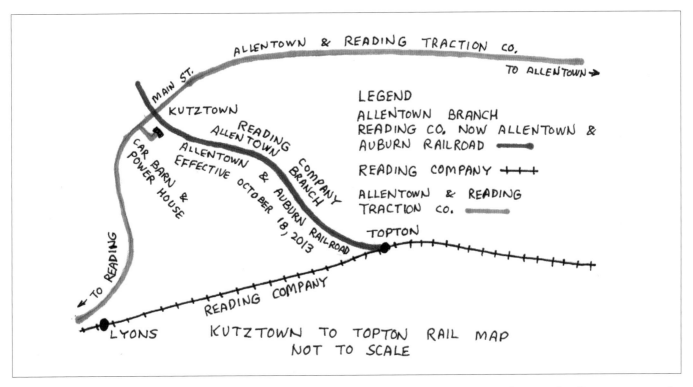

Kutztown was the terminal point of the Reading Company Allentown branch. The Allentown & Reading Traction Company operated a broad gauge 5 foot 2.5 inches line from Reading via Temple to Kutztown and a standard gauge 4 foot 8.5 inches line from Kutztown via East Texas (Pennsylvania) to Allentown. Kutztown-East Texas service ended on November 1, 1929. Temple-Kutztown service ended on February 25, 1930. Reading–Temple service ended on March 27, 1936.

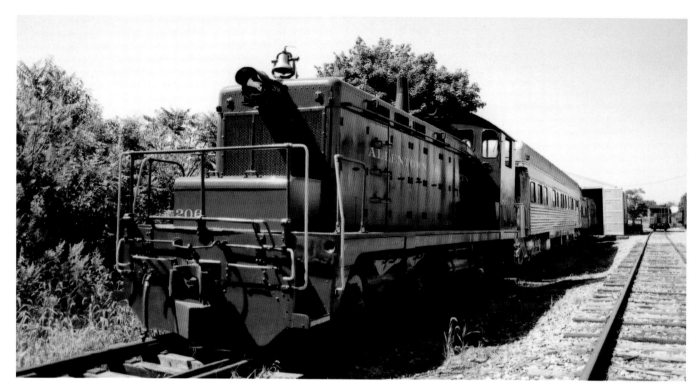

On August 28, 2016, Allentown & Auburn Railroad diesel locomotive No. 206 is at the Topton yard. This locomotive was built by the Electro-Motive Division (EMD) of General Motors Corporation as No. 206 in March 1937 as a 600-horsepower type SW for the Philadelphia Bethlehem & New England Railroad. In 1947, it was sold to the Steelton & Highspire Railroad and renumbered 23. EMD rebuilt it in 1957 as a type SW-900m. (Kenneth C. Springirth photograph)

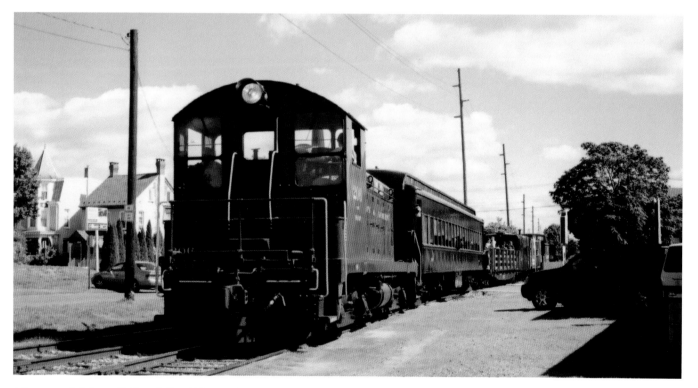

Allentown & Auburn Railroad diesel No. 206 is powering an excursion train across Main Street in Kutztown on September 24, 2016. This locomotive was purchased in 1967 by the Maryland & Pennsylvania Railroad and renumbered 83. It was acquired by the Stewartstown Railroad and renumbered 11. In the 1990s, the locomotive powered Rail Tours Inc. excursions at Jim Thorpe. It was acquired by the Reading & Northern Railroad when Rail Tours Inc. went out of business. Now owned by the Allentown & Auburn Railroad, the locomotive has been refurbished, renumbered 206, and repainted in May 2015. (Kenneth C. Springirth photograph)

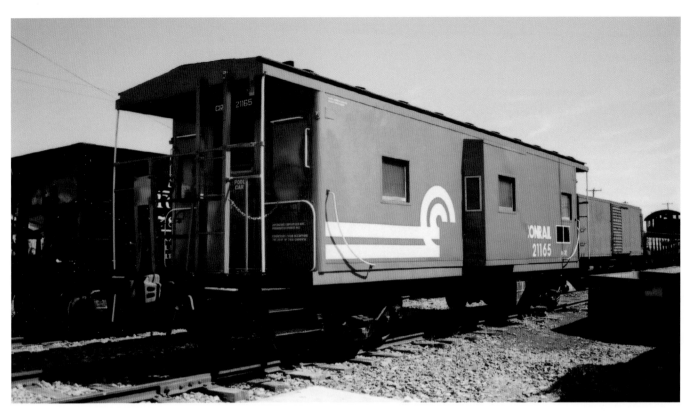

Brightly painted bay window Conrail caboose No. 21165 (owned by the Conrail Historical Society) is at the Allentown & Auburn Railroad yard at Topton on August 28, 2016. This caboose was formerly Erie Lackawanna Railroad caboose C368, built in October 1969. (Kenneth C. Springirth photograph)

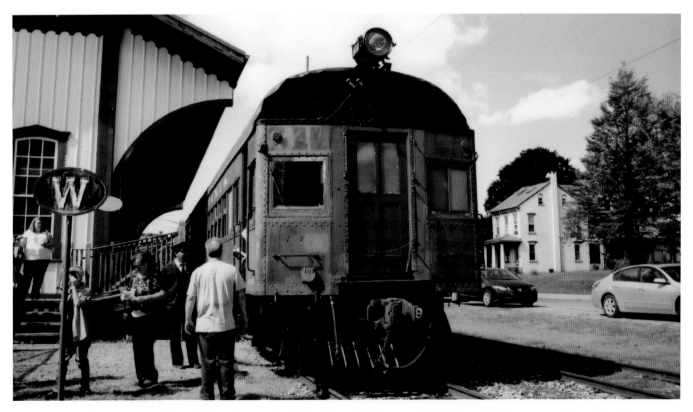

Former Pennsylvania Railroad doodlebug No. 4666 (built by J. G. Brill Company in 1930) is at the Kutztown station of the Allentown & Auburn Railroad on September 24, 2016, operating passenger excursion service. This rail car had been on the Black River & Western Railroad and was brought to the Allentown & Auburn Railroad on April 16, 2016. (Kenneth C. Springirth photograph)

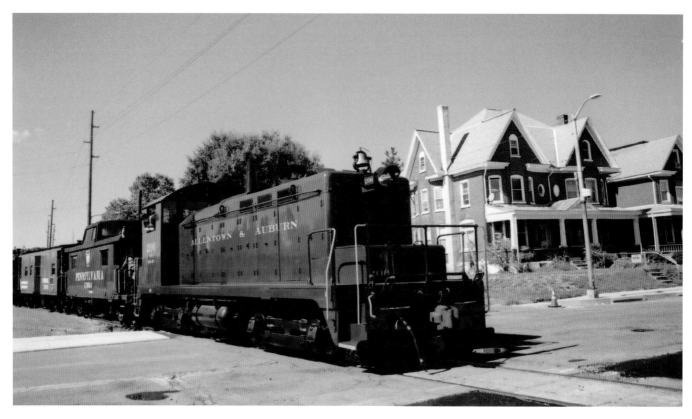

On a beautiful September 24, 2016, Allentown & Auburn Railroad diesel No. 206 is crossing Main Street in Kutztown, pulling a passenger train excursion to Topton and return to Kutztown. Originally built in 1937, this may be the oldest type SW diesel locomotive built by EMD still in active service. (Kenneth C. Springirth photograph)

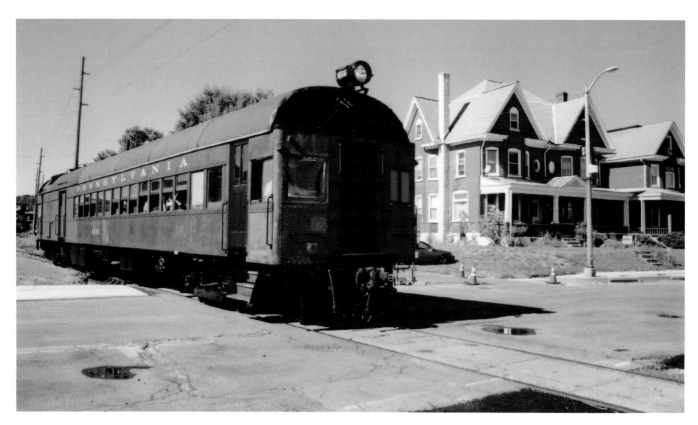

Approximately 20 minutes after Allentown & Auburn diesel No. 206 pulled the excursion in the upper photograph, former Pennsylvania Railroad doodlebug No. 4666 is at Main Street in Kutztown for a round trip to Topton. (Kenneth C. Springirth photograph)

Chapter 8

Colebrookdale Railroad

The Colebrookdale Railroad was incorporated on April 15, 1853, and opened the 8.5-mile line from Pottstown to Boyertown in September 1869 to serve the iron ore industry along the Manatawny Creek. It was extended 4.5 miles to Mt. Pleasant in November 1869. On January 1, 1870, it was leased to the Philadelphia & Reading Railroad.

The Oley Valley Railway Company began construction of a trolley car line, and the first section opened between Reading and Friedensburg on November 5, 1901. Trolley car service from Reading to Boyertown opened on May 23, 1902. The Ringing Rocks Electric Railway Company opened a trolley car line from Pottstown to Ringing Rocks on June 14, 1894. Construction began on March 18, 1907, to extend the line to Boyertown. Under the name Boyertown & Pottstown Railway Company, trolley car service opened between Pottstown and Boyertown on May 28, 1908. The trolley car line on Philadelphia Avenue in Boyertown was not allowed to cross the Philadelphia & Reading Railroad, which meant that riders would get off the trolley and walk across the tracks to the trolley on the other side. An underpass was completed on 4th Street on July 27, 1921, so that trolley cars could go under the railroad tracks. As automobile ownership increased, trolley car riding declined. The last day for Boyertown to Pottstown trolley car service was on August 21, 1927. Boyertown to Reading trolley car service made its last run on July 21, 1932.

With the exception of Sunday and Monday when there were less trains, the Philadelphia & Reading Railroad had about six passenger trains per day for the remainder of the week in each direction in 1916 on the Pottstown via Boyertown to Barto line. Over a period of time, passenger service declined and ended. The railroad was merged into the Reading Company on December 31, 1945. When the Reading Railroad was merged into Conrail on April 1, 1976, the Colebrookdale branch was acquired by the Pennsylvania Department of Transportation (PennDOT). The branch line was initially operated by the Anthracite Railroad, followed by the Reading & Blue Mountain, and later the East Penn Railroad. Berks County had previously stepped in to prevent abandonment of the line and acquired it in March 2009. The line was then conveyed to the Eastern Berks Gateway Railroad which wanted out of the operation at the end of 2013 and conveyed the line to the Colebrookdale Railroad Preservation Trust of Boyertown.

This railroad is focusing to recreate the Edwardian era and provide a special experience. Part of that experience is the train ride itself. After a long search, three mainline long distance passenger cars were acquired from the Saratoga & North Creek Railway, which operates passenger service between Saratoga Springs and North Creek in New York. These cars had structural integrity, workable car bodies, clerestory roofs, and three-axle trucks. Local cabinet makers spent an amazing amount of time refurbishing the interiors of coach *Dawn Trader* No. 4970, dining car No. 5038, and parlor car *Storm King* No. 5033. Each of these cars express the elegance of the Edwardian era. On the September 26, 2016 11 a.m. train, the waiter in the dining car was Nathaniel C. Guest, director of the Colebrookdale Railroad Preservation Trust, dressed in the elaborate white Pullman uniform of the Edwardian era. Conductors were in proper uniform with white gloves. It was obvious that the uniforms represented pride in what they were doing. Each member of the train crew took their job seriously and was very safety conscious. Before passengers boarded the train, crew members had a meeting headed by the lead conductor for that day and reviewed employee assignments, plus any special requirements for that trip. The extensive amount of employee training has resulted in friendly, knowledgeable, and professional crew members who take pride in their responsibilities.

The railroad's website is www.colebrookdalerailroad.com, and the mailing address is Colebrookdale Railroad Preservation Trust, P.O. Box 492, Boyertown, PA 19512.

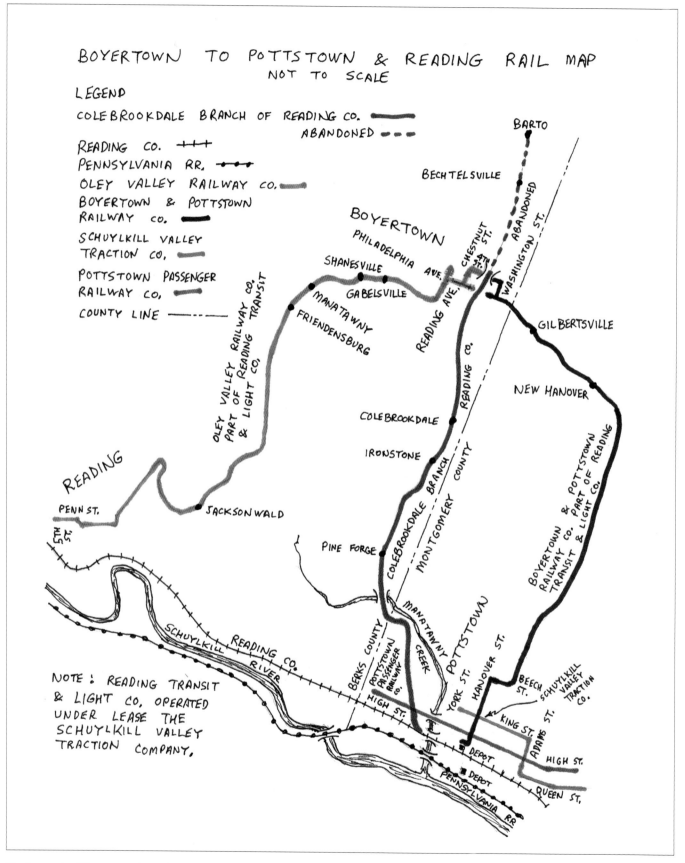

The borough of Boyertown in Berks County, Pennsylvania, had direct railroad access to the borough of Pottstown in Montgomery County, Pennsylvania, by the Reading Company, plus interurban trolley car service to Reading and Pottstown. Beginning December 18, 1916, there was through trolley car service between Boyertown and the Chestnut Hill neighborhood of Philadelphia.

An Oley Valley Railway Company trolley car is on the spur track on Reading Avenue at Philadelphia Avenue, looking north in the borough of Boyertown, in this postcard view around 1910. The steeple of St. John's Evangelical Lutheran Church and the commercial building to the right are still present in 2016. With the cornerstone laid in 1871, the brick Gothic-revival style church was built with the steeple later added in 1882. Safety concerns resulted in the removal of the steeple in 1933, and it was replaced in 1985.

In this 1910 postcard scene, an Oley Valley Railway Company trolley car is eastbound on Philadelphia Avenue, passing by the Twin Turrets home, which was built for Daniel Boyer around 1865. The copper turrets and front porch were added in 1880. In 2016, the building is the Twin Turrets Inn Bed and Breakfast; it also serves as an antique shop.

Colebrookdale Railroad four-axle, 1,750-horsepower diesel locomotive No. 7236 sparkles in the morning sunshine of September 25, 2016 for the 11 a.m. excursion train at Boyertown. The locomotive arrived on January 19, 2016. This was built as a GP9 in October 1959 by the Electro-Motive Division of General Motors Corporation as part of an order of 270 locomotives, Nos. 7000-7269, for the Pennsylvania Railroad. It was later rebuilt into a GP10 locomotive. (Kenneth C. Springirth photograph)

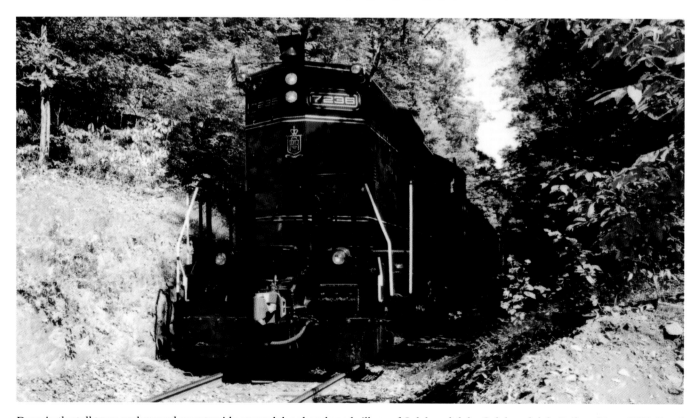

Deep in the tall trees and rugged countryside around the abandoned village of Colebrookdale, Colebrookdale Railroad type GP10 diesel locomotive No. 7236 is heading a southbound excursion run to Pottstown on September 25, 2016. (Kenneth C. Springirth photograph)

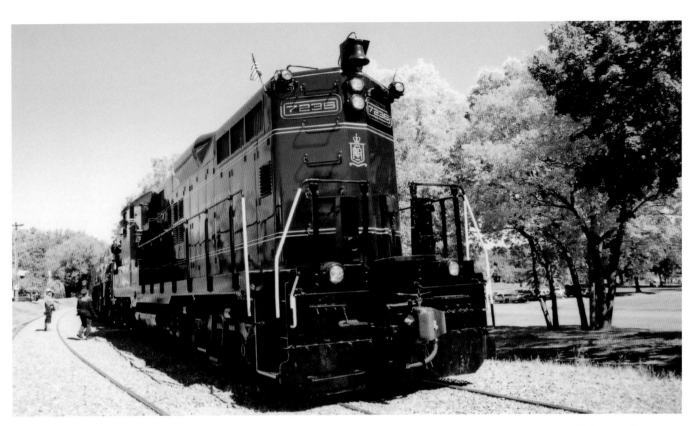

Colebrookdale Railroad type GP10 diesel locomotive No. 7236 is at the southbound terminus at Pottstown. It will shortly disconnect from the train and use the siding on the left to get to the other end and power the train back to Colebrookdale on September 25, 2016. (Kenneth C. Springirth photograph)

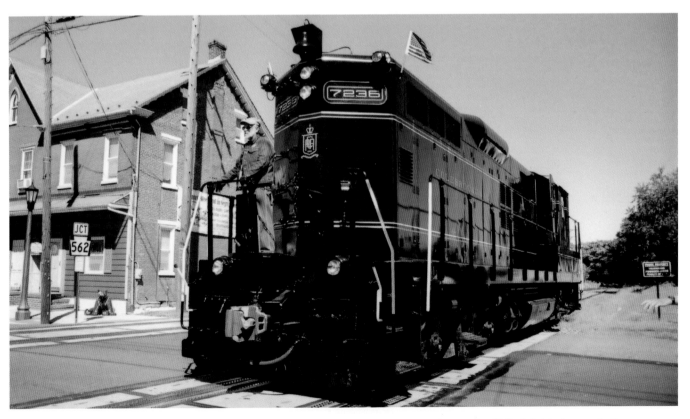

On September 25, 2016, Colebrookdale Railroad type GP10 diesel locomotive No. 7236 is crossing Philadelphia Avenue in Boyertown to get around the train. (Kenneth C. Springirth photograph)

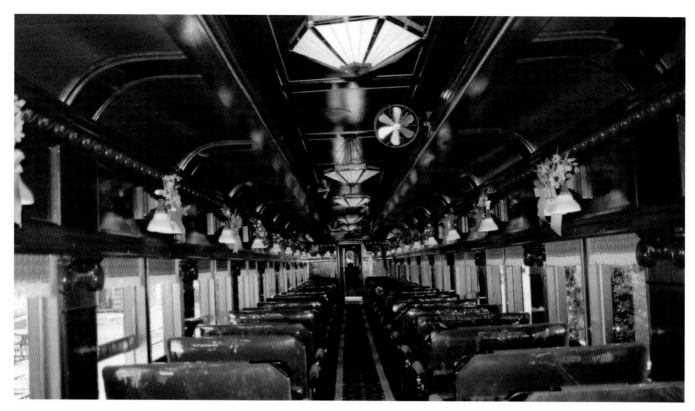

An interior view of the Colebrookdale Railroad coach No. 4970 shows a magnificent restored car interior on September 24, 2016. Beginning in mid-2014, volunteers invested thousands of hours of labor, including track work, restoring cars, and operations on the Colebrookdale Railroad. (Kenneth C. Springirth photograph)

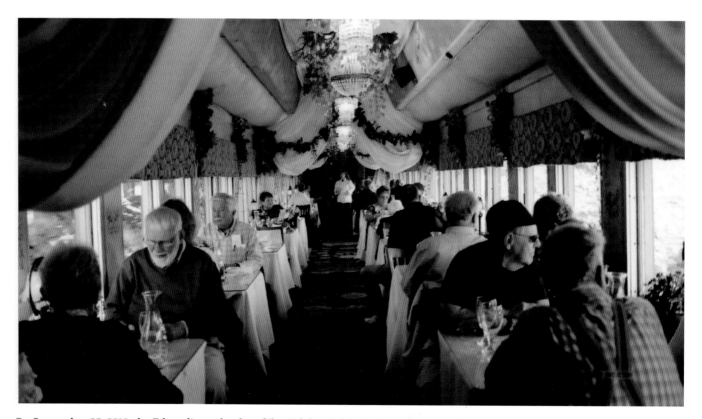

On September 25, 2016, the Edwardian splendor of the Colebrookdale Railroad dining car No. 5038 interior provides a look of the finest trains of a long gone era. The onboard white-gloved attendants serve passengers a variety of carefully prepared food items. (Kenneth C. Springirth photograph)

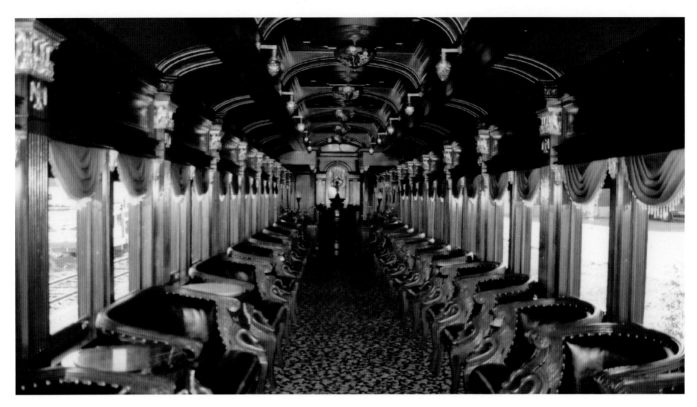

The elegance of Colebrookdale Railroad parlor car No. 5033 *Storm King* on September 24, 2016, coupled with beautiful scenery and remarkable geology along the route, provides a journey through an area that is primarily accessible by train. Volunteers not only staff each train excursion, but pride themselves with their special attention to detail that includes cleaning the train cars between each run. (Kenneth C. Springirth photograph)

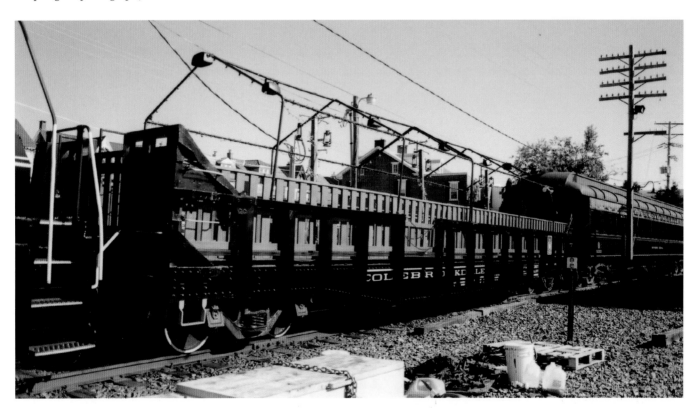

Colebrookdale Railroad open car No. 2764 is next to locomotive No. 7236, awaiting passengers for the next excursion on August 28, 2016. The open car was originally built as a stake body flat car for the Rutland Railroad in 1910. It was a major effort to acquire the rolling stock used on the Colebrookdale Railroad. (Kenneth C. Springirth photograph)

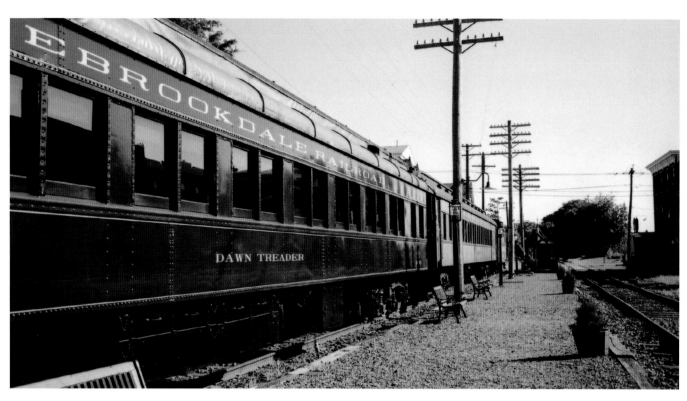

The last three cars of the August 28, 2016, Colebrookdale Railroad train at Boyertown are from left to right: repainted coach No. 4970 *Dawn Treader*, dining car No. 5038 (not yet repainted on the outside), and former Pennsylvania Railroad caboose No. 477768. (Kenneth C. Springirth photograph)

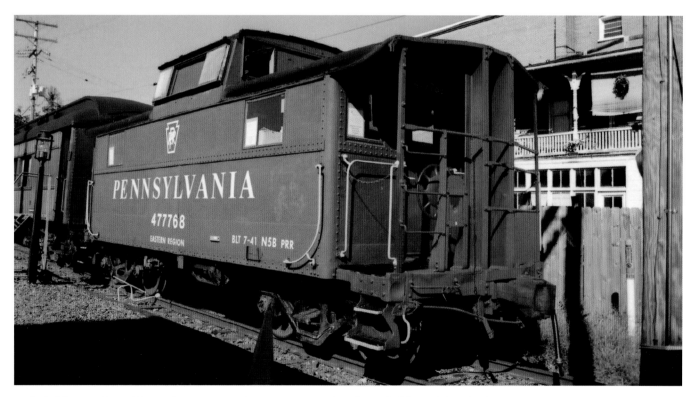

In the bright sunshine of September 24, 2016, caboose No. 477768 is at the end of the Colebrookdale train at Boyertown. This Pennsylvania Railroad type N5B caboose was built in July 1941 at the Pennsylvania Railroad shops in Altoona, Pennsylvania. It was later used on the Knox & Kane Railroad. The Ravenna Chapter of the National Railway Historical Society of Charlottesville, Virginia, spent six years restoring this caboose. With a $5,000 donation from the Boyertown Lions and Rotary Clubs to the NRHS Restoration Grant Fund, the Colebrookdale Railroad received the caboose. (Kenneth C. Springirth photograph)

Reading Company Technical & Historical Society

The Reading Company Technical & Historical Society (RCT&HS), an all-volunteer and educational corporation, was founded in 1975, incorporated July 16, 1976, and in 1983 was approved as a 501(c) (3) non-profit organization. During 1985, it acquired its first locomotive, No. 5513, former Reading Company type GP30 which was the first of the second-generation diesel locomotives built by the Electro-Motive Division of General Motors Corporation. Since the Society was able to obtain information and photographs on the Reading Company, it has become a repository of knowledge, artifacts, and memorabilia on the Reading Company. In 2003, the RCT&HS purchased a seven-acre section of the former Pennsylvania Steel Foundry property in Hamburg, Pennsylvania, and opened the Reading Railroad Heritage Museum to the public in 2008. The museum has become a place where the Society's collection of over 70 Reading Company locomotives, freight cars, and passenger cars are being preserved and can be viewed by the public. In addition, the amazing history of this railroad, along with its contribution to the development of southeastern Pennsylvania, can be explored. The exhibit building displays tools, machines, documents, and a wide variety of items used by the Reading Company. This is one of the largest collections of a single railroad in one museum in the United States.

The Reading Railroad Heritage Museum is located at 500 S. Third Street, Hamburg, PA 19526 and the website is www.readingrailroad.org.

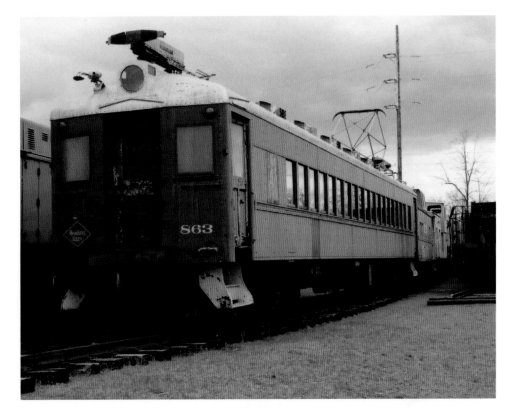

Seating 86 passengers and powered by two General Electric type 620 motors, Reading Company electric multiple unit car No. 863 looks massive on display at the Reading Railroad Heritage Museum (RRHM) on April 2, 2016. This car was built in 1932, and the original fleet of 100 electric powered cars were maintained at the Wayne Junction electric car shop in Philadelphia. Heavy repairs were done at the Reading shops. These cars, with their electric heating and fast acceleration, could be operated as single cars or as multiple unit trains on the railroad's commuter lines that radiated from Philadelphia. (Kenneth C. Springirth photograph)

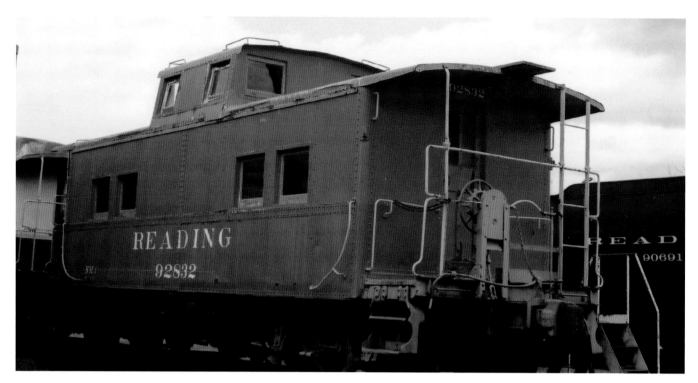

Reading Company class NMj caboose No. 92832 is at the RRHM on April 2, 2016. This was one of 25 steel cabooses, Nos. 92830-92854, built in 1936 at the Reading Car Shops, costing $2,889.12 per caboose with Duryea cushion underframes and Andrews trucks that were built using new and second-hand parts acquired from the Central Railroad New Jersey. Equipped with Westinghouse brakes, the caboose had four sleeping berths, four cupola seats for observation, four lockers, four closets, one long seat, washstand, water cooler, drop table, desk, stove, and tool box. (Kenneth C. Springirth photograph)

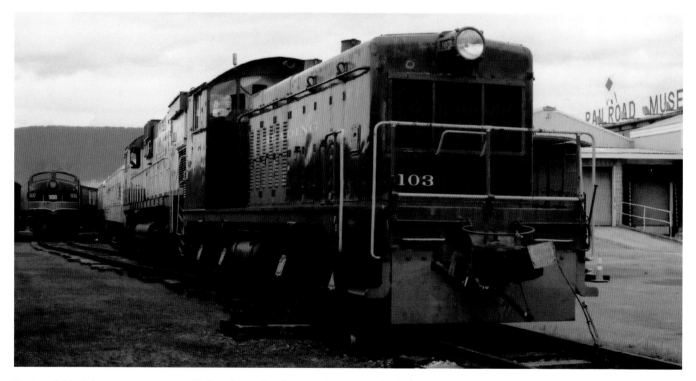

Restored 1,000-horsepower type NW2 diesel switcher locomotive No. 103 looks like it is ready to go at the RRHM on April 2, 2016. This was built by the Electro-Motive Division of General Motors Corporation for the Reading Company in July 1947 with a tractive effort of 62,030 pounds. After spending most of its time in the Philadelphia area, it was sold to the Canadian leasing firm Andrew Merrilees Ltd. and worked at the US Steel Fairless Works. It was out of service for several years and was donated by Andrew Merrilees Ltd. to the RRHM in 1991. (Kenneth C. Springirth photograph)

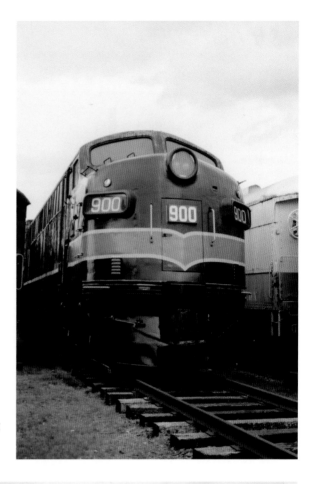

Right: Looking fresh from the paint shop, 1,500-horsepower type FP7A diesel locomotive No. 900 is at the RRHM on April 2, 2016. Built in 1950 by the Electro-Motive Division of General Motors Corporation, this locomotive weighed 255,100 pounds, had a tractive effort of 63,775 pounds, and had a top speed of 89 miles per hour. Ownership of the locomotive was transferred to Southeastern Pennsylvania Transportation Authority (SEPTA). The National Railway Historical Society (NRHS) purchased the locomotive from SEPTA in 1983, and it was later purchased by the RRHM. (Kenneth C. Springirth photograph)

Below: Built by the American Locomotive Company for the Reading Company in June 1952, this 1,600-horsepower type RS3 diesel locomotive No. 485 is at the RRHM in this April 2, 2016, scene. In 1973, the locomotive was sold to United Railway Supply Company and was used on the Roberval & Saguenay Railroad as No. 30, later leased to Domtar Packaging as No. 68 from 1978 to 1987, and was acquired by the RRHM with arrival on October 28, 1997. (Kenneth C. Springirth photograph)

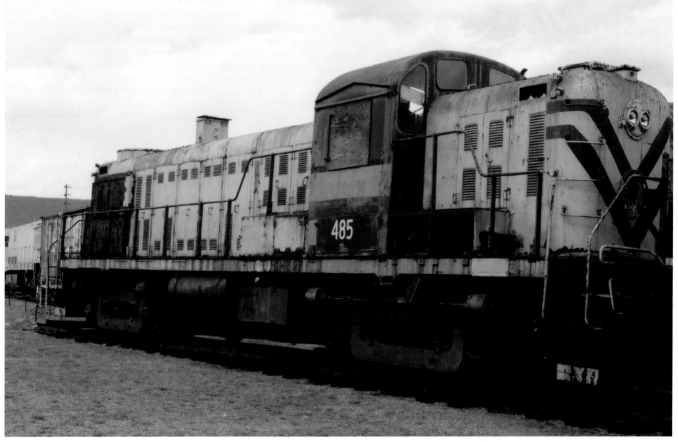

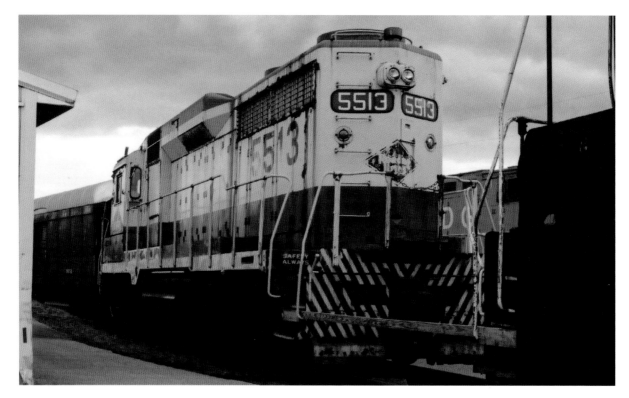

Type GP30 diesel locomotive No. 5513 is at the RRHM on April 2, 2016. This 2,250-horsepower locomotive, built in March 1962 for the Reading Company by the Electro-Motive Division of General Motors Corporation, introduced the new green and imitation gold paint scheme. In 1964, the locomotive was renumbered 3613 to fit in with a possible merger with the Baltimore & Ohio Railroad. When the Reading Company merged into Conrail, it became No. 2181 and was the first locomotive purchased by the RRHM. (Kenneth C. Springirth photograph)

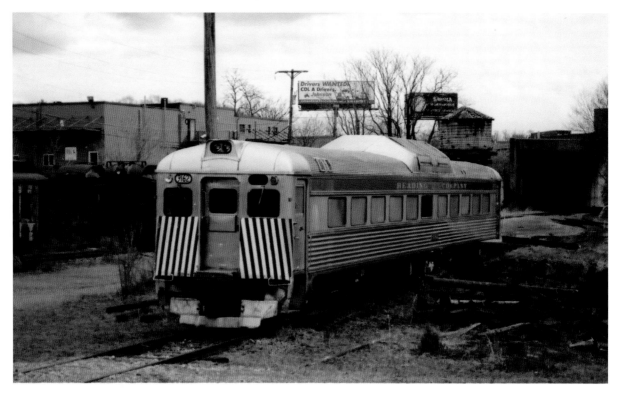

Type RDC-1 No. 9162 is at the RRHM on April 2, 2016. This was one of twelve rail diesel cars, Nos. 9151-9162, built by Budd Company in December 1962 with government funding and leased to the Reading Company. It was later acquired by the Massachusetts Bay Transportation Authority. (Kenneth C. Springirth photograph)

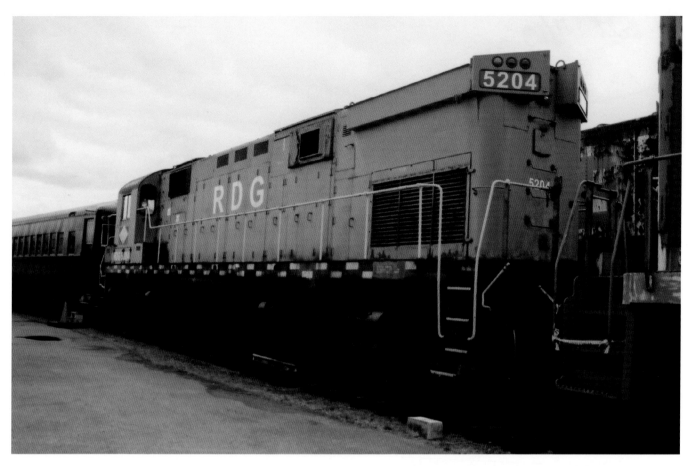

Above: On April 2, 2016, 2,400-horsepower type C424 diesel locomotive No. 5204, built by American Locomotive Company in October 1963 for the Reading Company, is surrounded by rolling stock at the RRHM. When Conrail took over operations, this locomotive was renumbered 2493 and retired in 1979. In 1980, the locomotive was rebuilt and became Green Bay & Western Railroad (GBWR) No. 322. After the Wisconsin Central Ltd. took over the GBWR in 1993, the locomotive was retired. Signet Leasing & Financial (the locomotive's owner) sold the locomotive to RRHM. (Kenneth C. Springirth photograph)

Right: In April 2, 2016, 3,000-horsepower type U30C locomotive No. 6300 is at the RRHM. Having a tractive effort of 101,462 pounds, this was one of five locomotives, Nos. 6300-6304, built by the General Electric Company in June 1967 for the Reading Company. These were the heaviest single-diesel units ever operated by the Reading Company, and were the first locomotives to have "Bee Line Service" on the long hood sides. In April 1976, the locomotive became Conrail No. 6840 and was retired on July 28, 1982. It was sold to the Chicago & Northwestern Railroad and acquired by the RRHM in 1991. (Kenneth C. Springirth photograph)

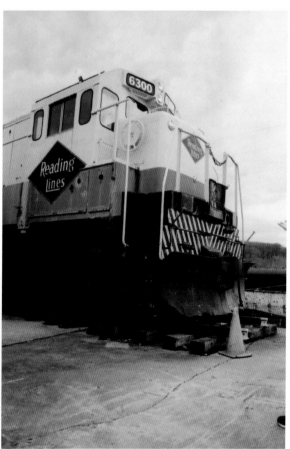

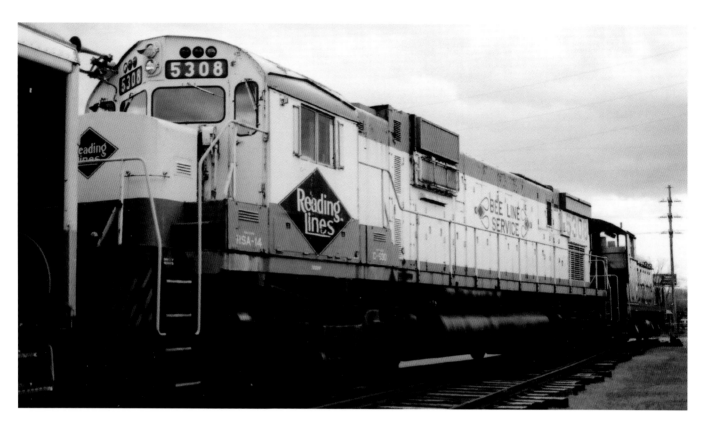

Type C630 diesel locomotive No. 5308, lettered for "Bee Line Service," is in the lineup of locomotives and rolling stock at the RRHM on April 2, 2016. This 3,000-horsepower locomotive, with a tractive effort of 98,435 pounds, was built by the American Locomotive Company in September 1967 for the Reading Company. Under Conrail, it was renumbered 6761, placed in storage in 1979, and sold in February 1983. The RRHM purchased the locomotive in 1986. (Kenneth C. Springirth photograph)

Reading Company tool car No. 90685, later transferred to Conrail, is among the extensive line up of equipment at the Reading Railroad Heritage Museum on April 2, 2016. (Kenneth C. Springirth photograph)

Chapter 10

SEPTA's Former Reading Company Commuter Lines

The Philadelphia, Germantown & Norristown Railroad (PG&N) built a line on private right of way from 9th and Spring Garden Streets in Philadelphia to Price Street and Germantown Avenue in Germantown, which opened on June 6, 1832. Steep grades north of Germantown resulted in a separate line built along the Schuylkill River to Norristown, which opened on August 15, 1835. The PG&N was extended from Germantown to Chestnut Hill, which opened on December 1, 1854. These lines became part of the Philadelphia & Reading Railroad (P&R) in 1870. The Chestnut Hill line became known as Chestnut Hill East to differentiate it from the Pennsylvania Railroad line which was just west of it. Philadelphia via Lansdale to Doylestown P&R passenger service began on October 7, 1857. In 1876, the P&R opened the line from Jenkintown to Bound Brook, New Jersey, where connections were made with the Central Railroad of New Jersey.

On July 26, 1931, electrified commuter service began on the Doylestown, Hatboro, and West Trenton lines. Full electrified commuter service began on the Norristown Line and Chestnut Hill East line on February 5, 1933. Passenger service between Hatboro and New Hope ended in 1952. The Newtown line was electrified to Fox Chase with Philadelphia city funding, and service began on September 25, 1966. A decline in revenues resulted in the Reading Company declaring bankruptcy on November 23, 1971. The Reading Company extended electrification from Hatboro to Warminster, which opened on July 29, 1974. Commuter lines not included in the Final System Plan were acquired by the Southeastern Pennsylvania Transportation Authority (SEPTA). Consolidated Rail Corporation (Conrail) operated passenger service until SEPTA took over the operation of Philadelphia area commuter lines on January 1, 1983.

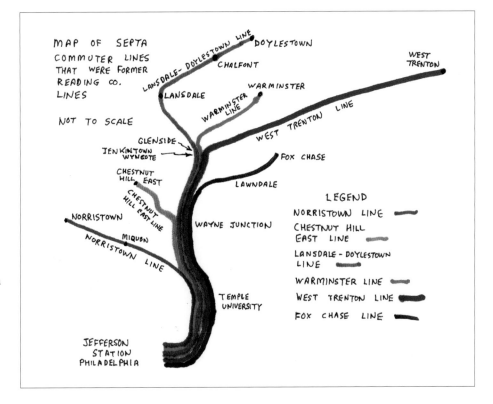

SEPTA operates the former Reading Company commuter lines from the underground Jefferson Station (known as Market East until September 4, 2014) which replaced the Reading Terminal in Philadelphia. This station is part of the Center City Commuter Connection, which connects the former Pennsylvania Railroad and Reading Company commuter lines.

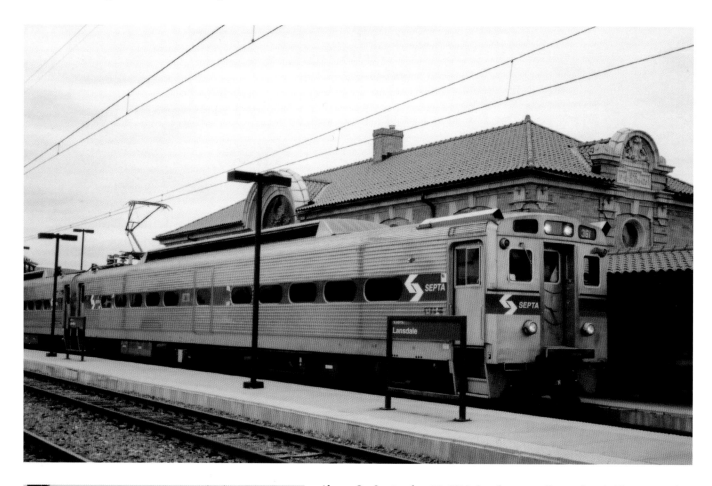

Above: On September 26, 2016, Southeastern Pennsylvania Transportation Authority (SEPTA) commuter train headed by Silverliner IV car No. 361, built by the General Electric Company, is on the 35.8-mile Lansdale/ Doylestown Line at the Lansdale station, originally built in 1902 by the Reading Company, waiting for departure time. According to SEPTA data, in 2015, this line required 41 cars during the peak period. (Kenneth C. Springirth photograph)

Left: SEPTA commuter car No. 708 (one of 38 Silverliner V cars, Nos. 701-738, built by the Hyundai Rotem Company during 2010-2011) is at the end of a commuter train at the Lansdale station on a southbound trip to Philadelphia on September 25, 2016. The Lansdale station was once a transfer point between the Lansdale/Doylestown electric commuter line and the rail diesel car (RDC) service to Quakertown, Allentown, and Bethlehem. Budget cuts resulted in the elimination of the RDC service to Bethlehem in 1981. (Kenneth C. Springirth photograph)

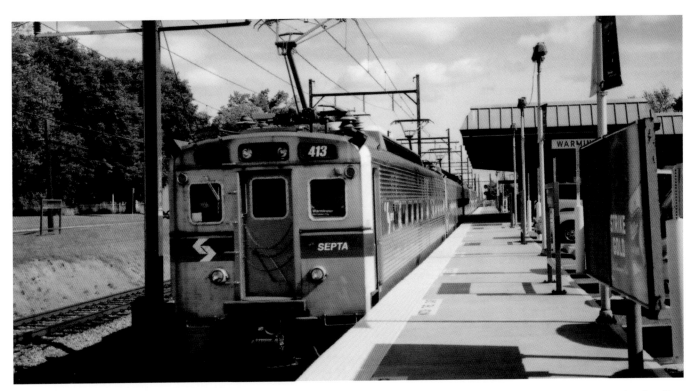

On a sunny September 26, 2016, SEPTA Silverliner IV car No. 413, built by the General Electric Company, is at Warminster station heading a trip to Philadelphia. Electric commuter service was extended by the Reading Company from Hatboro to Warminster on July 29, 1974. According to SEPTA 2015 data, the 22.3-mile Warminster line required 20 cars during the peak period. (Kenneth C. Springirth photograph)

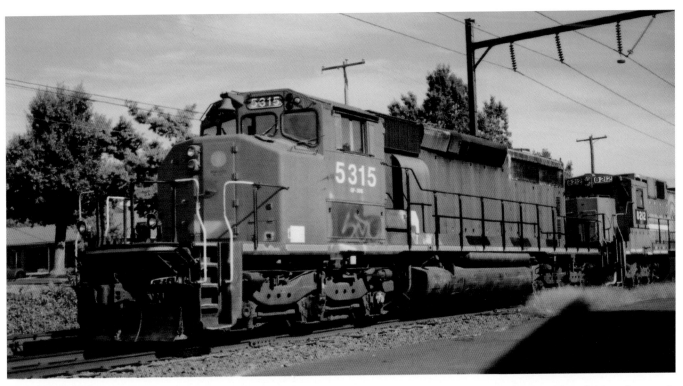

Pennsylvania Northeastern Railroad 3,000-horsepower type SD40-2W diesel locomotive No. 5315 is in a lineup of three locomotives north of the SEPTA Warminster station, waiting for the next assignment on September 26, 2016. This was one of 123 locomotives, Nos. 5241-5363, built with the four front windows Canadian Safety Cab by the Diesel Division of General Motors of Canada Ltd (formerly General Motors Diesel) in December 1979 for the Canadian National Railway. No. 5315 was later used on the New Hope & Ivyland Railroad. Directly behind is locomotive type C39-8 diesel locomotive No. 8212. This railroad operates on former Reading Company trackage in Bucks and Montgomery counties. (Kenneth C. Springirth photograph)

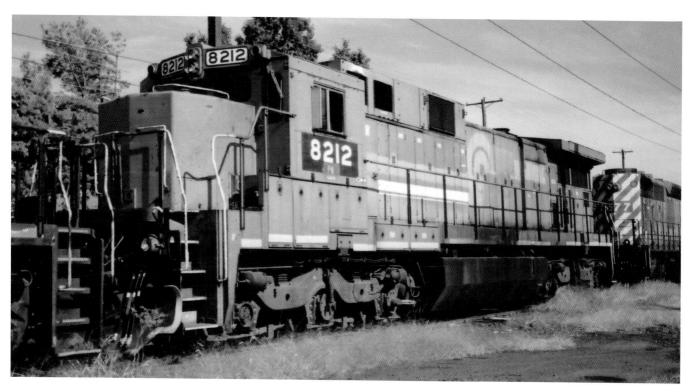

On September 26, 2016, Pennsylvania Northeastern Railroad 3,900-horsepower type C39-8 diesel locomotive No. 8212 is in the lineup of locomotives north of the SEPTA Warminster station. This was originally No. 6021, one of 22 locomotives, Nos. 6000-6021, built by General Electric Company in August 1986 for Consolidated Rail Corporation. It later became Norfolk Southern Railway No. 8212, was acquired by the National Salvage & Service Corporation, and later by the New Hope & Ivyland Railroad. Behind it is diesel locomotive No. 5577. (Kenneth C. Springirth photograph)

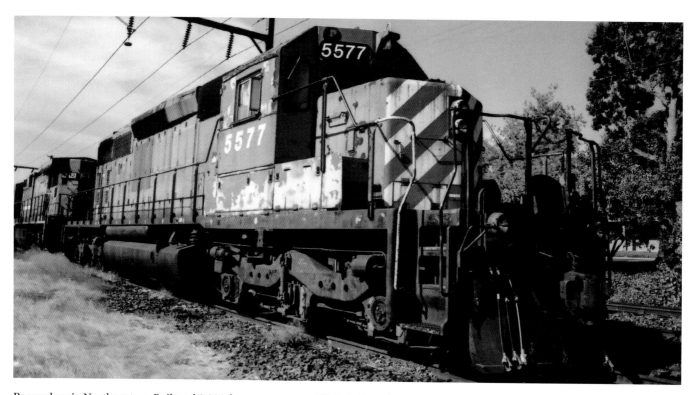

Pennsylvania Northeastern Railroad 3,000-horsepower type SD40-2 diesel locomotive No. 5577 is north of the Warminster station on September 26, 2016. This was one of 486 locomotives, Nos. 5560, 5565-5879, and 5900-6069, built by the Electro-Motive Division of General Motors Corporation for the Canadian Pacific Railway. No. 5577 was built in March 1972 and was later used on the New Hope & Ivyland Railroad. Behind it is locomotive No. 8212. (Kenneth C. Springirth photograph)

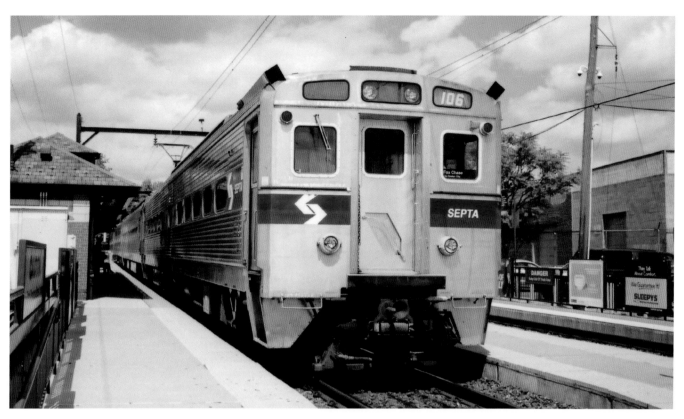

On September 26, 2016, SEPTA Silverliner IV commuter car No. 106, built by the General Electric Company, is at the Fox Chase station in the Fox Chase neighborhood of Philadelphia, heading a southbound run to downtown Philadelphia. According to 2015 SEPTA data, the 12.5-mile Fox Chase line required fourteen cars during the peak period. (Kenneth C. Springirth photograph)

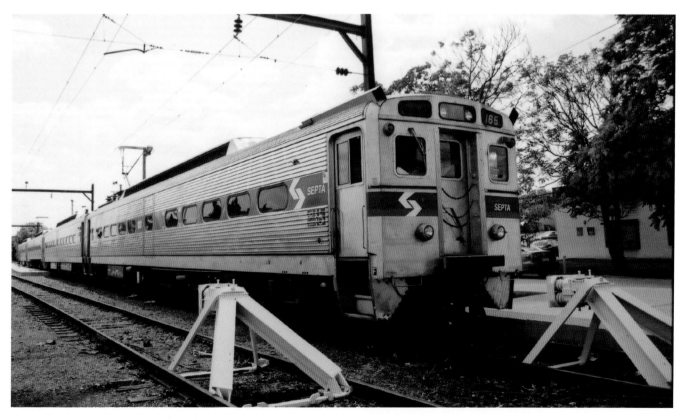

SEPTA Silverliner IV car No. 165, built by the General Electric Company, is at the Fox Chase terminus on September 26, 2016. The Silverliner IV cars were built between 1974 and 1976 with 231 active in 2016. (Kenneth C. Springirth photograph)

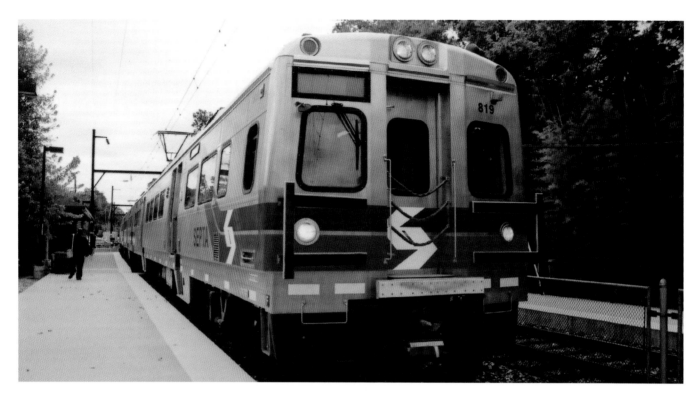

Heading for Norristown, SEPTA Silverliner V commuter car No. 819 (one of 82 cars, Nos. 801-882, built by Hyundai Rotem Company during 2010-2011) is the lead car at the Miquon station stop of the Manayunk/Norristown Line on September 26, 2016. As a result of fatigue cracks found in the equalizer beam of the truck on car No. 812, inspection of other Silverliner V cars revealed the problem on 95 percent of these cars, and all 120 Silverliner cars were taken out of service on July 2, 2016. Beginning July 5, 2016, SEPTA Regional Rail Lines operated basically a Saturday schedule. New equalizer beams were installed, and regular service resumed on October 3, 2016. (Kenneth C. Springirth photograph)

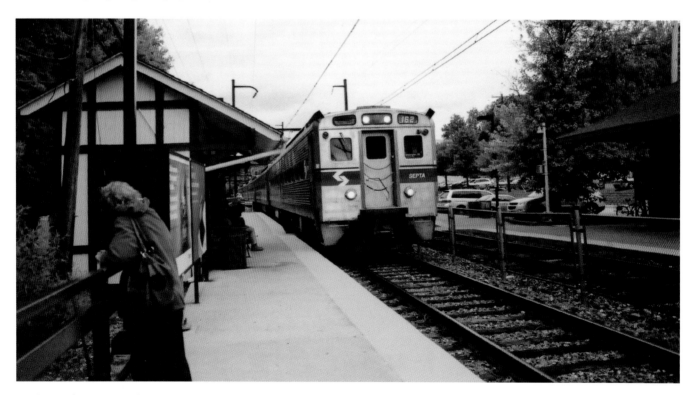

On September 26, 2016, SEPTA commuter train headed by Silverliner IV car No. 162, built by the General Electric Company, is arriving at Miquon Station (originally built in 1910) on the Norristown line on an afternoon trip to Philadelphia. According to 2015 SEPTA data, this 19.5-mile line required 23 cars during the peak period. (Kenneth C. Springirth photograph)

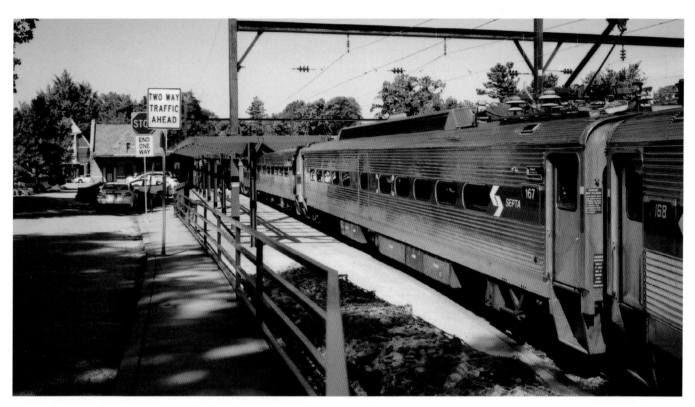

Chestnut Hill East Station (built in 1931 by the Reading Company to replace an earlier station) is the location of SEPTA Silverliner IV car No. 167, built by the General Electric Company, in the lineup of cars for the next trip to Philadelphia on August 26, 2016. According to 2015 SEPTA data, the 12.2-mile Chestnut Hill East Line required eleven cars during the peak period. (Kenneth C. Springirth photograph)

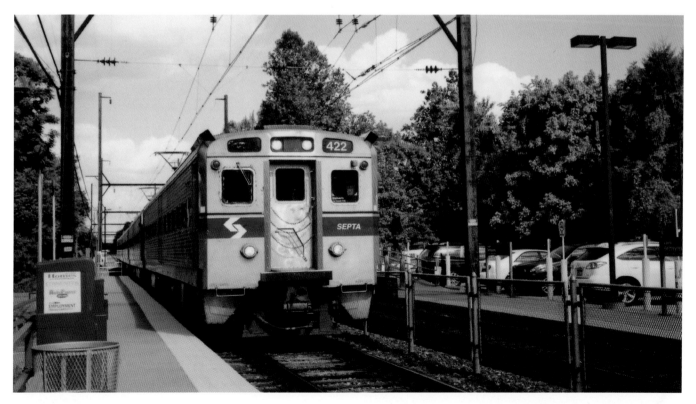

A Philadelphia bound SEPTA commuter train headed by Silverliner IV car No. 422, built by the General Electric Company, makes a stop at Bethayres station along the West Trenton Line on August 26, 2016. Bethayres is the last boarding stop for AM express trains to Philadelphia and the first discharge stop for PM express trains from Philadelphia. According to SEPTA 2015 data, the 34.7-mile West Trenton Line has 36 cars during the peak period. (Kenneth C. Springirth photograph)

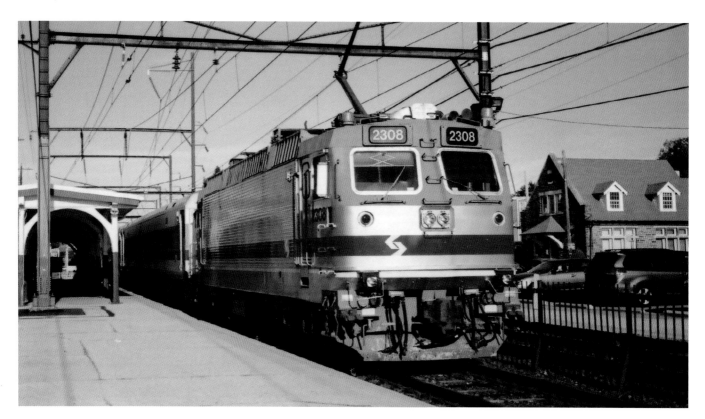

SEPTA electric locomotive type ALP-44 No. 2308, built by Asea Brown Boveri in 1996, is at Glenside Station for a southbound commuter run to Philadelphia on September 26, 2016. In 2016, this is the only single operating type ALP-44 locomotive in the world. Glenside station is served by both the Warminster and Lansdale/Doylestown lines, which split just west of the station. (Kenneth C. Springirth photograph)

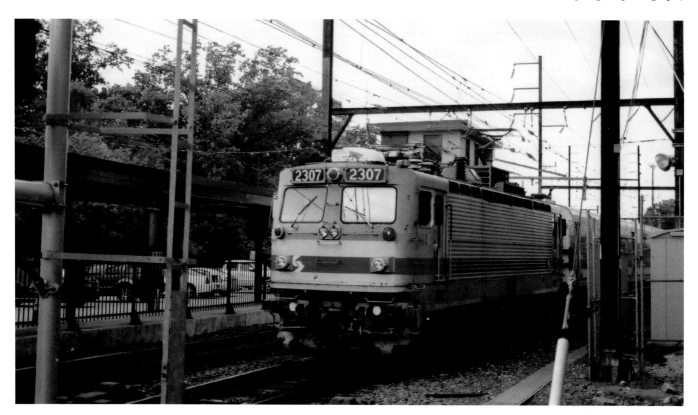

On August 26, 2016, SEPTA electric locomotive No. 2307, one of seven locomotives, Nos. 2301-2307, built by Asea Brown Boveri in 1987, is arriving at the Jenkintown-Wyncote station on August 26, 2016, for a rush hour trip to Philadelphia. This station, built in 1932 by the Reading Company, is served by the Warminster, West Trenton, and Lansdale/Doylestown lines. (Kenneth C. Springirth photograph)